Art & Money

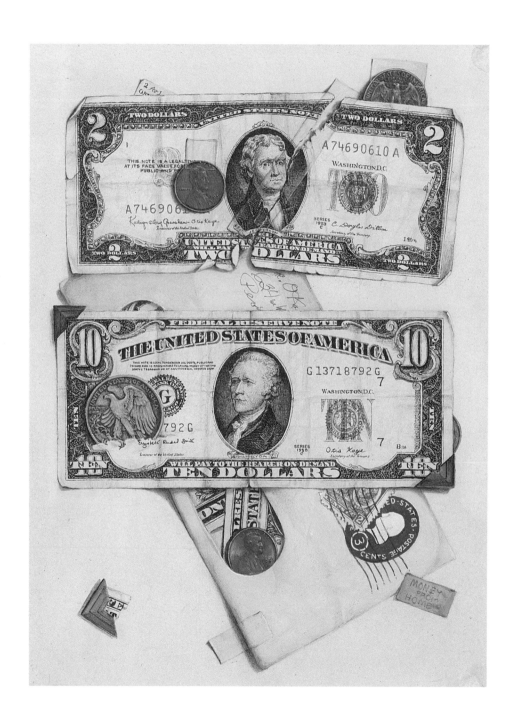

Otis Kaye, *2 for 1, or Money from Home*, 1953. Ink drawing on paper with watercolors, coins in oil, 8 × 10 in.

MARC SHELL

ART & MONEY

THE UNIVERSITY OF CHICAGO PRESS

CHICAGO AND LONDON

Marc Shell is professor of comparative literature and of English and American language and literature at Harvard University, where he is also director of the Center for the Study of Money and Culture. He is a recipient of the John D. and Catherine T. MacArthur Prize for 1990–95. He is a contributor to both scholarly and freelance publications, and his books include *The End of Kinship* and *Money, Language and Thought: Literary and Philosophical Economies from the Medieval to the Modern Era.*

The University of Chicago Press, Chicago 60637
The University of Chicago Press, Ltd., London
© 1995 by The University of Chicago
All rights reserved. Published 1995
Printed in the United States of America
04 03 02 01 00 99 98 97 96 95 1 2 3 4 5

ISBN: 0-226-75213-5 (cloth)

Library of Congress Cataloging-in-Publication Data

Shell, Marc.
 Art & money / Marc Shell.
 p. cm.
Includes bibliographical references.
 1. Art—Economic aspects. 2. Art—Economic aspects—United
States. I. Title. II. Title: Art and money.
N8600.S53 1995
701′.03—dc20 93-29238
 CIP

This book is printed on acid-free paper.

For Brian

CONTENTS

ILLUSTRATIONS

Color Plates (*following p. 50*)

Figures

Detail of plate 1, Paolo Uccello, *Profanation of the Host,* 1467–68

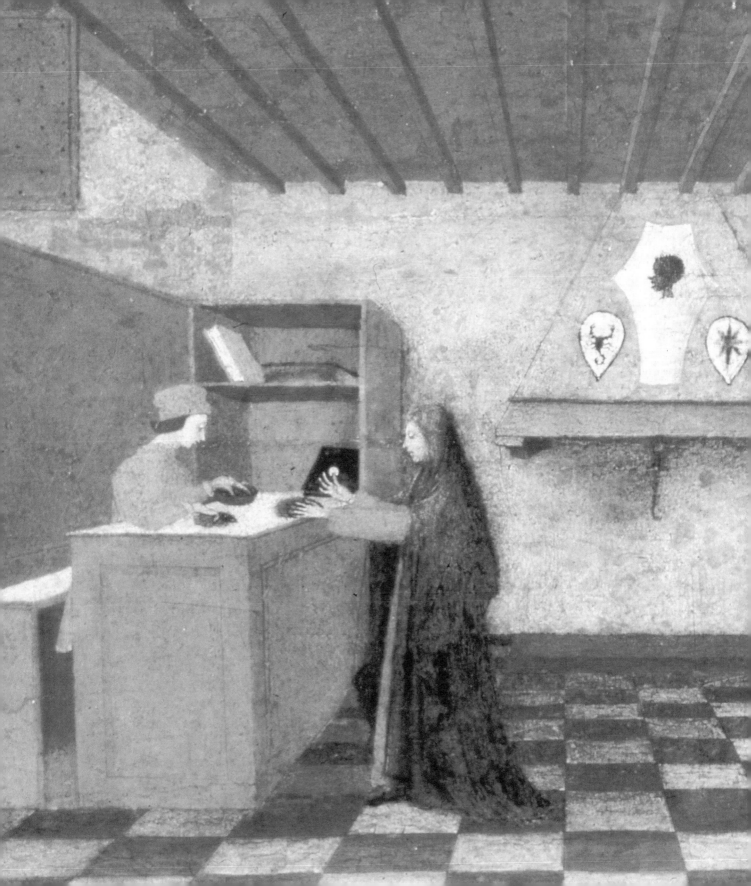

ACKNOWLEDGMENTS

I am most grateful to Susan Meld Shell for her amiable encouragement and thoughtful criticism and to our children, Hanna Rose and Jacob Adam, from whose intelligence and perspicacity I have learned more than words can say.

For their personal generosity and intellectual acumen I am also grateful to Jacques Birouste, Catherine de Léobardy, and Jean-Marie Thiveaud.

Museums and galleries have provided photographs and other materials. I am especially thankful to Jürgen Harten, director of the town hall museum in Düsseldorf; the Berry-Hill Galleries in New York; Paul Banks Jr. in Chicago; and the many artists—among them J. S. G. Boggs, Barton Lidice Benes, Cildo Meireles, and Alain Snyers—who sent original artworks.

Recent conferences have provided useful forums for discussing art and money. These include "How to Think Money," convened by the newspaper *Le Monde* in Le Mans; "Money and Truth," organized by the Swiss Comparative Literature Association in Neuchâtel; "The Gift," held at the National Humanities Center in North Carolina; and "Money: Lure, Lore, and Liquidity," convened at Hofstra University in New York. The Federal Reserve Bank in Boston sponsored a lecture on monetary representation and published it in its handsomely illustrated *Review;* the Association d'Economie Financière in Paris organized a collaborative research project on the subject of finance and confidence; and the Bairati Center for American Studies in Turin sponsored a seminar on problems of economic and aesthetic credit.

For their intelligent questions at these meetings I am especially grateful to Andrea Carosso, Bruce Chambers, Jacques Derrida, Peter Hughes, Barbara

Lanati, Steve Sass, Ron Sharp, Mark Taylor, and Vivianna Zelizer. For their perceptive comments elsewhere I am happy to thank Howard Bloch, Stanley Cavell, Robert Fishman, Carol Jacobs, Michael Kaspar, Don Levine, Kevin McLaughlin, Paul Meyers, Gregory Nagy, Mark Roskill, and George Steiner. I am also indebted to students at Harvard University, including Kio Lippit, Tina Lu, Johnny Tain, and Jed Wyrick.

Last, not least, I am grateful to the John D. and Catherine T. MacArthur Foundation for its generous support.

Detail of figure 92, Guillaume van Haecht, *L'atelier d'Apelle,* 1628

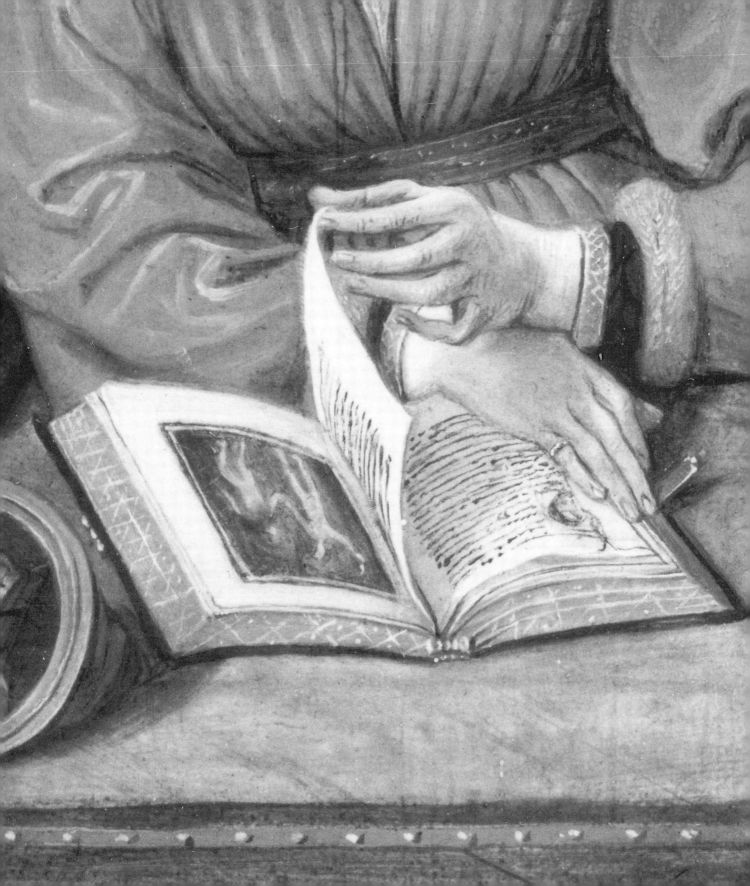

INTRODUCTION

*It is better to idealize commercial things
than to commercialize aesthetic things.*

Grand-Carteret, *Vieux papiers* (1896)

*I*n recent years the price of artworks has skyrocketed,[1] and inquiry into the economics of the visual arts has come increasingly to inform the problematics of art criticism and the thematics of art exhibitions.[2] Prices and exhibitions have made the study of art and money urgent—at least for investors and cultural critics. At the same time, crises in finance have challenged institutions of economic as well as aesthetic belief and credit. In this context *Art & Money* focuses on what binds together and drives apart the realms of art and money. It looks into how money becomes (or is) artwork and how artwork comes to assume some of the characteristics of money.

What a subject is not can obscure what it is. It is sometimes good, therefore, to introduce a deceptively familiar subject by specifying what it is not but can easily be mistaken for. My subject, then, is not immediately the external political economy of art as pursued by art historians and critics since John Ruskin's *Political Economy of Art* (1857).[3] Critics in that tradition study such problems as the place of art as commodity in a national economy,[4] the general disappearance from the public sphere of costly artworks,[5] the business of investing in paintings,[6] the role of patrons and dealers,[7] the motives for private collecting,[8] the politics of mass distribution,[9] the commercial effect of museums,[10] the influence of advertisement,[11] and the scholarly appeal of artists' account books.[12] Some theorists assert that the price of artistic "genius" is much like corn to be weighed in the balance;[13] others claim that artwork is a product unlike any other commodity.[14] John Ruskin had asked earnestly whether the political economy of

artwork differs from that of other products.[15] The boorish might not think so: "I collect money, not art," said a jesting Frank Lloyd of Marlborough Galleries, as reported in "Turning Pictures into Gold."[16] The problem is whether others less crude, perhaps, than Lloyd might not have grounds to agree with him.

My main interest here is no more the depiction in art of scenes from the political economy than it is the external economy of art. Artworks can, of course, provide illustrations from the realm of political economy just as they do from other realms. Whole histories might be written about such themes as the money devil and the beggar; mythological themes, like Danaë in a shower of gold coins, are legion; and biblical tableaux illustrate passages in the New Testament about monetary trade and exchange. But in most such artworks, ways of exchange and production usually remain external objects for contemplation. Likewise, their creators and critics seem generally to think about monetary symbolization and generation as they would about any other theme or problem. Yet money, which always involves a system of tropes, is also an "internal" participant in logical or semiological organization.[17] Whether or not a painter depicts money or is aware of its role, monetary forms of meaning and value come to affect the meaning of meaning in painting. This participation of economic form in painting and in the discourse about painting is defined neither by what painting depicts (sometimes money, sometimes not) nor by why painting depicts it (sometimes for money, sometimes not) but rather by the interaction between economic and aesthetic symbolization and production. This interaction, which goes beyond the general purview of "cultural histories" of money,[18] is as unaffected by whether the thematic content of a particular work includes money as by whether the physical content of the liquid a work is painted with includes gold. "Money," Georg Simmel suggests, "is similar to the forms of logic which lend themselves equally to any particular content, regardless of the content's development or combination."[19] Money is not just one theme, visible content, or "root metaphor" in some paintings; it participates actively in all.[20] Minimalist, conceptualist, and investment artists thus sometimes say that the essence of money resides not so much in its visible or material qualities as in numismatic engravings that are impressed into electrum ingots or on state papers that are tracked, as nowadays, at the speed of electricity.

4

Looking at the matter this way requires calling into question the view that art and commerce—or as Proust calls them, following Ruskin, the "aesthetic" and the "economic" realms—are essentially separate.[21] An ideology that allows iconic art and disallows commerce would have it that art and economics are separable. (The New Testament says "You cannot serve God and money [or mammon]"; Matt. 6:24; Luke 16:13.) Thus certain artists have held that God, whom they associate with art, and the money devil, whom they associate with some sort of market economy, are entirely different. Robert Motherwell writes in his *Modern Painter's World* (1944) that "the modern artist's social history is that of a spiritual being in a property-loving world."[22] Michael Fried claims in a similar vein that art might well have an internal historical dynamic separate from economics. Fried writes that "although [stylistic] changes cannot be understood apart from consideration of economic and other non-artistic factors, by far the most important single characteristic . . . has been the tendency of ambitious art to become more and more concerned with problems *intrinsic to itself*."[23] I do not want to take direct issue here with the common thesis that art develops according to a logic peculiar to itself. I shall suggest, however, some of the ways that economic factors generally and monetary factors particularly are intrinsic to art and hence are properly artistic concerns.

A R T A N D M O N E Y :
C H R I S T I A N I T Y

W estern art, whether or not its subject matter is monetary, frequently takes on a monetary patina or aura. In the present chapter we will consider the religious mien of this aura, assessing general associations of art with money and relevant habits of thinking about mind and matter. In the next chapter, on America, we will see, among other things, how a persistently theological economics continues to inform modern understandings of aesthetic representation and exchange.

In considering the monetary aura of artwork in the West it may be heuristically useful to begin with an elementary hypothesis. Plato founded philosophy in the distrust of money and art taken together.[1] But in the broad spectrum of Judeo-Christianity one group, often figured as Jewish, is relatively comfortable with money and uncomfortable with representational art while another group, frequently reckoned as Christian, is relatively comfortable with art and uncomfortable with money.[2] It is, according to this stereopticon, the essence of Judaism to reject representational art and the essence of Christianity to expel changing coins from the temple.[3]

What is it about money that irks Christianity? One answer would be that Christianity, unlike "paganism," has a universal God, like Judaism; and Christianity, unlike Judaism, has an incarnate God, in some ways similar to paganism. Money is a particularly tender subject in Christian thinking because money is a universal equivalent and also because money expresses, as does Jesus as god-man, a manifestation of an ideal *and* a real thing. Money is thus understood as a mani-

festation of authority and substance, of mind and matter, of soul and body; to use the terms I will employ generally in *Art & Money,* money is the expression of inscription and inscribed. This makes money disturbingly close to Christ as a competing architectonic principle. ("No graven images may be / Worshipped—except the currency" was the ironic quip of the ambiguously Christian poet Arthur Hugh Clough).[4] When Christians say that Jews wickedly worship money as a graven image and good Christians do not, this is usually a projection onto others' religion of what the speaker fears to be true about his own.[5] Judaism, perhaps, simply absorbs or deals with money with less discomfort than Christianity because Judaism does not treat money together with God in such a way that money becomes an architectonic principle that, like the money devil in Christian mythology, defines God by an apparent polar opposition.

Icon and Inscription

To whom then will ye liken God?

Isa. 40:18

The tendency to merge money with art is often misinterpreted as essentially a late capitalist phenomenon.[6] That is why, in essaying to comprehend the fetishism of money and the different viewpoints on money held by theologians and modern philosophers, it is useful to consider how the "spirit of the marketplace" or "money spirit" is a spiritual model not only for our era but for other eras as well. There is, for example, the iconoclast controversy of the eighth and ninth centuries in Byzantium. (Byzantium itself, of course, looks back to "older" theological expressions of the merger between aesthetics and economics.)

In Byzantium the words of Isaiah were much debated: "To whom then will ye liken God? or what likeness will ye compare unto him? The workman melteth a graven image [*pesel*], and the goldsmith spreadeth it over with gold, and casteth silver chains" (Isa. 40:18–19). These words, quoted by John Hylilas to the iconodule (or icon-serving) Pope Leo in the tenth century,[7] allude to the

commandment from Sinai, "Thou shall not make unto thee any graven image" (Exod. 20:4).

Graven images—"graven" in the King James version is not a bad translation of the Hebrew[8]—are all too easy to confuse with coins. A coin is a combination of a politically or aesthetically significant engraving with an economically valuable material—an inscription with an inscribed thing. Insofar as a coin is an ingot, its *real* material is the conveyer of value. Or so we say. Insofar as a coin is aesthetic or political, it is the *intellectual* inscription or drawing that suggests value. But spirit and matter, ideal and real, inscription and inscribed, are inextricably linked. "The true inscription," writes G. E. Lessing in *On the Epigram,* "is not to be thought of apart from that whereon it stands or might properly stand."[9]

In this respect coins are, as I argued in "The Language of Character" and "'What Is Truth?'" both economically valuable things and visually aesthetic objects:

> The material or commodity . . . on which coin [engraving] appears is, unlike Gutenberg's paper or the painter's canvas, an especially valuable one. The pictorial or verbal impression in this material changes it (esthetically) from a shapeless, if valuable, piece of metal into a sculptured ingot; and, more significantly, that impression changes it (economically) from a mere commodity into a coin or token . . . of money. . . . The sometimes beautiful impressions on ingots transform them into always useful tokens: *dulce et utile.* This transformation distinguishes minting from other kinds of sculpturing (even those that fashion equally valuable metals); and it distinguishes [specifically] monetary [drawings and] inscriptions from other kinds.[10]

Coins, which were among the first widely produced publications and reproductions in history, were icons with a value at once spiritual and material, or aesthetic and economic.

The contemporary sculptor David Smith writes that "the association of art with the graven and golden image . . . makes art taboo."[11] This way of putting things, though tendentious, at least serves to explain why the iconoclast controversies in Byzantium privileged debate about whether coins in general—*all* coins regardless of their particular "type"—were iconic or idolic images. An

icon, after all, is like a coin when its inscription's claim about the material quali-
ties of the inscribed thing (weight and purity of substance) are "true," or "equal
to" its actual qualities. (The traditional definition of truth as *adequatio res et intel-
lectus*—the unifying adequation of the thing with the intellectual conception of
it—is, as Heidegger seems to suggest in "On the Essence of Truth," in this sense
numismatic. In *Being and Time* an anti-Semitic Heidegger notes wrongly that
this definition of truth was essentially Jewish.)[12] An icon, like a coin, is an in-
stance of intellectual value invested or impressed in a material thing. (Like all
coins, the *real*—the term specifically names the coin that circulated in Spain and
elsewhere—is composed both of its "real" material and its "royal," or *rial* in-
scription.)[13] When this adequation breaks down, numismatics as well as ico-
nology is affected. Certain theorists argue that this breakdown occurred when
the first numismatic engraving claimed, by virtue of some political or religious
authority, a status unwarranted by sole virtue of its ingot's physical qualities.

The first coin engraved with the numeral 2, insists one theorist of art, was
the earliest conceptual art: it fiduciarily dissociated symbol from thing.[14] Or as
in Anton Stankowski's *One Becomes Two* (1990), the coin multiplies by an amoe-
boid division (fig. 1). In 1969 the Brazilian artist Cildo Meireles placed a stack
of one hundred one-cruzeiro bills on a pedestal, pasted on the stack a label
titling it *The Tree of Money,* and authoritatively priced the stack and label at two
thousand cruzeiros for both together.[15] The same theme is explored by Marcel
Broodthaers in his 1971 project, a "contract proposed by the financial section
of the Department of Eagles" for a fictive "Museum of Modern Art," in which
the price of a stamped "kilogram of fine gold in the ingot" is fixed at double
the current rate for the gold alone. To a journalist's question, "Should I under-
stand that it is a matter of literature?" Broodthaers wrote out his answer: "Si-
lence/absence → gold theory."[16]

For many Christians, religious terms like "god-man" (*homme-dieu, Gott-
mensch, theanthrōpos*) and items like Eucharist wafers and communion tokens
(*méreaux*) generally make the problem of representation considerably more
complex. These terms and items suggest a theory of representation of spirit and
matter—or spirit together with matter—that sometimes seems to border on so-
called idolatry.[17] Moses Mendelssohn, drawing upon an older analogy between

10

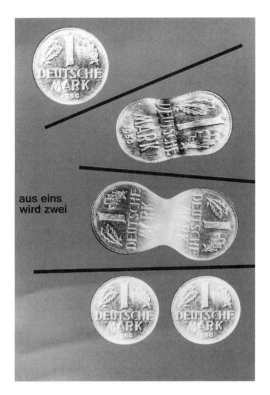

aus eins
wird zwei

Fig. 1. Anton Stankowski, *One Becomes Two (Aus Eins wird Zwei),* 1990. Serigraph, 84 × 59.5 cm. Editions Klaus Staeck, Heidelberg.

coins and words or letters, argues in his *Jerusalem* that "something as innocuous as a mere type of script can easily degenerate in the hands of some men [in]to idolatry."[18] Whereas Christian iconodules defend the use of religious imagery as needful for those who cannot read,[19] the Jewish Mendelssohn suggests that "the need for written symbols . . . was the first cause of idolatry."[20] Here a coin, which is both money and commodity, plays the same role in confusing the relation between spirit and matter as the written word does among monetarily illiterate peoples.[21] Since a coin appears as both a *res* and an *intellectus*—just as a word might appear, to monetarily illiterate persons, as both hieroglyphic and alphabetic—"the uninformed person . . . can easily misjudge or fail to recognize the . . . value [of coins] as [mere] currency. Of course, inscriptions on coins . . . do not encourage misunderstanding as much as the outlines of images do. For these outlines are composed of disjunct and heterogeneous parts; they represent [for monetarily illiterate people] shapeless and meaningless images which have no prototypes in nature."[22]

The civil war in the Byzantine empire involved the characteristic problem, at once numismatic and aesthetic, of the representation of the spiritual God *in the flesh,* or artful incarnation.[23] (Saint John of Damascus liked to emphasize that the New Testament calls Christ "the coin-impression [*charaktēr*] of God's being"; and for many iconodule church fathers, the numismatic *charaktēr* became the key term in trinitarian doctrines aiming to show that the image and the thing imaged are identical.)[24] By the same token, the Byzantine civil war involved the tension between the image of the Roman emperor, who claims the status of a god-man on an iconic coin, and the image of Jesus, who likewise claims the status of god-man when he interprets a Roman coin's engravings to mean that his followers should render unto God what is God's, as we shall see. (Muscalus's *Christ on Paper Money* suggests the same problem in a purportedly "secularized" United States.)

In the iconoclast controversy of Byzantium, the inscribed ingot—the canting badge, *type parlant,* or *redende Zeichen*—was the main apparently nontheological example of the combination of *intellectus* and *res.* Iconoclast stories in which coins are attacked as icons illustrate the point. One story tells how the iconoclast Stephen "was examined by the emperor and demonstrated the justice of his attitude toward images by throwing on the ground a coin bearing the emperor's effigy and trampling on it."[25] Another such eighth-century story discusses the infant Christ as a coin in the womb, or somatic purse, of Mary, which we will consider below.

Saint John of Damascus, in his *Defense of Holy Images* (ca. A.D. 730), explains his defense of artful images of divinity on the basis of an idea of incarnation that makes icons simultaneously visible and invisible, or material and nonmaterial—like Christ.[26] In iconodule Christianity, as in the tradition of Abraham's idol-fashioning father Terah, "the idol [or *eikōn*] felt, saw, heard and spoke. The cult opened the mouth, eyes and ears of the idol."[27] According to John, "images speak."[28]

Icons represent spiritual value's investment in a valuable material thing like gold or silver ingots, thus recalling the physical incorporation of the Holy Ghost on earth. At the same time many icons, *imagines clipeata,* also look just like coins.[29] They appear in the form of roundels—symbolic shapes used to render

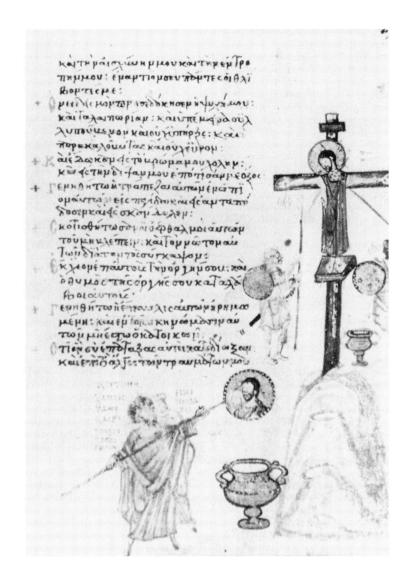

Fig. 2. Illuminated manuscript, Chludov Psalter, ninth century. State Historical Museum, Moscow.

the "conveyance" or "translation" of the soul to heaven.[30] Icons as such were interpretable as numismatic signs in the tradition of the famously powerful Christian coin motto, *In Hoc Signo* (By this sign).[31]

In the ninth century, icondule writers and illuminators sometimes contended that destroying sacred images amounted to the same thing as purchasing them, or that iconoclasm was essentially simony. The Chludov psalter thus compares Saint Peter's victory over Simon Magus with the iconodule Nicephorus's triumph over the iconoclast John the Grammarian (fig. 2). In one

miniature John, like Simon, lets coins fall as Nicephorus holds Christ's *imago*. ("Your silver perish with you, because you thought you could obtain the gift of God with money," said Peter [Acts 8:20].) A parallel miniature depicts the destruction of a coinlike icon as an angry iconoclast uses a sponge to efface a similarly numismatic image of Christ.[32] Other paintings display money devils simultaneously encouraging Jews to bribe the guardians at Christ's tomb and inspiring iconoclasts to deface divine images. Such illustrations suggest the pervasive discomfort of iconodule and iconoclast Christendom with the idea of anything other than Christ qua God as the conveyor—or translatory "gester" (Latin *gestor*)—between spirit and matter.[33]

Eucharist Wafer

> The first form of money was shared food, which for
> many centuries preceded the evolution of coinage.
> Coinage . . . had the same significance as the
> Grail—that of a sacred relic symbolizing a holy meal
> among a loyal fellowship.
>
> Laum, *Heiliges Geld*[34]

> One for Peter, two for Paul,
> Three for him who made us all.
>
> "Soul-Cake"[35]

The numismatic and aesthetic iconology I have been discussing informs the rite of the Eucharist. The material flour of the Eucharist wafer was said by the Lateran Council of A.D. 1215 literally to change in the throat—utterly—into the body of God,[36] and throughout the history of this rite its way of linking the spirit and body of Jesus has been an issue of intense debate and bloody wars.

The person of the Christian god-man, as Pusey reminds us in his *Real Presence of the Body and Blood of Our Lord Jesus Christ,* was sometimes called the "wafer-god":[37] the spiritual value of the Holy Ghost is invested in, or impressed

into, a coinlike wafer that allows people to eat or digest the spirit-made-flesh from the paten, or Eucharist dish. "After the consecration [of the host]," Neal reminds us in his theory of Christian remnants, or relics, "there remains not . . . any other substance but God-Man."[38]

The wafer was expressly manufactured like coin: it was pressed between wafer irons and impressed with insignia like those of coins.[39] (One insignium would be the Christian monogram *IHS,* as shown in the traditional irradiating or haloed silver wafer floating in the Eucharist chalice [fig. 3].[40] Interpreted as *In Hoc Signo* [By this sign], *IHS* indicates the victorious sign of the cross—the cross itself often appears on the crossbar of the letter *H.* Interpreted as *Iesus Hominum Salvator* [Jesus the savior of men], it designates the God for whom the inscribed wafer is exchangeable or into whom it is changeable.) That the manu-facturing process of making the Eucharist wafer from flour paste was often tech-nically similar to making coins from metal ingots allowed thinkers like Nicholas of Cusa in fifteenth-century Germany to observe how the Eucharist wafer's symbolic representation of the body of Jesus—or its actually being that body—has a numismatically iconic character. The Roman emperor Constantine had much earlier defended his view of this relationship in the following manner: Christ "gave a perpetual memorial of the incarnation. He bade his disciples give a type [*tupos*] of his body, which by the priestly ministration we may receive really and truly as his body, and though we may wish to make it an image [*eikōn*] of his body, what we actually have is a figure [*morphōsis*] of his body."[41] Mone-tary papers issued by the Vatican's memorably named "Bank of the Holy Spirit" seem similarly to conjoin the Holy Spirit with the intellectual quality of the monetary token (fig. 4).[42]

That the Eucharist wafer is conceptually numismatic disturbed many Chris-tian thinkers who, in a Platonic tradition referred to earlier, feared money as an architectonic principle competing with God. So goaded, Christian thinkers were often driven to contrast the wafer with coin much as they contrasted God with the devil. Thus they projected their own conflation of God and coin out-ward from, or out of, Christianity; they expelled the devilish money changer, as it were, from the temple of the soul.

Here a definite anti-Semitism helped to define Christianity itself. Paolo

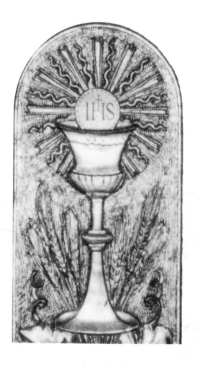

Fig. 3. Chalice with irradiating wafer, nineteenth century. Worked wood covered with silver and gold. Chiesa San Ippolito, Bardonecchia, Italy. Photograph by author.

Fig. 4. Vatican bank note, 1796. Banco di Sancto Spirito di Roma. In Grand-Carteret, *Vieux papiers*, 378. Harvard College Library.

Uccello's *Profanation of the Host* provides an example (plate 1). This painting illustrates a well-known story about a Jewish shopkeeper who obtains a stolen host from a Christian woman. The scene shows the woman in the shop, offering the host to the Jew, who has his hands on what look like two heaps of coins; she has her hand on a third heap. The white wafer stands out against a black book on a shelf.[43] (Relevant comparisons would include Judas's receiving the silver shekels in return for delivering Jesus to the Romans.)[44] According to the story, the Jew tries unsuccessfully to destroy the host by fire, but he and his entire family are eventually apprehended and are burned alive.

Communion Token

No penny, no Pater Noster.

Old proverb[45]

The Eucharist wafer thus understood as the coin that is Christ figures the *méreau*—or communion token—for which Christ is exchanged or exchangeable.[46] From the early medieval period to our own day, communion tokens have been

16

distributed to Christians either as entrance tickets to Eucharist ceremonies or as proof that the celebrants have attended such ceremonies. In Protestant Switzerland, for example, *méreaux* probably "originated with John Calvin's use of tokens in 1561 to exercise control over such [people] as presented themselves for communion services."[47] The celebrant had to give a *méreau* in order to receive the communion wafer, the *méreau* acting as a safeguard against traitors or informers.[48] In most other places, however, *méreaux* were given by priests to those who had already received the Eucharist host in order to receive dinner.[49] The Book of Revelation is relevant: "To him that overcometh will I give . . . a white stone, and in the stone a new name written, which no man knoweth saving he that receiveth it" (Rev. 2:17).

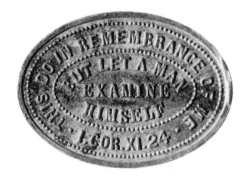

Fig. 5. Communion token, Ballingry Church, Scotland, 1864. Reverse: "This do in remembrance of me. But let a man examine himself." A reference to 1 Cor. 11:24, in which Paul describes the institution of the sacrament by Jesus at the Last Supper. British Museum, London.

To help retain a remembrance (fig. 5), the "Eucharist coin" was often given at the moment the celebrant said "This is my blood" or "This is my body."[50] Through the centuries communion tokens thus represented the real wine and wafer, and hence the ideal nourishment, for which the token was exchangeable. A *méreau* of 1613, for example, displays both the wafer and the chalice (fig. 6; cf. fig. 3). The reverse has the inscription *Mirari non rimari sapientia vera est* (To admire rather than to investigate is true wisdom). To scrutinize the host on the paten would be unfaithfully to doubt Christ, who said "This is my body, this is the chalice of my blood"; to investigate (or test) would be to challenge the aura of Christ—literally, his *patina*.[51] Several other *méreaux* include first-person inscriptions like "I am the bread of life,"[52] suggesting the extraordinary Christian collapse of the ordinary distinction between meal ticket and meal or between spirit and matter. (Compare the milk ticket's claim, "I am milk," in Thomas Nast's *Milk-Tickets for Babies, in Place of Milk*, [fig. 48]. Likewise, Nast's congressional bank note in *Milk-Tickets* claims that "this is money," and his drawing claims that "this is a cow.")

By the eighteenth century, the types on communion tokens included the paten of bread.[53] In Protestant churches in Europe such tokens were now generally used to limit admission to communion, whereas in Catholic ones they were usually given only to the clergy. But tokens were common in the New World too. In Canada there have been at least two hundred varieties,[54] and in the United States their use began to give way only about 1825 when (as we will

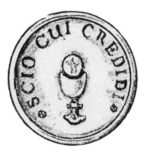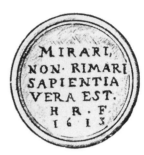

Fig. 6. Communion token, 1613. *American Journal of Numismatics and Bulletin of American Numismatic and Archaeological Studies* 22, no. 1 (1887). American Numismatic Society, New York.

consider in chapter 3) paper money was widespread, debates involving the economics of *real* substance and idea—about the "physics and metaphysics of money"[55]—were informing essays about economics in the popular press, and the image of Christ frequently appeared on bank notes.[56]

A nineteenth-century American essayist, broaching the interrelationship between coins and *méreaux,* protests too much when he writes that "it would be foreign to [his investigation] to give even the merest outline sketch of . . . controversies which involve . . . *transubstantiation* as held by the Roman church and its denial by the . . . Anglican Church; . . . *consubstantiation* [as held] by the Lutherans; and the other various theories as to the . . . character of the *real presence* of the Master of the Feast."[57] In the final analysis both coins and *méreaux* as well as Eucharist wafers involve the ideology of spirit and matter: *méreaux* represent the apparent transformation of divine intellect into matter, while coins are apparently intellectual inscriptions united with material things.

The contemporary Brazilian artist Cildo Meireles' *Massão/Missões; or, How to Build Cathedrals* seems to allegorize here one transition to the secular mien of the communion token (plate 2). *Massão/Missões* is a sculpture commissioned in the mid-1980s for an exhibition about the Jesuit missions in southern Brazil, concerned with the "theoretic estates" based on the cattle raising that supposedly required "relocating" the native peoples from their land. Central to the work is a vertical column made of eight hundred Eucharist wafers that connects six hundred thousand coins below with two thousand dead bones above. It is as if, as one critic says, "the [Eucharist] wafers were themselves coins."[58] *How to Build Cathedrals,* created in a Roman Catholic and hyperinflationary Brazil, fig-

ures the link between such simultaneously ideal and material items as quasi-sacred wafers and pseudosecular coins; and like a *méreau* or communion token, *Cathedrals* seems to transcend, at least in the ideal realm, the difference between religious and secular spheres. It is no mystery that the old Christian monogram, *IHS,* became in America the sign of money, $ (fig. 7).[59]

The Holy Grail

Gratia dei omne donum. [Every gift is by the grace of God.]

Coin motto

Sang et or. [Blood and gold.]

Catalan adage

Fig. 7. Crucifix, France, 1750–75. Limoges enamel, entwined letters: IHS. Benson, *The Cross,* no. 143. Harvard College Library.

The hypothesis of the free and infinitely large gift, in old-fashioned theology and in modern economic anthropology, supposes a definitive limit to everyday exchange and hence buttresses one easy definition of that exchange. Ordinary gifts, so goes the argument, can hardly be given without the giver's obligating or intending to obligate the recipient to give something back or to feel grateful and without the recipient's feeling obliged.[60] Traditional theology thus seeks to define the ordinary economic exchanges of earth, as opposed to the extraordinary ones of a heaven conceived in Christian terms, by raising up such ideological linchpins as grace. Here the idea of grace serves the ideologically useful role of defining the economic exchanges of this world by apparent polar opposition to them. In much Christian thinking this grace figures as the Holy Grail—the free gift that is the container of Jesus' blood. Folk etymology connects the Holy Grail with grace (*grâsce*): the Holy Grail, it says, is the thing that serves to satisfaction (*à gre*), pleases (*agrée*) everyone, and distributes its infinite sums freely (*gratis*).[61] Narratologically within the medieval Holy Grail tales,

19

moreover, the Grail is the material and spiritual nutrient that defines the ideal plentitudinous center of an economy of scarcity.

The Holy Grail of medieval Christian legend, as scholars have averred, is both symbol and thing, both representation and product.[62] This dual status is its most attractive aspect but also its most puzzling. The specific quandary for the theory of representation arises when, following the lead of the Grail tales themselves, we ask whether the cornucopian Holy Grail is a member of the group of all ordinary worldly things or a thing not of this world. In the legend's own terms, it is unclear whether the Holy Grail is a horn or Christ's body, a *cors* or the *corpus Christi*. If the Holy Grail is a member of the group of all worldly things, then it is homogeneous with its products and produces itself: a horn of plenty, after all, may produce a horn. If, on the other hand, the Holy Grail is, like Christ, a thing not of this world, then it is heterogeneous with its products and has the same relation to them as God has to the material wafer and wine into which and from which he is mysteriously metamorphosed during the Eucharist.[63] The pagan Grail tales in such Christianized versions as the *Estoire du Saint Graal* raise this problem of the genus of the Grail and then skirt it by rhetorical conflation of the container with the contained, of the *cors* with the *corpus Christi*.[64] The Holy Grail tales thus present the Grail as being a thing both of this world and not of this world, or as both homogeneous and heterogeneous with all things. The Holy Grail, which is the source of all things, is the source of itself. Or to put it another way, one of the contents of the container that is the Grail is the container itself.

How can anything be both the symbol of all things and the source of them? In Christian theology generally, such problems of symbolization and production often come to involve the relationship between God the Father and God the Son, a relationship of unity figured by the "wafer-god" who is God made flesh. The theological expression of the general quandary about homogeneity and heterogeneity in the twelfth and thirteenth centuries took the form of widespread debates about the Eucharist, debates that focused on the doctrine according to which a material thing becomes a source of spiritual as well as corporeal nourishment. The association of food and drink with the Word of God dominated the debate about transsubstantiation (*metabolē*) even after the Fourth La-

teran Council decreed in 1215 that "the body and blood of Jesus . . . are truly contained in the sacrament of the altar under the species of bread and wine, the bread and wine respectively being transsubstantiated into flesh [*corpus*] and blood by divine power." Such a position helps to explain the confusion surrounding the famous scene at the Grail Castle where the hungry hero sees a *cors,* perhaps the *corpus Christi,* within the *cor*—a host, perhaps the body of Christ, within the dishlike horn, or paten.

It is not surprising, then, that medieval theories of metallic money tend to share with discussions of the Eucharist the problem of homogeneity and heterogeneity, or confusion of representation with production. For it is unclear whether metallic money is a member of the group of commodities (a group that includes coins qua metal) or another kind of thing (a symbol). Nominalist theorists noted that coined money is not only a commodity (ingot) but also a symbol (inscription); money, like the Eucharistic word, seems to constitute a common architectonic denominator for all things. This simultaneous homogeneity and heterogeneity in the relationship between money and commodity, or between inscription and thing, raises the same metonymic problem of genus that makes mysterious the Holy Grail, the Eucharist, and the Word. That is what gives the Holy Grail its special patina in Christian religious art. Indeed, if money were available in cornucopian quantities in a place where its purchasing power was not limited, money would be an exchange for all (other) things—hence the means of getting (or purchasing) them—and money would seem to be, like a Eucharist meal ticket, the source of their begetting (or production).

The monetary as well as the eucharistic expression of problems of homogeneity/heterogeneity in production was especially important in the medieval period. The begetting of money and the getting of things by means of money—that is, minting and exchange—were among the most important medieval analogues for explaining the doctrine of the Trinity. Peter Abelard, for example, presents a nominalist doctrine of the Trinity through a complex image involving sealing or minting. In associating the Father, Son, and Holy Ghost with one another, Abelard distinguishes among the metal of a seal, the impression on the seal, and its productive use as a seal.[65] By the same token, the Old Testament's manna—that other source of nourishment for wanderers in deserts

or wastelands—often has the appearance of both Eucharist wafer and coin, as in *The Collection of Manna* (fig. 8), a fifteenth-century artwork in which the gathering of God's marvelous nourishment resembles that of his semen in later representations of Danaë (fig. 14 below).[66]

The Grail is a literary species of the blank check, the Arabic *sakh,* introduced to Europe by Jewish merchants before the fall of Jerusalem to the Crusaders in 1099.[67] The widespread popularity of the cornucopian Grail legends thus occurs in twelfth-century Christendom, a time and place whose population was generally ignorant of, or just beginning to become acquainted with, checks and credit—with mere "sign or . . . symbol" money. It was an age of which one can almost say that "the gift of boundless wealth could [not] be made another way" than through the topos of the Grail.[68] Many "pagan" coins, tokens of an economy of scarcity, show types of Grail-like cornucopias (fig. 9); but the Christian Grail is more precisely a type or topos of the resourceful, infinitely exchangeable, and inexhaustible purse for which the Greek Midas and the medieval Fortunatus wished.[69] The Holy Grail ideally supersedes in Christendom the checkerboard, or *scaccarium,* of the exchequer (fig. 10). It is both the *unreal,* or disembodied, form of wealth and the true "intellectual," or *ideal,* bill of exchange.[70]

The Golden Annunciation

How shall this happen?

Mary, in the Gospel according to Luke[71]

In classical mythology, King Acrisius of Argos locks away his daughter Danaë because he wants to avoid the fate told him by the oracle—that Danaë would bear a son by whom Acrisius would be slain. But Jupiter, in a shower of gold, inseminates the imprisoned Danaë. Acrisius does not know that the god did the deed; he has his daughter thrown into the sea. But Danaë is fished out, and her son Perseus, called *chrusopatros* by the Greeks and *aurigena* by the Romans

Fig. 8. Maître de la Manne, *The Collection of Manna,* Netherlands, fifteenth century. Oil on wood, 51 × 66.5 cm. Musée de la Chartreuse, Douai. Giraudon/Art Resource, New York.

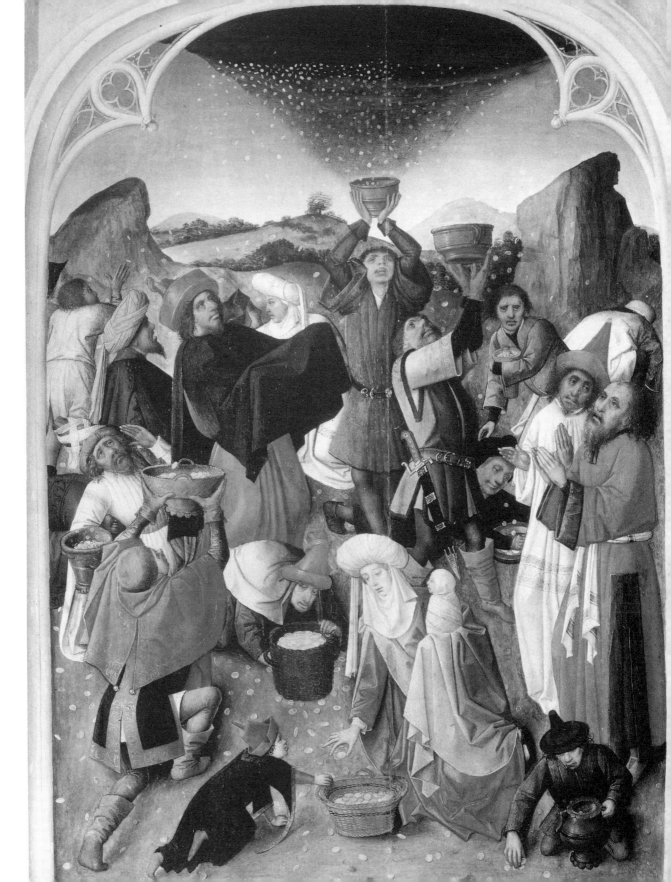

("fathered by gold" and "generated by gold"), later unknowingly kills his grandfather.[72]

The Danaë story helped Christians, understandably puzzled by the New Testament's admirable annunciation, to answer the question, first raised by Mary herself, of how Mary might have been impregnated. How had God, or his messenger Gabriel, intimated to Mary the divine incarnation in her womb with the quality of the divine or angelic substance? Christian theologians saw the likeness here between Danaë's insemination by the classical god and Mary's insemination by the Christian God. They saw the parallel between the aurigenetic conception of Perseus and the mysterious conception of Jesus. "If Danaë conceived from Jupiter through a golden shower," remarks Franz of Retz in the early fifteenth century, "why should the Virgin not give birth when impregnated by the Holy Spirit?"[73]

The early fourteenth-century *Ovid Moralized* similarly emphasizes the ideas that the substance of God's semen is gold (which the French author calls both *or* and *aure*), that it enters Mary by the ear (*oreille*), and that Christ is an *aurigena* like Perseus.[74] (Christian authorities had long pictured God's Word as a shower of gold entering the Gospel-writing Saint Matthew's ear and then issuing forth from his pen;[75] see Ebo Gospel, fig. 11.) And it was not difficult for artists to imagine God's golden semen entering the Virgin through the vagina: Titian's *Danaë* thus displays a shower of gold streaming from a turbulent aureole toward Danaë's lap (fig. 12). And the fifteenth-century Catalan artist Bernardo Martorell's panel *The Annunciation* shows Gabriel announcing the coming of the Lord even as God showers gold from a fertile halo.[76] (See fig. 13, where Mary receives God's semen in the form of the angel Gabriel's chrysographic letters—"words written in gold," literally—and plate 3, where the gold comes from above God's messenger.)

The Danaë tale also helped theologians deal with the complex question whether Jesus was partly consubstantial with his earthly parent (Mary) or wholly consubstantial with his divine parent (God the Father). They included in their discussions debate about whether God's golden semen was material, like a golden ingot from earth, in which case Jesus was wholly divine, or was intellectual, like an inscription impressed into a gold ingot and together with which

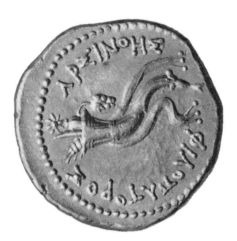

Fig. 9. Gold octadrachm of Ptolemy III, 246–221 B.C. Cornucopia bound with diadem and surmounted by radiate crown. Hirmer Verlag.

24

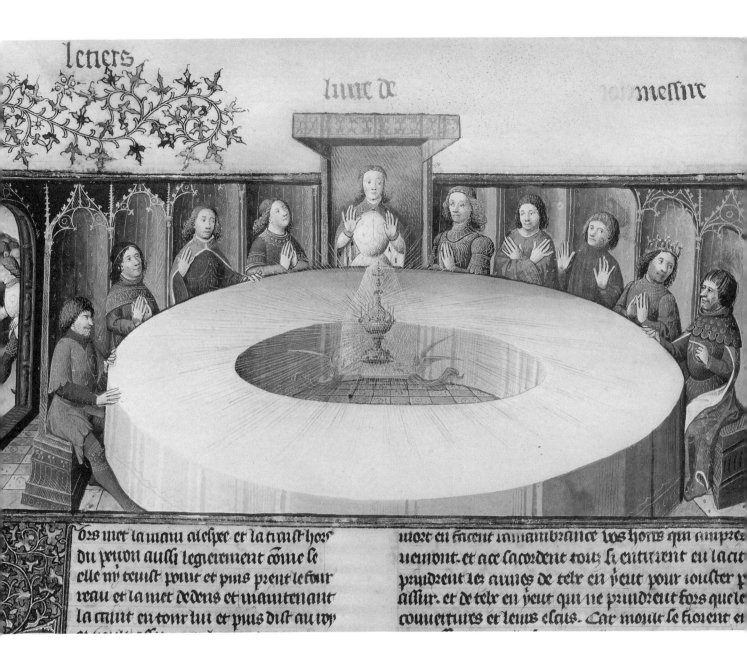

ôes met la mam alespee et la tuist hors
du peron auffi legierement come se
elle ny teuist pomt et pius prent le four
reau et la met dedens et mamtenant
la taint en tour lui et pius dist au roy

mort en facent remambrance vos hoes qui aupre
uenront. et ace sacordent tous si entirent en laci
prndrent les armes de telr en peut pour iouster p
assur. et de telr en peut qui ne prndrent fors quele
couuertures et leurs escus. Car moult se fioient et

Fig. 10. Illumination from *Lancelot du Lac,* painted by Master of Berry's Cleres Femmes and associates, France, early fifteenth century (repainted later fifteenth century). Arthur's round table is realistically represented with a white tablecloth and a circular opening in the middle. Within this opening is a surface that recalls the checkerboard (*échiquier*) used by treasurers (*eschequers*) in feudal times (see *Livres des rois,* ca. 1190). From the Grail, as from a divine presence, radiates effulgence, indicated by the lines of gold. Bibliothèque Nationale, Paris.

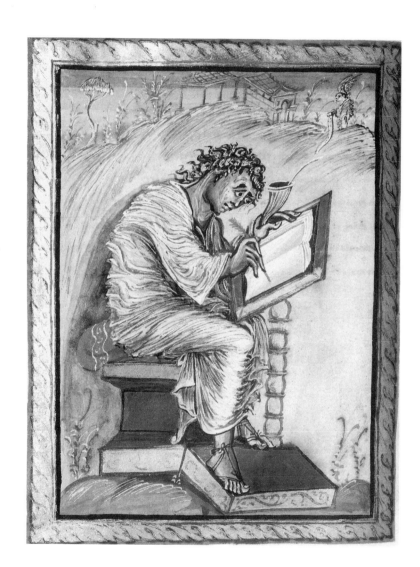

Fig. 11. Portrait of Matthew, from the chryso-graphic Ebo Gospel of Matthew, France, Carolin-gian (between 816 and 835). Bibliothèque Municipale, Epernay. Photograph by Ann Münchow.

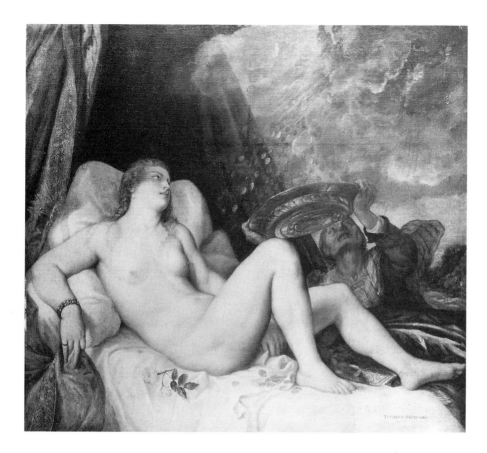

Fig. 12. Titian, *Danaë,* 1545–46. Museum of History of Art, Vienna.

Fig. 13. Sandro Botticelli, *The Annunciation,* 1481. Metropolitan Museum of Art, New York.

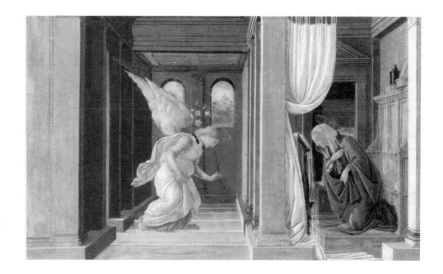

the ingot becomes a gold coin, in which case Jesus was part God and part man. The divine semen is numismatic gold in Paolo Veronese's sixteenth-century work[77] and in Dionisio Fiammingo's *Danaë* (fig. 14); and in a manner of speaking it is also numismatic in *Aurum divinum,* a collection of coins modeled on Klimt's *Danaë* (fig. 15). The seed is more like the regular commodity gold in Klimt's *Danaë* itself (plate 4) and in Jan Gossaert's *Danaë in a Rain of Gold.*[78] In Titian's *Danaë* (fig. 12) the rain falling into Danaë's lap includes gold both as commodity and as money; here Danaë's old nurse, a "literalist of the imagination," greedily collects God's semen in her apron as though she confuses God with coin.[79] "Iupiter dum orat / Danaen, frustra laborat; / Sed eam deflorat auro dum se colorat." (Jupiter gets nowhere by pleading with Danaë, but when he takes the form of gold, he deflowers her.)[80]

Christian authorities embellished the classical Danaë story in their interpretation of the father's suspicion of who did the deed. In the post classical Christian version of the story, Acrisius believes his brother is responsible for impregnating his daughter.[81] This incest itself recalls the conception of Christ. In the story of that conception, the Virgin Mary has some sort of intercourse with one who is simultaneously her brother, father, husband, and son. The apparently figural incest in the Holy family is connected with the fact that the Magi—said to be incestuously begotten—were the first to greet the newborn Christian God, who was himself incestuously begotten.[82] Nor is it meaningless that these gift-bearing Magi were Persians, whom the Greeks and Christians called *chrusogonoi* ("begotten of gold") because they were descended from the god-man Perseus[83]—Perseus, the son of Danaë, who was conceived aurigenetically by the semen of a Roman god and whom Christian authors recognized as the Christ-like offspring of an incestuous union. It is no wonder that the story of Danaë's setting up her residence in Rome was popular with the Christian cults at Rome.[84]

Christianity at Rome combined incest in the person of the god-man Christ with a numismatically iconodule connection of spirit with matter. "God created two evil inclinations in the world," we read in a Jewish work attacking iconolatry. "One inclination is toward idolatry and the other toward incest; idolatry has been uprooted, but incest still holds sway."[85] Nowhere does the conjunction of

Fig. 14. Dionisio Fiammingo (Denys Calvaert), *Danaë,* ca. 1600. Lucca, Pinacoteca. Alinari/Art Resource, New York.

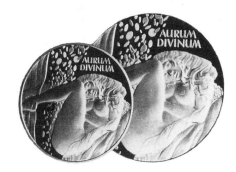

Fig. 15. Gold medals and coins of various denominations, twentieth century. Stone, "Danaë: *Aurum divinum.* Das göttliche Gold." Harvard College Library.

idolatry and incest show itself more clearly than in Christian representations of Danaë as the spiritually incestuous Virgin Mary and of Father Jupiter's material semen as the golden vehicle of annunciation entering the purselike womb of Danaë. "The uterus," so goes the traditional analogy, "is a tightly sealed vessel, similar to a coin purse [*Seckel*]."[86] Hence the discussion of God's consubstantiality involves, as we shall see in the next section, the analogy between the contents of a purse and the contents of Mary's womb—or between coin and Christ.

The Holy Foreskin

> My purse, my person, my extremest means,
> Lie all unlock'd to your occasions.
>
> Shakespeare, *The Merchant of Venice,* 1.1.137–38

Christians have a material God. But God's material person has all but disappeared since Jesus' ascension to heaven on the fortieth day after his resurrection.[87] All one might have now, in the period before his second coming, are spiritual inscriptions, as it were, in material media—*spiritualia sub metaphoris corporalium* (corporeal metaphors of things spiritual).[88] Or so it seems.

As John Calvin wrote, however, "On ne pouvait laisser échapper le corps de Jésus-Christ sans en retenir quelque *lopin*." (They couldn't let Christ's body go without keeping a piece.)[89] Many Christians wanted or needed a material relic *lopped off* from the divine corpus. Thus they discovered remnants of Jesus' body—relics of blood from various wounds (including those from the circumcision and the crucifixion) as well as sweat, tears, baby teeth, hair, umbilical cord, fingernails, urine, feces, and other bodily remains.[90] Of these bodily leftovers, each is iconologically problematic in its own way. (Jesus' umbilical cord, for example, is Mary's human flesh as well as Jesus' partly human flesh. Since relics were perceived "as the living Saint,"[91] whereas feces generally were ordinarily thought of as "dead"—even as "diabolic"—remains or leftovers, the

adoration of Jesus' feces in some church treasuries is interesting, especially in view of the psychoanalytic association of feces with money and gift giving.)[92] The only unambiguous trace of Jesus' actual flesh still on earth, however, is the foreskin removed from his body eight days after his birth on our New Year's Day.[93] That cut is the "Holy Foreskin."[94]

What was it about Christ's foreskin that made it the object of unique cult veneration? The relics of Jesus' flesh and blood are uniquely treasured in Catholic dogma and highly appraised in the treasuries of Catholic churches because they literalize the otherwise figural Eucharist. "Eat me," Jesus is interpreted to have said at the Last Supper.[95] The Eucharist ceremony would live up to this commandment. It transforms the bread on the paten and the wine in the chalice more or less literally into Jesus' flesh and blood.

Just how literally we should understand this transsubstantiation—and just how literally we should understand the difference between figural and literal meanings—has always been a matter for church debate. The Lateran Council of 1215 argued that in the Eucharist the wafer became literal flesh only when it reached the middle of the celebrant's throat, but agreement was not unanimous. What privileges the Holy Foreskin in this debate about transsubstantiation is that the *praeputium* is already what the bread can only figure. Thanks to the Holy Foreskin, Jesus' commandment "Eat me" could be followed out to the letter.

The Holy Foreskin is privileged in Catholic dogma in much the same way as the Holy Grail and its contents. The Grail's literalization of the Eucharist blood helps to explain the special status of the Grail and its contents as Jesus' *sang real,* or real/royal blood. By the same token, the Holy Foreskin's literalization of the Eucharist flesh helps to explain the enduring popularity of the foreskin as Jesus' *carne vera sancta,* or true and holy meat—as the foreskin is called in Italy.[96] No fanciful argument involving transsubstantiation needs to make the point that a cut of the foreskin, if genuine, can provide the most valuable kind of spiritual and material fleshly nourishment, both *intellectus* and *res.* Saint Birgitta's description of the joy of eating Christ's foreskin says that "so great was the sweetness at the swallowing of this membrane that she felt a sweet transformation in all her members and the muscles of her members."[97] "Of all things that

Jesus Christ left on earth," writes Baillet in his history of the Holy Week, "nothing is more worthy of our veneration than the flesh that he distributed for us. . . . Thus nothing merits more that we carefully gather and preserve it."[98]

Among commercial traders, of course, the genuineness of the treasured foreskin was always subject to question, especially as the prices in the European relics market skyrocketed and tales of their theft along the major trade routes became so common that they came to form a medieval literary genre, replete with hints of financial corruption, much like that of twentieth-century journalists' articles about "priceless" artworks.[99] And so buyers and sellers developed various tests to determine the genuineness of any given foreskin. Tasting was the test of choice. A properly trained physician chosen by the local priest would taste the shriveled leather to determine whether it was wholly or partly human skin. Since tasting involves a little consumption—or so one school of gastronomy and the anthropology of taste would have it[100]—the surgeon who ate Jesus would be called *croque-prépuce*.[101] (Perhaps when European travelers indignantly wrote about foreskin-eating cannibals in Asia, they were attributing to others an alimentary craving they declined to recognize in themselves.)[102]

The uniqueness or oneness of the treasured foreskin was subject to question (along with its genuineness), and this too led to analogies with the Eucharist. Many churches claimed to have the foreskin.[103] Could it be that some of these churches had only a part of it? The Protestant Calvin doubted that it was physically possible to divide the foreskin into so many pieces. Calvin marveled similarly at the number of churches that had vials of the Virgin Mary's breast milk; "Had Mary been a cow all her life," wrote Calvin, "she could not have produced such a quantity."[104]

Perhaps, though, the foreskin had multiplied into many, each one miraculously keeping the unique patina or aura of the original. The idea of the multiplication of the foreskin led to comparisons with the miracle of the loaves and fishes. Nineteenth-century Calvinists would recognize such multiplication as the target of Nast's satire *Milk-Tickets . . . in Place of Milk* (fig. 48). Honorat Nicquet mentions the Holy Foreskin in this context when he "assimilate[s] the [apparent] multiplication of the wood of the true cross [as suggested by its appearance in homes and churches throughout Europe] to the body of Christ in

the Eucharist."[105] Other writers, skeptical of a particular church's claim to have the authentic foreskin, denigrated the relic of the Holy Foreskin only in order to elevate the "relic of relics" that is the Eucharist. Guibert of Nogent, for example, in his *On the Relics of the Saints* (ca. 1130), doubts the authenticity of the Holy Foreskin owned by the monks of Charroux—Charroux means literally "red flesh," from the French *chair rouge*[106]—just as he promotes "the veneration of the Eucharist, which was the physical presence of the body of Christ, as superior to the veneration of ordinary . . . relics."[107]

"Be circumcided in the Lorde, and cut awaye the foreskynne of your hertes," says Saint Paul—depending as usual on the distinction between figure and letter—in Coverdale's version of the Bible.[108] Christianity, in its attempt to "transcend" the purported materialism of Judaism, seeks to replace "literal" circumcision with "figural" circumcision of the heart. Paul's way of distinguishing between the literal and figural realms encouraged theologians to investigate whether the divine body into which the Eucharist wafer is transformed (in the celebrant's throat) is circumcised and also whether, in the interval between his resurrection and ascension, Jesus' foreskin was resurrected along with his penis.[109] The Pauline call for absolute dematerialization thus encouraged willy-nilly an adoration of the foreskin among some Christians that, along with the general adoration and handling of bodily leftovers, seems sometimes to border on social pathology. It is worth reporting here the striking claim that, of medical and psychiatric patients in contemporary America who are preoccupied with their absent foreskins to the point of seeking surgical reconstruction or "uncircumcision," all are Christian and none are Jewish.[110]

In considering the Holy Grail in its iconic and monetary aspect, we saw how Christ is thought of simultaneously as both container and thing contained—as both purse and purse. (The word *purse* means either "moneybag" or "the contents of a moneybag"—or "moneybag and contents taken together.")[111] And in considering the aurigenesis of Christ, we saw how the Virgin Mother is thought of as the purse (or container) of the purse that is the infant Christ, as expressed in the story about the iconoclast Stephen. Another story about Christ

and purses is told about the eighth-century iconoclast emperor Constantine V, who convened the council on image worship, or iconolatry, in A.D. 754:

> Taking in his hand a purse full of gold and showing it to all, he asked, "What is it worth?" They replied that it had great value. He then emptied out the gold and asked, "What is it worth now?" They said, "Nothing." "So," said he, "Mary" (for the atheist would not call her *theotokos*), "while she carried Christ within herself was to be honored, but after she was delivered she differed in no way from other women."[112]

Mary, whether as Danaë-like recipient of God's golden semen or as purselike bearer of Christ, is not of the same substance as the god (*theos*) she contains in the way that money is of the same substance as the interest (*tokos*) it generates. The divine Son, though he has a likeness (*homoiōtēs*) to his mother, Mary, is not of the same substance (*homousios*).

This iconodule confusion of purse (as container) and person (as thing contained) also informs a famous episode in Shakespeare's *Merchant of Venice*. The Christian gentlemen Salario and Solanio tell a story about Shylock, who is a sort of Elizabethan money devil. Shylock, says Solanio, ran through the streets of Venice, crying out for his precious "stones":

> "My daughter!—O my ducats!—O my daughter!
> Fled with a Christian!—O my Christian ducats!—
> Justice! the law! my ducats, and my daughter!
> A sealed bag, two sealed bags of ducats,
> Of double ducats, stol'n from me by my daughter!
> And jewels, —two stones, two rich and precious stones,
> Stol'n by my daughter! —Justice! find the girl!
> She hath the stones upon her, and the ducats!"[113]

Having lost the person of his own "flesh and blood"—his supposedly consanguineous child Jessica—Shylock is concerned with the loss of his purse, or scrotum, by means of which he might generate another such child.[114] And like many a money devil in Christian ideology, Shylock cries out at the loss of the purse, or moneybag, by means of which he might generate other coins as interest.[115] (In the traditional Greek and Christian understandings of usury, children and interest are compared and contrasted as *tokos,* or offspring.)[116]

The Christians' joy at Shylock's double loss of generative potency might be worth considering in terms of the reported practice in Christendom of lopping off the foreskins or testicles of enemies and hoarding them as monetary war "tribute" in such varied places as Montenegro and Sicily.[117] This practice was often projected by Christian missionaries or traders onto the "barbaric" peoples of Africa: travelogues of the 1590s depict African blacks assembling presentation baskets of their defeated enemies' testicles (fig. 16).[118]

Thus in *The Merchant of Venice*, in which Alcides redeems a virgin "tribute" and Bassanio gives Antonio the "tribute" that is Portia's ring,[119] the Christians' joy at Jessica's running off with Shylock's "stones" tells more about the white Venetian Christians than about either the alien Jew Shylock or the Moslem prince of African Morocco whom the Christians seek to stigmatize. The Christians' mockery of Semites projects Jewish or Moslem circumcision (removal of the prepuce) as a Christian fear of castration (removal of the stones).[120] Here as

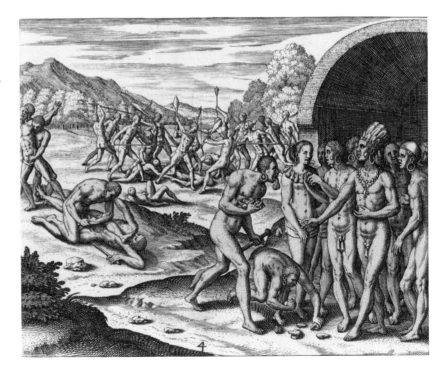

Fig. 16. Woodcut depicting amputated male genitals as war trophies in East Africa, 1598. Lindschotten, *Ander Theil*, 505. Courtesy of John Carter Brown Library, Brown University.

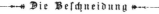

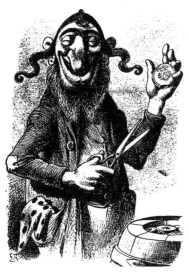

Fig. 17. *The Circumcision* (*Die Beschneidung*), 1912. From the anti-Semitic journal *Kikeriki* (Austria). Harvard College Library.

elsewhere in Judeo-Christian ideology, the Jewish ritual circumcision stirs up Christian memories of their originary crucifixion myth and becomes a motive spring for anti-Semitism.[121]

In *The Merchant of Venice* it is the Christian Antonio who embodies the literal castration that the joyful yet fearful Christians project onto Shylock. Antonio would have sacrificed his person as well as his purse for his friend in imitation of Christ's stigmatic sacrifice on the cross (an act that certain Protestant theologians, by the way, would count as a sinfully presumptuous attempt to imitate Christ).[122] But Antonio turns out to be a penniless man with little to give. And in this play that conflates coins with testicles, Antonio comes to describe himself as a castrated ram—"a tainted wether of the flock."[123] This wether's opposite number is the Jew who supplied money to Shylock and who presumably remains even after Shylock disappears: Tubal. (*Tubal* was pronounced like "two ball";[124] *Jew* may have been pronounced like "ewe," a term that in *The Merchant of Venice* suggests the fertile person, the "fulsome ewe," that is the wealthy Portia.)[125] Even as Shylock disappears from the action of this Christian comedy about the search for a golden fleece of love, Tubal's Fortunatus-like power of purse and person remains left over for them.[126]

The view that coin clipping and penis snipping amount to the same thing (at least for Jews) is the basis for the anti-Semitic mockery in *The Circumcision,* which appeared in an Austrian periodical before the First World War (fig. 17).[127] This cartoon's assertion, that Jews practice circumcision because it is lucrative in much the same way that people snip ducats because it is profitable, suggests more about Christians than about Semites. For *The Circumcision* projects onto the Jewish practice the characteristic foreskin adoration that many Christians repress, or fear to recognize, in Christianity itself. After all, as we have seen, it is Christians, not Jews, who have revered a foreskin as the moneylike relic of relics, seeing it as the quintessence of ideal realization and seeking at once both to preserve and to digest it.

And what actually became of Christ's foreskin? Its history is shrouded in mystery like that of the Holy Grail. We are told, however, that the Virgin Mary, who had carried the infant Jesus in her womb, or somatic "purse," kept the

Fig. 18. Reliquary Purse of the Circumcision, known as the Reliquary of Pepin, ninth century (reworked in subsequent centuries). Gold, 17.8 × 18.6 × 9 cm. Conques-en Rouerge (Aveyron, France), Treasury of Saint-Foy Basilica. Hirmer Verlag.

foreskin with her all her life as a precious jewel. Saint Birgitta in her "De prae-putio Domini" tells us further that Mary entrusted this treasure to Saint John.[128] The Holy Foreskin was thereafter safeguarded for seven centuries in a shriveled phylactery-like leather pouch or purse. One day, however, someone carried the purse to the court of King Charlemagne at Aix-la-Chapelle.[129] There artists made for it a golden reliquary in the shape of the leather purse. This was the famous ninth-century Reliquary Purse of the Circumcision (fig. 18).[130] Gauthier, discussing "the traffic in relics and art investments," remarks that the shape of the purse that contained Christ's foreskin was thereafter commemorated by adopting it as the fashionable shape for purses (and some pockets) in Christendom.[131] A historical study of the shape of purses in conjunction with their contents as coins or as Christ would constitute a telling contribution to the history of art as fashion.[132]

Aurum and Aura

From early times, artworks in the Christian tradition have depicted saintly people's heads or bodies surrounded by auras, aureoles, nimbi, coronas, or halos. What, besides a reworking of "pagan" Roman images, is this aura?[133] And what does the aura have to do with art?

The question is an old one.[134] And already in the seventeenth century Johann Nicolai had discussed the Gospel according to Saint Matthew in order to explain why the nimbus surrounds the head while the aureole envelops the entire body.[135] In later centuries others discussed the specifically Christian nimbus,[136] referring to Thomas Aquinas and other church authorities.[137] Although the halo can be treated in these and other ways (and has been), the aura also has a definite numismatic character.

Just as *aureole,* or *corona,* means "halo," so *aurum,* or *corona,* indicates "coin," generally a coin of Byzantium or Spain.[138] In this philological context the visual resemblance between certain coins and nimbi—see earlier in relation to Byzantine manuscripts—makes sense. Moreover, the colors of halo and coin are the same,[139] the shapes (circles, triangles, and squares) are alike,[140] and the various methods of denomination are similar.[141] Further, halos appearing in or on coins frequently draw attention to themselves as numismatic objects. The coins of the ninth-century eastern emperor Michael III look much like *imagines clipeata,* for example, and some coinlike medals represent halos as partial coins (fig. 19). Many manuscripts too include coinlike medals depicting holy men and saints with halos painted in the margins (fig. 20);[142] and the *Book of Hours for Engelbert of Nassau,* for example, includes a miniature of the Virgin and painted representations of pilgrim badges bought by the faithful.[143] (Actual badges survive clipped onto the pages of other old books.)[144]

In Christian art, the iconic aureole (halo) often confronts the numismatic *aurum* (coin). It is as if the aureole were divine and the *aurum* devilish—the one God and the other mammon. For example, in a work of the second half of the fifteenth century, Jesus' halo both imitates and opposes Judas's coins (fig. 21). In this picture the designs on Jesus' halo are the same as those on the thirty pieces of silver.[145] A miniature of about the year A.D. 1000 depicts Jesus with a whip

Fig. 19. Matteo de Pasti, medal, fifteenth century. The high-relief halo around Christ's head matches the curve of the coinlike medal's perimeter. Hill, *Medallic Portraits,* 10. British Museum, London.

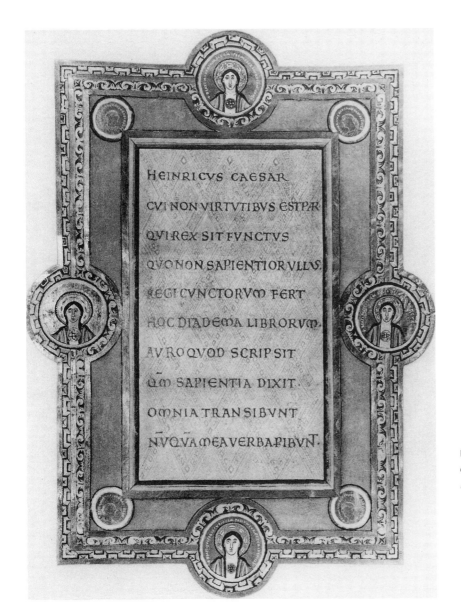

HEINRICVS CAESAR

CVI NON VIRTVTIBVS EST PAR

QVI REX SIT FVNCTVS

QVO NON SAPIENTIOR VLLVS.

REGI CVNCTORVM FERT

HOC DIADEMA LIBRORVM.

AVRO QVOD SCRIPSIT

QM SAPIENTIA DIXIT.

OMNIA TRANSIBVNT

NVQVAM EA VERBA PIBVNT

Fig. 20. *Codex aureus Escorialiensis* (Vitrinas 17), eleventh century. Boeckler, *Das goldene Evangelienbuch,* abb. 9, fol. 4. Harvard College Library.

expelling the Jewish money changers from the temple. Jesus here wears a halo as the Jewish money changers leave their coins (fig. 22).[146] In other miniatures Jesus expels the money changers with a whip whose tassels have iconic coinlike objects attached to them.

The Swiss National Museum in Zurich includes at least two representations of the *Adoration of the Magi* in which the infant Jesus' halo is linked visually with

Fig. 21. Miniature, wall panel (detail), second half of fifteenth century. Christ appears to the blessed Gregory. Germanisches Nationalmuseum, Nuremberg.

Fig. 22. Miniature. *Expulsion of the Money Changers,* ca. A.D. 1000. MS Lat. 4453, fol. 120v. Bayerische Staatsbibliothek, Munich.

— Jésus n'a-t-il pas dit : « Allez et remettez les mauvaises actions. » ?

Fig. 23. Emmanuel Barcet, cartoon, *L'Assiette au Beurre* 80 (11 October 1902). Houghton Library.

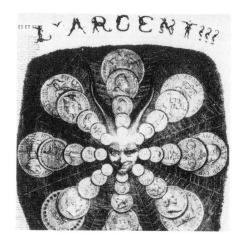

Fig. 24. Lithograph, cover for the songbook *L'argent,* Paris, ca. 1850. Author's collection. (Massin, *Letter and Image,* no. 365.) By permission of Van Nostrand Reinhold.

the gold coins that the Magi bring him as gifts. In Pietro della Vecchia's *The Penny of Caesar,* the tax penny that Jesus discusses with the scribes and pharisees contrasts with or balances the halo around Jesus' own head.[147] And in some paintings of the severed head of John the Baptist, the golden platter on which the holy head appears has an appearance at once numismatic and auratic.[148] Emmanuel Barcet's cover for the journal *L'Assiette au Beurre* (1902) suggests, in the modern context of the stock exchange, the same opposition between Christian aura and monetary *aurum* (plate 5). The theme is taken up inside *L'Assiette,* where Barcet includes a cartoon of a haloed Jesus confronting the moneyed members of the stock exchange (fig. 23). The nineteenth-century songbook *L'argent* similarly recalls the auratic money devil cartoons of previous centuries (fig. 24).[149]

Fig. 25. Christian Eckart, *Eidolon,* 1989. Poplar frame in gilt, 183 × 259 cm. Galerie Tanit, Munich/Cologne.

A history of Christian painting could be written in terms of how, through the centuries, the gilt halo was gradually eliminated from the artwork, becoming instead the gilt frame that defines and surrounds the artwork—or, as in Christian Eckart's *Eidolon,* eventually replaces it (fig. 25). Friedländer writes about gold leaf that "ejected from the surface of the picture [in the modern era, and] exiled as it were into the ante-room, . . . [it now] encloses and frames the fragment of nature and separates art, born of spiritual conception, from our reality."[150] "No paint or dye can give so splendid a colour as gilding," writes the political economist Adam Smith in his *Wealth of Nations.*[151]

The impression of auratic divine images on coins precipitated the destruction of the divine aura and cult worship of the gods in the ancient Greek and Roman periods, as I have discussed elsewhere.[152] Portraits of the ancient Roman emperor-god and the medieval Holy Roman kaiser,[153] surrounded by auras and impressed in coins made of *aurum,* may have helped to "secularize" the old gods—though not in the way Walter Benjamin says that the camera destroyed the aura of so-called original things. Photography, argues Benjamin in an essay relating superstructure (artistic reproduction) to substructure (economic production),[154] annihilated the ontological status of the original and its imitation: "The technique of reproduction detaches the reproduced object from the domain of tradition. By making many reproductions it substitutes, apparently miraculously, a plurality of copies for a unique existence. And in permitting the

reproduction to meet the beholder in his particular situation, it reactivates the object reproduced. These two processes lead to a tremendous shattering of tradition."[155] Even more than photography in the modern world, one might speculate, minting in the ancient and medieval world shattered tradition.[156] (In his studies of mass art and caricature, Eduard Fuchs reminds us that "there was no cheap form of reproduction in the ancient world apart from coins.")[157] Coins destroyed the aura of individual objects and encouraged a sense of the universal equality of things.[158] With the mechanical reproduction in the sixth and seventh centuries A.D. of coins often bearing, ironically, impressions of the auratic gods themselves, "the criterion of [original] authenticity ceased to be applicable to artistic production."[159]

Tax Advice

All passes. Art alone
Enduring stays to us;
The bust outlasts the throne—
The coin Tiberius.

Austin Dobson[160]

For analysis of the relationship in Christian ideology between spiritual inscription and material inscribed thing, no passage in the Judeo-Christian tradition is more important than the one in the New Testament where Jesus tells his interlocutors to give Caesar what Caesar has coming to him.[161]

The story is represented in paintings like Bartolomeo Litterini's *The Tax Penny* and Titian's *The Tax Penny* (fig. 26). Its most influential author is Saint Matthew, the onetime tax collector whom Jesus called to a new vocation as a Christian (Matt. 9:9), a calling that is itself often represented in Christian art.[162]

According to Matthew's version of the tax penny story, Jesus is asked by the scribes and pharisees whether it is lawful, following God's law, to pay taxes to the Roman Empire. Jesus responds by saying, "Show me the coin for the tax" (Matt. 22:17–21; cf. Luke 20:21–25 and Mark 12:14–17). Although ordi-

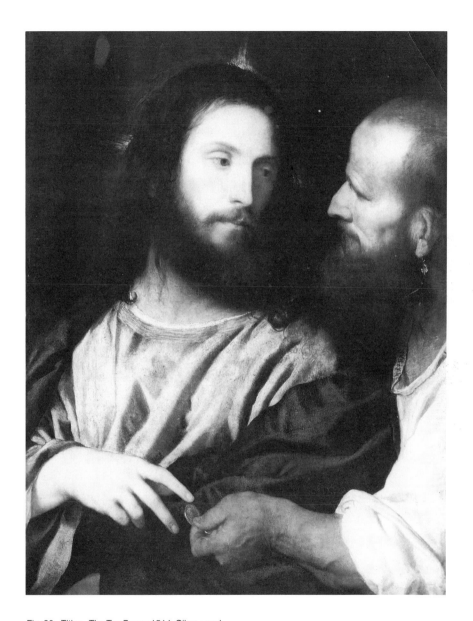

Fig. 26. Titian, *The Tax Penny,* 1514. Oil on wood,
75 × 56 cm. Staatliche Kunstsammlungen,
Dresden.

nary commodities like grain could have served as examples of how taxes could be paid, Jesus asks specifically for a coin. The example of coined money, which is both intellectual and material, offers the god-man Jesus a specific political opportunity to query the relation of divine to human authority and hence to question who God is.[163]

Christians such as Matthew said that Christ was God. Romans, however, said that Caesar was a god—and so did some inscriptions on Roman coins. Indeed, the coin that the scribes and pharisees presented to Jesus was probably just such a one—a silver denarius minted by Tiberius Caesar with the words "High Priest" and "Tiberius Caesar Augustus, son of the divine Augustus."[164] Jesus, with the help of this coin's inscriptions and its purported likeness of a god, presents himself as Tiberius's archrival to divinity: "Jesus said to them, 'Whose likeness [eikōn] and inscription [epigraphē] is this?' They said, 'Caesar's.' Then he said to them, 'Render therefore to Caesar the things that are Caesar's, and to God the things that are God's.'" Matthew's story seems to mean that some things should be rendered to Caesar as political authority and others should be rendered to the Christian God as religious authority; or that all things should be rendered to the Christian God because nothing is really Caesar's; or that all things should be rendered to Caesar because nothing material—nothing of the sort with which one might pay taxes in a nonmonetary tradition—is the Christian God's. The iconodule John of Jerusalem makes the argument that "to 'render to Caesar what was Caesar's' meant rendering to Caesar the icon of Caesar on the coin, and to 'render to God what was God's' meant rendering to God the icon of God in the church."[165] (Jesus' contest with Caesar for the numismatically defined aura of god-manhood is often rendered by iconographic emblems like the woodcut *Et quae sunt Dei Deo;* fig. 27.)

Jesus' apparent indirection in argument thus allows him to give tax advice without offending either the nationalist parties with an overt approval of paying taxes or the seat of the empire with an overt disapproval. He is a prudent tax adviser, "economical" with his words:[166] he represents the conflict between such a man as the Roman Caesar and such a God as the Jewish Jahweh while at the same time muting the similarity—at once attractive and potentially discomforting to potential Christians—between Caesar and Christ as god-men. Christ,

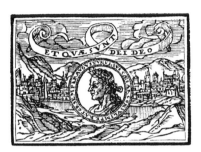

Fig. 27. Woodcut, *Et quae sunt Dei Deo,* ca. 1610. Depicts coin with image of emperor, and city. The inscription (not shown) includes these words: "El cielo y tierra, y todo lo criado / Es del Señor, y obra de sus manos" (The heaven, the earth, and all creation belong to God, and all his handiwork). Henkel and Schöne, *Emblemata,* 1284 (Covarrubias 2, no. 6). Harvard College Library.

46

the god-man with whom Christians take this conflict between the newly de-
fined "secular" and "religious" realms to end, is the "Word made flesh" as much
as the likeness (or intellectual inscription) impressed in the ingot is "made flesh"
by the material ingot that it transforms into a denarius and together with which
it becomes one in body and spirit—in *intellectus* and *res.*

Jesus' response to his interlocuters frames the crucial tension between reli-
gious God and secular mammon that helps define the ideology of Christianity.
And it serves to elucidate the struggle within Roman Christianity itself over
whether Christianity should support or endorse a Roman Christendom that
demands tribute of the secular sort. (Likewise, his response sheds light on how
the firstborn son Jesus, as father of himself, in some fashion must pay his own
"redemption money" to the temple—or is himself that money; and it explains
why Jesus tells Peter to pay off yet another financial assessment, the "didrachma
tax," with a gold stater coin taken from the mouth of a fish, the word for which,
ICHTHUS, various traditions link with Christ himself— *Iēsous CHristos THeou
hUiios Sōtēr.*[167] The Roman demand for the "Peter penny" is hinted in Masac-
cio's *Tribute Money,* which depicts the tribute-paying Peter, who eventually
founded the papacy and its institutional system of taxation based on both im-
perial Roman and theocratic Jewish principles.[168]) "High priest" (*pontifex max-
imus*)—the words on Tiberius's coin—is what the tribute-seeking Roman
pontiff came to be called. *ROMA,* says a goliardic acrostic poem, means *Radix
Omnium Malorum Avaritia* (Avarice is the root of all evils).[169]

The Numismatic God

The Chinese have never treated their coinage as coins,
passing on their face value irrespective of their intrinsic
worth, but have always looked beneath Caesar's super-
scription; and the token currency of the capital is rated
closely to the value of the metal contained in it.

Morse, "Currency in China"

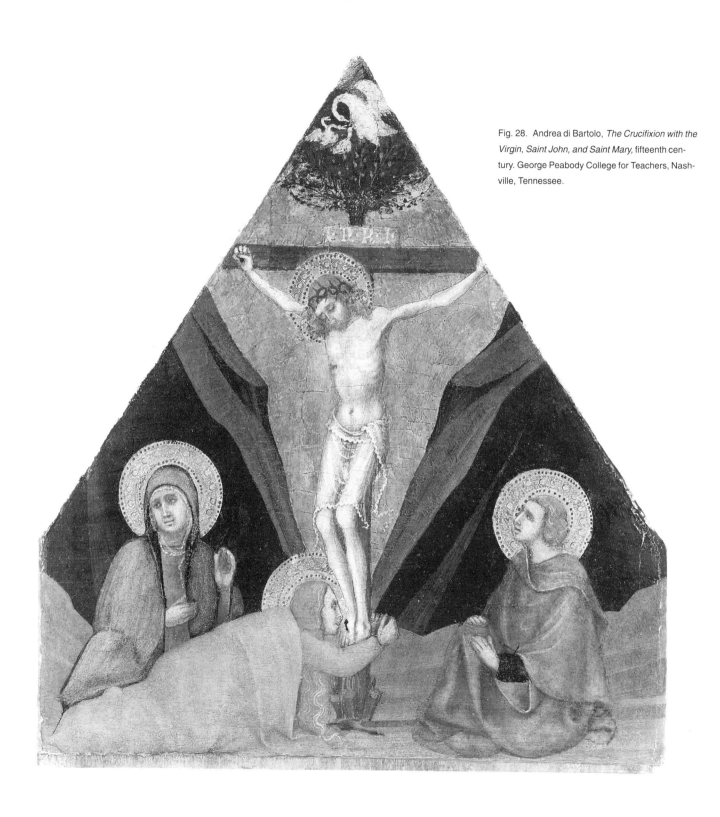

Fig. 28. Andrea di Bartolo, *The Crucifixion with the Virgin, Saint John, and Saint Mary*, fifteenth century. George Peabody College for Teachers, Nashville, Tennessee.

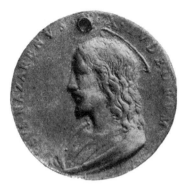
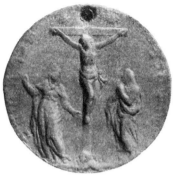

Fig. 29. Medal, issue of the papal mint, sixteenth century (?). A haloed bust of Christ bears the inscription IESUS NAZARENUS REX IUDEORUM on one side of the coinlike medal; the same inscription, in Hebrew, is on the other side. Hill, *Medallic Portraits,* 59. British Museum, London.

There is a hitch between the inscription on the Roman tax coin, considered above, and the well-known inscription *IHS Nazarenus Rex Iudeorum* (Jesus of Nazareth king of the Jews; sometimes abbreviated *INRI*), which was placed on the Roman cross above or on the body of the crucified Jesus (fig. 28). Both inscriptions are called *epigraphē* (translated "superscription" in the epigraph to the present section), and both the inscribed wood (the plank) and the inscribed metal (the coin) became standard holy relics.[170] More significantly, the inscription on the cross eventually found its way onto the tax coins and coinlike medals of Roman Christendom (fig. 29). It is as if the crucified God who cancels all debts were to become his own redemption money.[171] In modern iconology, it is as if the cross were to be hung with—and also to become—a monetary token (fig. 30).

This numismatic appearance or epiphany of God, memorialized by a second crossbar on many crucifixes,[172] appears to complete a long numismatic tradition, with both monetary and theological aspects. On the coins of the imperial Syrian ruler Antiochus IV, for example, had been the notorious motto *Antiochus theos epiphanēs* (Antiochus God made manifest).[173] Likewise, the coins of the foreign-dominated Alexander Jannaeus had had the bilingual inscriptions "Jonathan the King" (in Hebrew) and "Of King Alexander" (in Greek). The

Fig. 30. Alain Snyers, *Ten French Francs, Cruci-fied,* 1975. French ten-franc bill nailed and wired to a wooden cross, 75 × 35 × 15 cm. Courtesy of the artist.

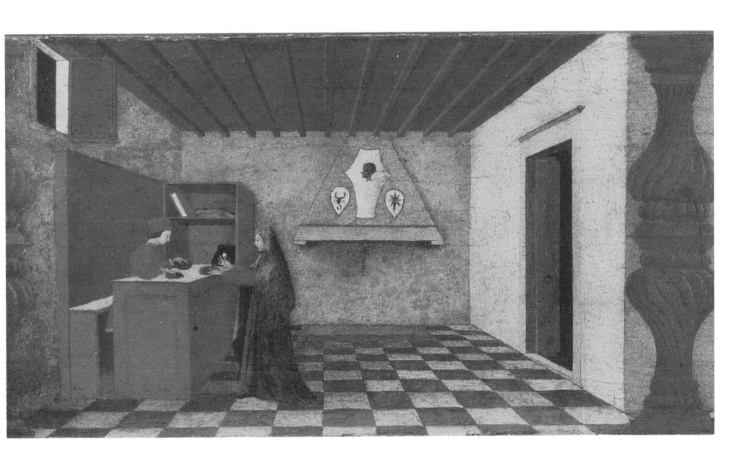

Plate 1. Paolo Uccello, *Profanation of the Host,*
(first scene of predella for Confraternity of Corpus
Christi, Urbino), 1467–68. Galleria Nazionale delle
Marche, Urbino. Scala/Art Resource, New York.

Plate 2. Cildo Meireles, *Massão/Missões; or, How to Build Cathedrals,* 1987. Six hundred thousand metal coins, two thousand bones, eight hundred communion wafers, eighty-six paving stones, and black cloth. Ikon Gallery, Manchester, England. Photograph courtesy of the artist.

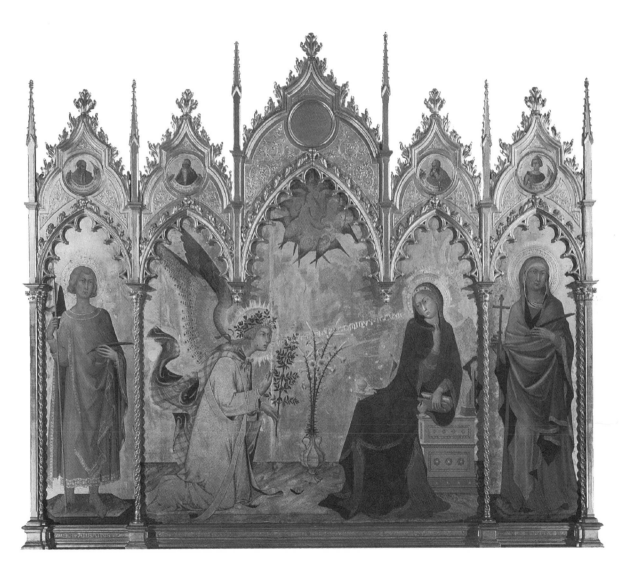

Plate 3. Simone Martini, *The Annunciation*, 1333.
Divine chrysographic letters from the angel Gabriel
inseminate the Virgin Mary through the ear. Uffizi,
Florence. Scala/Art Resource, New York.

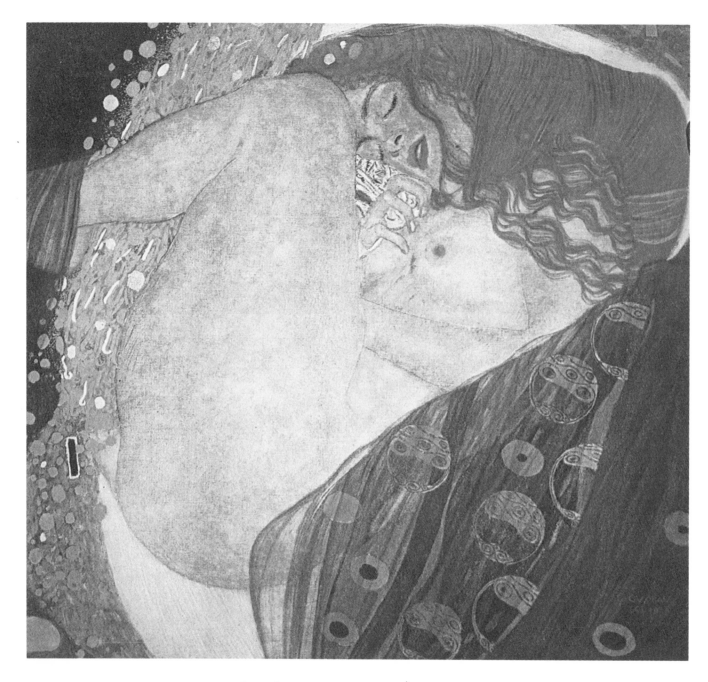

Plate 4. Gustav Klimt, *Danaë,* 1907–8. Würthle
Gallery, Vienna.

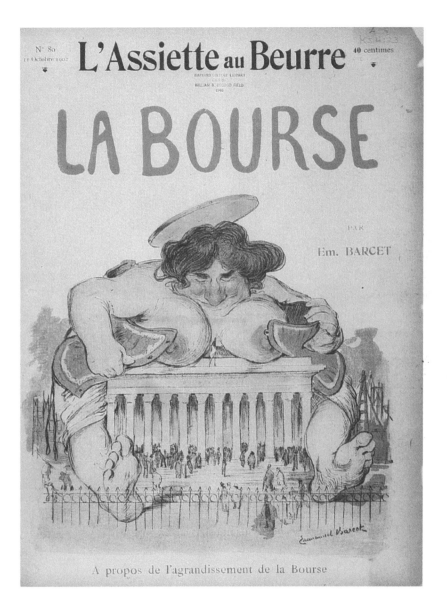

Plate 5. Emmanuel Barcet, *La Bourse*. Cover for
L'Assiette au Beurre 80 (11 October 1902). Hough-
ton Library.

Plate 6. Victor Dubreuil, *Don't Make a Move!*
ca. 1900. Oil on canvas, 24½ × 32 in. Private
collection.

Plate 7. Larry Rivers, *French Money,* 1962–63.
Lithograph, 22⅛ × 31 in. Gimpfel Fils, London. Hof-
stra Museum Collection, Hempstead, New York. ©
Larry Rivers/VAGA, New York, 1993.

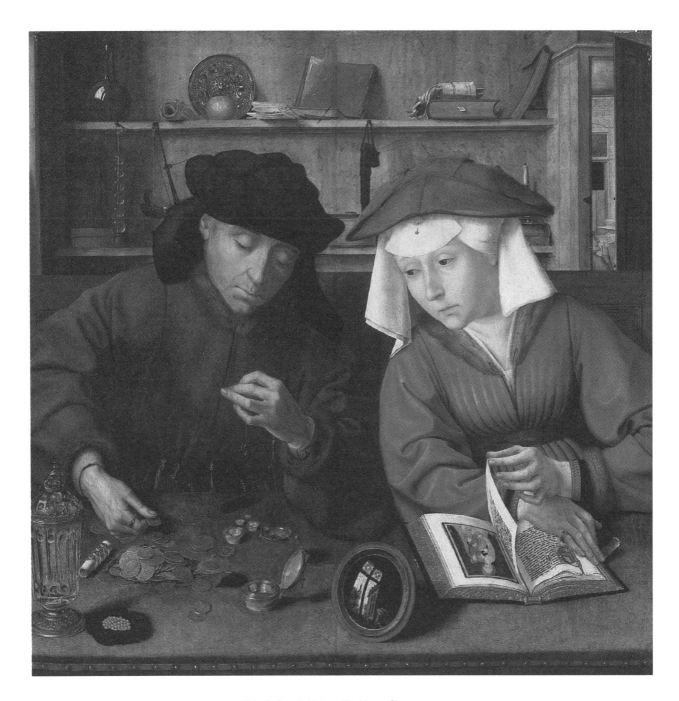

Plate 8. Quentin Metsys, *The Money Changer
and His Wife,* ca. 1514. Oil on wood, 71 × 68 cm.
Musée du Louvre, Paris. Photo R.M.N.

ideological tendency of such coins to turn men into gods and kings—considered above in relation to Byzantium and studied elsewhere in relation to ancient Greece[174]—was especially strong where people disregarded righteous warnings about the potentially idolatrous quality of specifically numismatic images[175] or mistook the usual numismatic claim that the image (*eikōn*) and the thing imaged were the same: "I and the emperor are one."[176] The Maccabees, heroes of the Chanukah story, rebelled against Antiochus—and established their famous mint (ca. 163 B.C.)—partly to counter his patently idolatrous claims to divinity.

We have seen that the competition between the Roman imperial god-man and the Christian god-man is linked with the numismatic relation of political *intellectus* to divine *res*. That link helps to explain why Christian debate about iconology grew especially bitter when coins issued by the Christian emperors of Rome—including Constantine the Great, the "first Christian emperor"—came to display the imperial/pontifical image surrounded by the same "divine" auras that had surrounded the images of the old pagan Roman Caesars. The debate turned into warfare when the "likeness" of Christ himself began to appear on coins during the reign of the emperor Justinian II in A.D. 685–711 (fig. 31).[177]

The first Christ coin, Justinian's *solidus,* had Christ replace Caesar *absolutely* as the numismatic god-man.[178] Jesus was now the Word made flesh in Christ in the same way that a numismatic inscription is made material in the coin. (That conflation of god with coin is the probably unintended gist of the Victorian poet Dobson's otherwise clichéd claim, in the epigraph to the previous section, that Tiberius's coin as art would outlast the Roman god-man Tiberius. "Money," says the sculptor Dennis Oppenheim, "is a root of all art.")[179] When, beginning in the tenth century, representations of the Virgin Mary and the saints began to appear regularly on coins, there were "difficulties over iconoclasm, whose history can be traced to the coinage of the period."[180] As some Christians rendered unto the Roman pontiff the things that were his, Christ's inscription in solid gold, *In Hoc Signo,*[181] became the focus for a systematic iconological controversy in Judeo-Christianity about the semiology of coins and paper money.

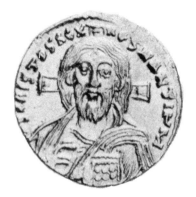

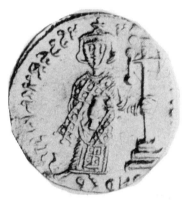

Fig. 31. Gold solidus minted for the emperor Justinian II, A.D. 669–711. Bust of Christ, inscribed IHS CHRISTUS REX REGNANTIUM. American Numismatic Society, New York.

Chrysography

The interrelation between golden inscriptions (or chrysography) and inscription in gold (or minting) makes for an important chapter in the history of iconoclasm. For the Second Commandment's prohibition of the "graven image" is interpretable both in terms of drawing with liquid gold (gilt painting) and in terms of sculpturing in solid gold (minting). In Christendom from the first century to the twelfth, a few iconoclast writers thus approached the problem of the internalization of economic form in art by writing about chrysography.[182]

Chrysography was already a controversial topic among the Jews in the first century. In *The Tractate for Scribes,* for example, certain Jewish authors considered the intellectual and spiritual implications of using gold in presumably much the same way that certain scholars had done when they translated the Pentateuch into Greek in the third century B.C.;[183] the *Tractate* prohibited chrysographic scrolls for use in the synagogue.[184] There were practical reasons for such a prohibition: chrysographic works were often stolen and destroyed for the gold in which they were written, for example. (It is ironic that "one of the main purposes of luxurious book production in the Byzantine Empire was to preserve copies of the Holy Scripture," as Diringer says.)[185] In this vein John Ruskin, long after the gold- and silver-loving conquistadores destroyed the religious art treasures of the Amerindians, tells how ancient Greek statues were melted down by people who believed their value as metal was greater than their value as art.[186] Marie-Madeleine Gauthier reminds us that "the amount of precious metal worked and not minted will remain forever incalculable."[187] And Marc Bloch, in *Esquisse d'une histoire monétaire de l'Europe* (A sketch of the monetary history of Europe), points out that handiwork in metal was sometimes so little valued by the Catholic church that coined money and religious art amounted to the same thing;[188] the ecclesiastical term "treasure," which indicates at once the icons and the coins in a church's storehouse, expresses this sometimes discomforting but telling union.[189]

Chrysography—writing with gold ink on parchment or with black ink on gold leaf[190]—often became relatively widespread among the "Peoples of the Book" (Jews, Christians, and Muslims) at about the same time as did minting

coins.[191] (See the ninth-century manuscript of Saint-Amand; fig. 32.)[192] And it began to decline as a serious art in the twelfth and thirteenth centuries, at the same time as the first issuing of negotiable papers, which are inscriptions on paper exchangeable for gold.[193] Throughout this period, chrysography provided thinkers with a visible example of what Luther later called *Gellt,* or gold qua money: "the language of the devil."[194] (*Chrusos* means "money" or "coin" as well as "gold.")[195]

But the Talmudists and the church fathers who imitated them had spiritual as well as practical reasons for prohibiting chrysography. In chrysography letters, which are the visible substance of the medium of linguistic exchange, are penned in ink made of gold, the economically valuable substance of monetary exchange. The rabbis and church fathers argued that the monetary value of the written letter should not conflict with spiritual value: the aura of gold should not compete with the aura of God. (*Aurum* means "gold" as well as "coin.")[196] Chrysographic letters, the rabbis knew, draw attention to themselves rather than to the Law, not merely because some are beautifully calligraphic, but also because they are made of the substance of money. Hence Saint Jerome said that chrysographic manuscripts were "burdens rather than books,"[197] and John argued that in chrysography the commodity value of the gold ink can appear to override the spiritual value of the words. If one were "to write [the word] *God* in gold,"[198] then the gold in the word *God* would come to outweigh God himself; the Talmud says that sometimes only the name of God was written in gold in the Torah.[199] Philip Fisher analogously argues that the painted lettering in artworks like Jasper Johns's *Tennyson* competes with the paint for the reader's attention in much the same way that gold leaf competed in paintings of earlier eras.[200] And Svetlana Alpers, in her interpretation of Rembrandt's *The Berlin Money Changer,* draws attention to the artist's fascination with hoarding, which Rembrandt associated "not only with the traffic in money [gold] but also with a loving and lavish traffic in paint."[201]

Some theorists have suggested that the value of ink as commodity can infect the spiritual value of words and have feared that words written in gold would be identical to the gilded words of "golden-mouthed" Saint John Chrysostom.[202]

The chrysographic ninth-century Ebo Gospel, written in gold ink, shows

Fig. 32. Sacramentary, Saint-Amand, second half of ninth century. MS 77. Ville du Mans.

Detail of figure 8, Maître de la Manne, *The Collection of Manna,* fifteenth century

Saint Matthew ready to receive through the ear the divine golden liquid that inspires his writing (fig. 11). Bernardo Martorell's painting *The Annunciation,* which includes a similar showering of gold—in this case into an auratic halo—depicts the angel Gabriel as he inseminates Mary with divine golden words.

Chrysography thus provided a focus for discussion of aesthetic and monetary values, the discourse about chrysography helping to connect "figuratively" the study of writing impressed *in* gold ingots with the study of writing printed on paper that is exchangeable *for* gold. As we shall see in chapter 3, the Judeo-Christian discourse about chrysography also helps explain the terminology of twentieth-century controversies about that money whose *only* material, if any, resides in electronic circuits printed in gold.

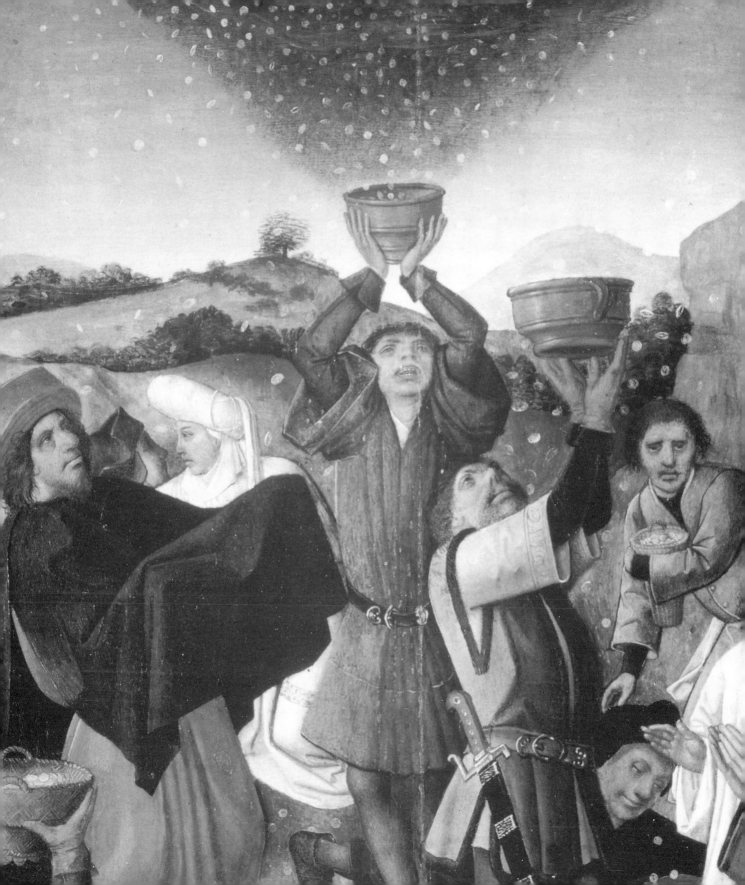

REPRESENTATION AND
EXCHANGE: AMERICA

*F*etishes, European travelers used to claim, were idols "worshipped in their own character, not as the images, symbols, or occasional residences of a deity." [1] Missionaries and anthropologists used to say likewise that "savages" invested their own powers in external objects; then the savages forgot the origin of the powers and began to worship these objects as magical or divine. Protestants leveled the charge of fetishism against Catholics, just as Catholics leveled it against pagans.

From the late eighteenth century onward, however, many theorists began to challenge outright the once comfortable distinction between false and true religions as that between secular and religious realms. [2] Karl Marx, for example, used to remark that the real "magic" in European Christendom's notion of the fetish was its denial that there was anything magic about it. [3] He employed an ironically theological analysis to argue, in good Protestant fashion, that "soon after its birth, modern society [European Christendom] pulled Plutus by the hair of his head from the bowels of the earth and greeted gold as its Holy Grail." [4] In his *Jewish Question* Marx (himself a convert) called the fetishistic quality of economic exchange in Christendom characteristically "Jewish." Similarly, the Jewish Moses Hess in his *Essence of Money* examined spiritual money (*geistiges Geld*) and called the fetishistic quality of capitalist exchange typically "Christian." [5]

The traditional theory of fetishism thus encouraged a bifocal view of sacred artifact with economic artifact—or of "pure" artwork with the commodity of commodities that is money. Likewise, it linked the numismatic Christian understanding of the connection between *intellectus* and *res* (the principal subject of chapter 2) with the economics of secular art (the main theme of this chapter).

A comparable crux in the ideal realm of art criticism informs the debate between those iconodules who call art pure "truth" or "beauty" and those iconoclasts who call art a mere "commodity" with fetishistic qualities.[6] Nowadays, as Mitchell writes, the confrontation between iconodules and iconoclasts "tends to destroy the possibility of mediating terms, of images that are neither true nor false, neither worshipped nor despised. The usual candidate for the function of mediating image (especially in post-Kantian aesthetics) is the aesthetic object. But these objects have a tendency . . . to cloister themselves in the enclave of aesthetic 'purity,' and to distinguish themselves from impure, idolatrous images."[7]

Amid the instability of the categories of "art" and "money" and amid the treachery of the secularist's generally premature distinction between religious and secular realms, the following sections seek to diagnose modern iconological vacillations between art as money and money as art. Many of the artworks and monetary artifacts that we will contemplate here are therefore definitively "intermediational" between art and money. They help to map out the relation of monetary tokens that are wholly works of art (like Duchamp's notoriously fungible *Tzanck Check;* fig. 74) with artworks that are wholly monetary tokens or processes (like counterfeit and trompe l'oeil—or visual trumping—paper money and conceptual investment art).[8] In the following sections we shall see how some artworks verge on becoming money. In the first instance this merger occurs when the artwork as a *whole* in some way imitates a coin, bank note, or fiduciary transaction. Sometimes the artful representation has something useful to teach, as in the case of certain joke notes (see "The Issue of Representation," below). Sometimes the artwork's imitation of a coin or bank note seems delightfully only to fool the eye, as in the case of trompe l'oeil money art (see "Visual Trumps"). And sometimes it cheats the economic trader, as in the case of counterfeit money ("Counterfeits").

A few traditional painters or writers about paintings have approached this subject by demonstrating that, just as commerce has an allegorical component—as expressed in early accountancy textbooks and in traditional artworks like Johann Heiss's *Allegory of Commerce* (fig. 33)—so artistic production gener-

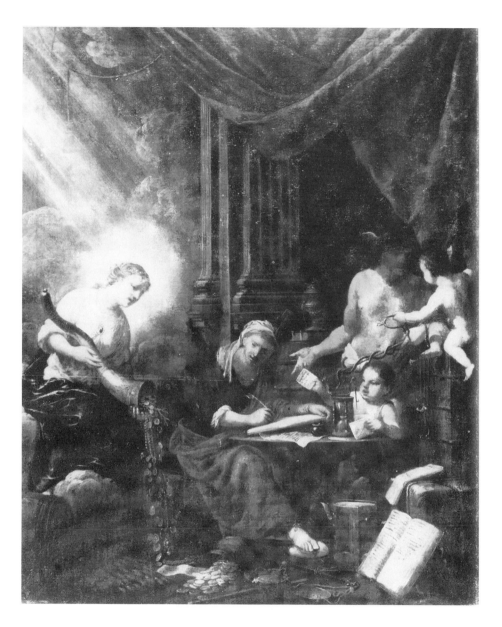

Fig. 33. Johann Heiss, *The Allegory of Com-
merce,* ca. 1680. Private Collection, Budapest.

ally is essentially always a form of commercial, even monetary, allegory.[9] In this allegorical consideration, the Judeo-Christian money devil has always been a key figure.

Pretty Money

Before we focus on artwork's becoming money, it is worth remarking that some monetary tokens verge on becoming partly or wholly artworks just as some artworks verge on becoming monetary tokens. Money's thus *becoming* art—as opposed, say, to its merely *depicting* artworks (as when coins show paintings, buildings, and various artifacts)[10]—would seem to lift money, at least temporarily, out of the realm of supposedly ordinary economic exchange to which it is often confined by the "two-world" ideologies of Christendom. Balzac calls these monetary tokens "veritable pieces of art."[11]

Some monetary tokens are indeed specifically earmarked for exit from ordinary economic exchange into the arenas of gift exchange, jewelry, clothing, study, and art. A few monetary tokens are given as beggars' tokens or alms pennies. Others are gifts or gift wrapping: an American gift-merchandising firm thus sells uncut sheets of actual paper money as gift wrap—an all-containing quasi-secular Grail (fig. 34). Some are used as gambling tokens.[12] Others are used as articles of clothing, jewelry,[13] or religious amulets (fig. 35). Still others become, at least for a while, artifacts for display in museum cases or subjects for scholarly or speculative essays like this one. And there are those monetary tokens that are included in—or become part of—such composite artworks or collages as John Murphy's *An Art of Exchange* (1976), Joseph Beuys's *John Dillinger* (1974), and various works of Robert Rauschenberg.[14] Likewise, seals are often attached collagelike to manuscripts and royal letters,[15] and painted representations of pilgrim badges sometimes appear in the margins of medieval manuscripts (fig. 36; cf. fig. 20).[16] Thus a *Life Magazine* article titled "Paper Money Made into Art You Can Bank On" remarks that "Painters [in the 1960s] are picturing dollar bills and sculptors are bundling and gluing real paper currency and coins into their constructions."[17]

Fig. 34. Newspaper photograph: "A salesman with the mail order clothing store Maus and Hoffman in Fort Lauderdale, Fla., holds up a sheet of genuine dollar bills that the store sells only as gift wrap each holiday season. A sheet of $32 goes for $55." *Miami Herald,* December 1990. Photograph by Beth Keiser.

Fig. 35. Coin amulet, West Frisian Islands, 1678. Silver coin, later pierced for suspension, with a fret-work Hebrew letter *he,* an amuletic device. Israel Museum, Jerusalem.

Fig. 36. Medieval manuscript, *Mary of Burgundy,*
1485–90, Ed. Alexander. Harvard College Library.

This "prettification" of money, as one sociologist calls it, sometimes frames money as an aesthetic object.[18] Most telling here are the various condemnations of the ideal transformation of money into a "gift"—a category of economic activity with particular implications for twentieth-century understanding of the tension between God and mammon. Many social anthropologists and sociologists adapt for themselves a pseudosecular version of the old "two realms" theory and assert that money is ordinarily illegitimate as a gift, since money belongs to the realm of the market economy (mammon), while the gift (given gratis) belongs to the realm of gift exchange (God). And so they grant those objects that appear to be both money *and* gifts privileged status.

Just as much social anthropology defines ordinary kinship categories in

terms of incest or its taboo, so much economic anthropology defines ordinary economic exchange—generally associated with the "domestic market economy" of Christendom—by means of the notion of an infinitely large and freely given archaic gift, or its impossibility. Put otherwise, social anthropology, born in the intellectual wake left by the church in the nineteenth century, hypothesizes a modified version of the spiritually incestuous Holy Family (discussed in "The Golden Annunciation," above) in much the same way that economic anthropology hypothesizes variably secularized versions of grace (discussed in "The Holy Grail," above). Moreover, in the same tradition of missionary literature and conversion handbooks, economic anthropology often projects onto "foreign" cultures this idealized model of gifts and gift giving to which the usual assumption underlying analyses of pretty money—that you cannot serve both God and mammon—is often implicitly indebted. Lévi-Strauss's most telling anthropological investigations in this respect rely implicitly on Richard Wagner's constructions of golden rings and Holy Grails. When Marcel Mauss, in his now celebrated anthropological romance *The Gift,* adapted to anthropological exchange theory a few tenets from Roman legal historiography, his anti-Semitic colleagues drove him from the temple of the French Academy as if Mauss were the money devil himself.

The Money Devil

And here is The Jokist's Own Treasury.

Twain and Warner, *The Gilded Age*

Plato was uneasy that a money of the mind informs thinking and cannot be expelled from it. He knew that money and its forms could hardly be eliminated from the academy where human lovers of wisdom converse—economic hypothesizing informs logical hypothesizing and change making informs the dialectical division of the One (*kermatidzesthai*). And he took into his account of metaphor and truth the tense symmetries between money and the idea or between rhetoric and its counterpart dialectic.[19]

The Christian response to the introduction of coined money was different. As a god or an "equal to the gods" (*isotheos*), Jesus tried to eject altogether from inside the walls of the temple the classical money changer (*kermatistēs*) and his changing coins (*kermata*). He wanted to keep the monetary agents of homogenization and uniformity out of view of the ark where he supposed himself—or the divine one—to dwell. And so the possibility of the money form's having infected such central doctrines in Christianity as the Eucharist and the incarnation is pretty much repressed in, or expressed from, Christianity.

Money is thus generally disliked in Christendom not only for the avarice with which it is associated ("the love of money is the root of all evil") but for the internalization of the money form in Christian doctrine itself.

Plato figured his struggle with the money changers of the mind as an argument with Gyges, the Lydian "tyrant" who first minted coined money (*Republic,* bk. 2). This Gyges, whom Plato describes as a tricky would-be "equal to the gods," historically was probably the same person as the mythical Gog, the architectonic enemy of the Jewish people in the Book of Ezekiel.[20] Such apocalyptic Christian literature as the Book of Revelation fit these myths of Gyges/Gog—as well as Greek and Roman stories about money jokers like Hermes and Mercury—with the Christian ideology of a money devil who always has to be eliminated but never is.[21] Plato sought to express the workings of the money form within philosophy itself; but Christianity sought to cleanse the temple with whips and scourges, thus repressing the money devil within by means of an expression, or evacuation, of a coin-excreting money devil to the periphery of the human world.[22]

It is outside ordinary space and time—at the extreme end of earth and the apocalyptic fulfillment of time—that the moneyed Gog of Christendom usually makes an appearance. On the last sheet of the Catalan atlas of 1375, which depicts Saint John's vision at the extremity of the planisphere, for example, a crowned Antichrist stands beneath a horned devil; he waves golden boughs beside the eastern sea as the peoples of the earth, including the rulers of the people in Gog and Magog, crowd round to adore him (fig. 37).[23] The devil was thus generally kept at bay at the periphery of the known world.

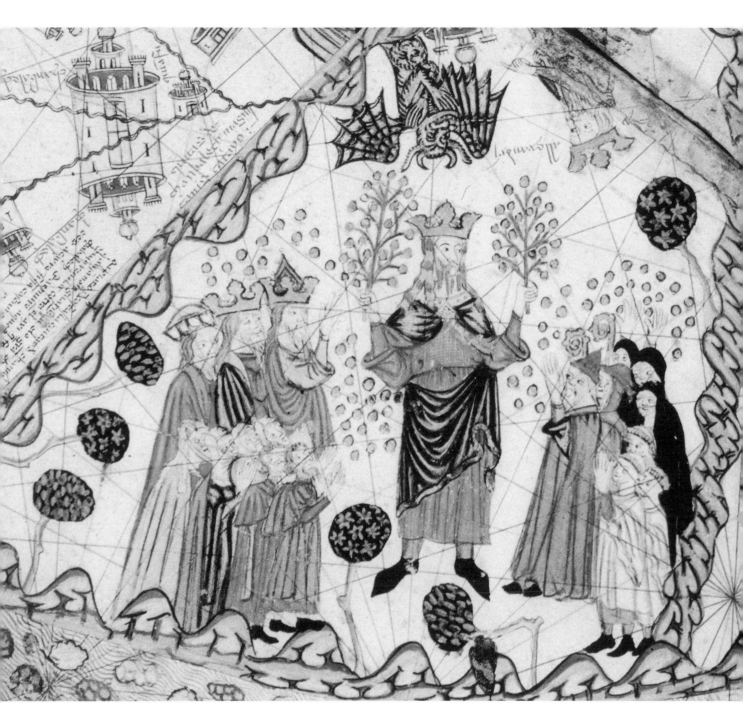

Fig. 37. Catalan atlas, Mallorca, 1375. MS 130, fols. 2v–3. Bibliothèque Nationale, Paris.

Rarely recognized as an element within Christendom itself, the money devil was said to threaten Christendom mainly in "cosmopolitan" commercial cities like Venice—the setting for Shakespeare's play about merchants, xenophobia, and the never-defeated Jewish money devil Tubal. Augustine associated the cult of the golden calf with the worship of the devil; and the saint argued that the Jews who had drunk the water into which the powder of the golden calf had been ground constituted the body of the devil himself,[24] as in an inversion of the Eucharist. (The golden calf was a favorite Old Testament scene for Christian artists: some make visual puns on terms like *peccus* and *pecuniary* ["cow" and "money"] or *capital*.[25] A traditional German drink, made of alcohol with shavings of gold in it, is called *Goldwasser* [goldwater], an actual *aurum potabile*.[26] A favorite Roman method of execution, along with crucifixion, was pouring molten gold down the throat.[27])

Representations of the alien money devil appear frequently in subject inventories of sixteenth-century visual art,[28] and by the seventeenth century the money devil's "international" aspect was already a worn theme. (The caption from a typical cartoon from the Dutch tulip scandal of 1637—a momentous financial crisis in which the flower bulb played the role of both money and commodity—reads: "All the world's nations seek the money devil.")[29] But only rarely did the internalization of the money form in theology itself, as in the mysteries of the incarnation and Eucharist, become a real issue for Christians. For example, Martin Luther, with his special focus on the fecal filth of the money devil and hence the need to cleanse the temple, tried to bring out an inescapable polar tension between money and God: "Money is the word of the devil, through which he creates everything in the world, just as God creates through the true Word."[30] (Luther presages the insistence in Goethe's *Faust* and Marx's *Kapital* that the Mephistophelean money devil was part and parcel of divine workings.)

With the introduction of paper money in the eighteenth century—which Johann Büsch in 1801 called "the papered century"[31] and Thomas Carlyle in his *French Revolution* called the "Age of Paper"[32]—the internalization of economic form in thought became an explicit theme in popular artworks about such "international" financial fiascoes as the John Law paper money scandal or

the land-based Mississippi Bubble scheme. This was a crisis in political confidence based on real estate *lopins* (parcels) in the New World that presents itself to French historians as one of the first mass upheavals, apart from war, linking public finance with a lack of public confidence and hence with a need for it.[33]

Many people in the eighteenth century were used to seeing depictions of a coin-covered money devil (fig. 38). But they were more puzzled by paper money than by coin, and so they were especially leery of the new paper money devil's graphic powers of production, or poiesis. With the coming of paper money's distinctive separation of *intellectus* from *res*—or of spiritual inscription from inscribed material thing—graphic artists' interest began to concentrate less on the numismatic being of the money devil than on the intellectual representativeness of the paper money with which the devil flattered his victims by powerful new modes of aesthetic usury.[34] ("Of all usurers," said Ségur, "the flatterers are the worst.")[35] The medieval church fathers had adopted Aristotle's argument

Fig. 38. Drawing, *The Money Devil*, France, 1680. De Meyer, "Le diable d'argent," 288. Cabinet des estampes, Bibliothèque Nationale, Paris. Harvard College Library.

Fig. 39. *Au bon diable.* Drawing of a mid-nineteenth-century commercial sign based on the money devil motif (originally outside at a shop in rue St.-Martin, Paris). Gaidoz, *Melusine* 7:54. Harvard College Library.

that coined money and monetary interest unnaturally made something out of nothing—or out of nothing natural (*Politics,* 1258); and now the cartoonists of the eighteenth century followed conservative suit with broadsides, captions like "All for/from nothing,"[36] and sketches of Grail-like cornucopias spewing forth coins.[37] By means of paper money, it now seemed, the devil might reverse Lucretius's dictum *Ex nihilo nihil fit* (From nothing nothing is made); he could make something out of nothing. The "devil in specie,"[38] as the money devil was sometimes called, was now personified as a fictive Nothing pretending to be Something (fig. 39).[39]

Daniel Defoe, considering John Law's paper money in the 1720s (a period of monetary scandal and increasing influence of the mass media), calls the French land-based paper money experiment a "chimera"—that is, "an unreal creature of the imagination, a mere wild fancy; an unfounded conception."[40] Voltaire writes similarly of "the chimerical value of paper money bills"[41] and "the commerce of the imagination,"[42] and he describes how, when the bottom falls out of the market, "real poverty begins to replace fictive wealth."[43] Montesquieu too remarks on the relation between imagination or fiction in aesthetics and credit in economics. He mocks John Law as a new wind-god, child of Aeolus, who convinces the people of the land of Betique to trade in their gold and silver for paper. "People of Betique you believe you are rich because you have gold and silver. I pity your mistake. Believe me, leave this land of vile metals; come to the *Empire of the Imagination;* and I promise you riches that will astonish you all."[44] Like Boy Charioteer—in the paper money scene directed by the wagering or gambling money devil Mephistopheles in Goethe's *Faust*[45]—Montesquieu's Aeolus distributes his merchandise. When the people, losing their investments, become intractable and refuse to take "kites" for gold, he cries out, "I advised you to imagine and you are not doing so. All right, now I order you to."[46] One cartoon of the period, *The Bubbler's Kingdom in the Aireal-World,* remarks that "the gold is melted and nothing but bubbles it produces" and that one "catch[es] at all and hold[s] nothing." Another cartoon, *The Bubblers Medley,* complains that "asses there / Give solid gold for empty air" and that "all the riches that we boast / Consist in scraps of paper." A playing card from one jokist's pack of the period reads: "I, thousandfold artist of the French

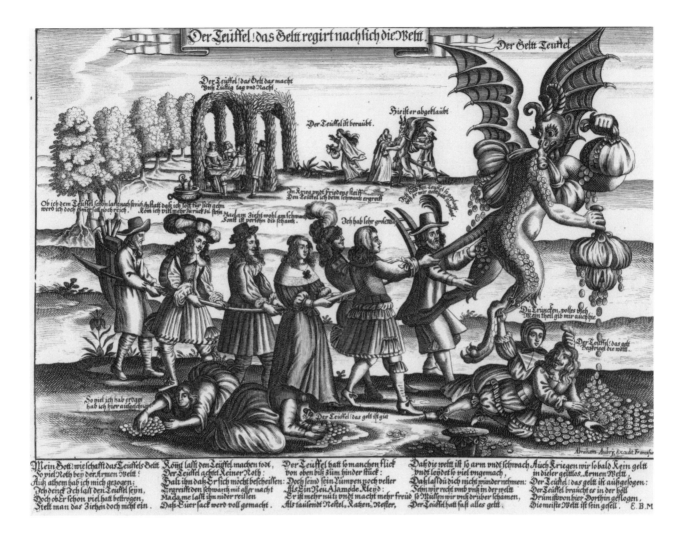

Fig. 40. Drawing, *The Money Devil Rules the World,* 1720. Germanisches Nationalmuseum, Nuremberg.

wind tent ballet, make my chief wind rupture in dancing while I am stretching my legs on the rope." [47] Similar representations of money devils appeared in England, Italy,[48] Holland,[49] and Russia[50] and later as well, as in Germany (fig. 40) and France. In France the destabilizing lack of *foi publique*—public confidence—that the John Law scandal elicited, just at the time when the French national bank was founded, inspired France to found its Caisse des Dépots et

69

Fig. 41. J. P. Retti, *Public Faith,* 1989. A replica based on the ancient original of the statue that stood in the sanctuary of Fidesse (Confidence) on the Capitoline Hill in Rome. Collection of Groupe Caisse des Dépots, Paris.

Consignations, charged a century later (in 1816) with the task of stabilizing public confidence in state money. Just recently the Caisse underwrote the replication of ancient Roman statues representing Fidesse, or "Public Faith" (fig. 41).[51]

Thomas Nast, who was born in Germany but studied in America with German emigrés, later linked the typically Americanized money devil—one example is the marionette-operating rogue in *Office Hunters for the Year 1834* (fig. 42)[52]—both with the American paper money debates (whose terms were gold versus paper and real versus ideal) and with the "ideal" of Hegelian dialectics, which Nast, like Karl Marx and Wilhelm von Schütz (both writing in 1844), suggests is a paper money philosophy that idealizes the double-dealing devilish world of modern commerce (fig. 43).[53] In this tradition are the auratic French money devil on the cover of *L'argent* (fig. 24) and the Quebec-born

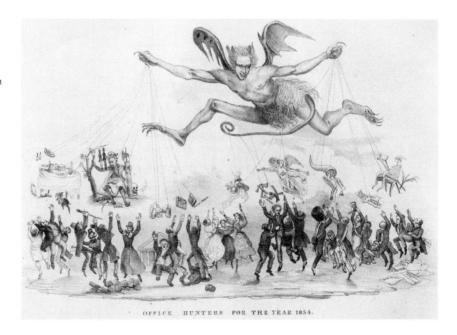

Fig. 42. Anonymous, *Office Hunters for the Year 1834,* 1834. Anthony Imbert, publisher. Andrew Jackson, here the Americanized money devil, holds strings from which dangle horns of plenty and moneybags. Houghton Library.

70

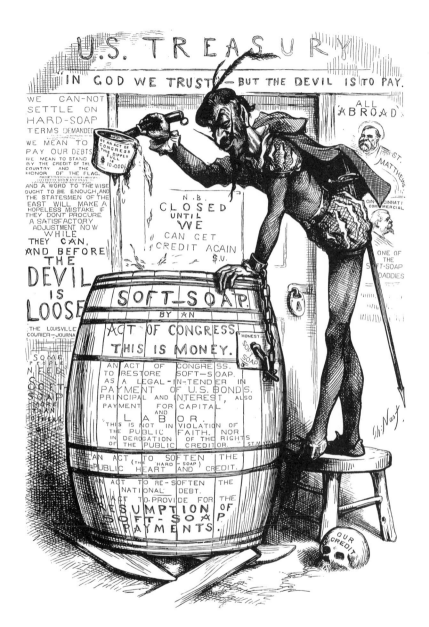

Fig. 43. Thomas Nast, *Ideal Money, Harper's Weekly* 48 (19 January 1878). Beneath the title, *Ideal Money*, in small script: "'Universal Suffrage can, if it likes, repudiate the whole debt; it can, if it likes, decree soft-soap to be currency.'—*The Louisville Courier-Journal*." Courtesy of Library of Congress, Washington, D.C.

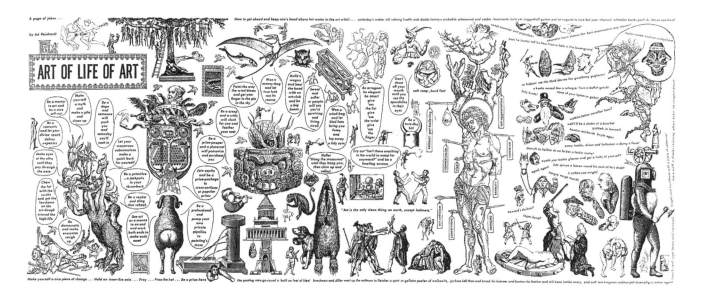

Fig. 44. Ad Reinhardt, *Art of Life and Life of Art,* 1952. In *Transformation* L/3, 1952. © Anna Reinhardt. Courtesy of the Pace Gallery, New York.

Napolean Sarony's jocular American *Treasury Note,* which depicts an updated money devil's chariot.[54] Ad Reinhardt's *Art of Life and Life of Art* (1952), which expresses a continuing attempt in America to aestheticize the artful theology of the money devil (fig. 44),[55] is not America's last word on the subject.

The Issue of Representation

A descriptive analysis of bank notes is needed. The unlimited satirical force of such a book would be equalled only by its objectivity. For nowhere more naively than in these documents does capitalism display itself in solemn earnest.

Benjamin, "Tax Advice"

The United States, the first place in the Western world where paper money was widely used,[56] is an interesting locale for the study of representation and exchange in art. This is not only because the United States sometimes presents itself as a "secular"—hence supposedly non-Christian—state. It is also because in nineteenth-century America there raged an extensive debate about paper money that, like the discussion of coinage in "religious" Byzantium, had aesthetic as well as political implications.

In the American debate, which blended the self-interested struggle between "hard money" creditors and "soft money" debtors with various disputes about the issue of representation, "paper money men" (as advocates of paper money were called) were set against "gold bugs" (advocates of gold).[57] It was shadowy art against golden substance. The zealous backers of solid specie associated gold with the substance of value and disparaged all paper as the "insubstantial" sign. A piece of paper counted for relatively little as a commodity and thus, they said, was "insensitive" in the system of economic exchange. Over the first half of the century, paper issued by banks (and supposedly backed by gold) was their primary focus. During the Civil War, controversy swirled over the government-issued "greenbacks"—monetary paper backed by no metal at all. Monometallists, at the end of the century, grew alarmed when some politicians wanted the government to declare silver to be money and to issue bank notes on this augmented monetary "base."

Credit, or belief, involves the ground of aesthetic experience, and the same medium that confers belief in fiduciary money (bank notes) and in scriptural money (accounting records and money of account, created by the process of bookkeeping) also seems to confer it in art. So the "interplay of money and mere [drawing or writing] to a point where," as Braudel says, "the two be[come] confused" involved the tendency of paper money to play upon the everyday understanding of the relation between symbols and things.[58] The sign of the monetary *diabolus,* which Americans said was like the sign impressed in Cain's forehead,[59] became the principal icon of America.

The American debates, viewed historically, were a plank in a cultural bridge to the contemporary world of electronic credits and transfers and government money unbacked by metal or other material substance. As we have considered,

the shift from substance to inscription in the monetary sphere began early, with the first appearance of coins. Coins as such were fiduciary ingots that passed for the values inscribed—values to which the metallic purity and weight of the coins themselves might be inadequate—thanks to a general forebearance and acceptance of the issuing authority on the part of buyers and sellers. Whether or not this workaday tolerance of political authority came on the heels of traders customarily overlooking the clips and wear and tear in old-fashioned ingots, the first appearance of coins precipitated a quandary over the relation between face value and substantial value—between, as it were, intellectual currency and material currency. As early as Heraclitus and Plato, idealist thinkers had wondered about the link of monetary hypothesizing with logical hypothesizing, or monetary change making with dialectical division. But awareness of the specific difference between inscription and thing exploded with the introduction of paper money.

For Americans the value of paper—the material substance on which monetary engravings were now printed—clearly had next to nothing to do with paper notes' value as money. Bank notes were backed by land; or by gold in a vault somewhere; or by silver; or by loans; or perhaps by actual or potential government power. (*Exitus in dubio est,* "the issue is in doubt," read the "continental" notes of the American Revolution.) But the precise connection between gold and paper seemed the stuff of mystery. Paper money thus regenerated a cultural disturbance that extended beyond money per se to include the artistic enterprise.

In Poe's famous story "The Gold-Bug," the treasure-hunting protagonist cashes in a devilishly "ideal" cryptographic drawing for "real" gold. The link between the economic and aesthetic realms that drives Poe's protagonist, with his golden bug and his bug for gold, is expressed inadvertently in *Gold Humbug,* H. R. Robinson's "joke" note depicting a devilish treasure hunt for the gold that "real" notes ("gold humbug") are supposed to represent (fig. 45). He and Napolean Sarony represented themselves as sellers of artful joke notes in much the same way that they represented bankers and legislators as sellers of genuine or counterfeit notes.[60] (Likewise, Johnston, in his joke note *Great Locofoco Juggernaut,* made the usual association of gold deposits, which back up paper

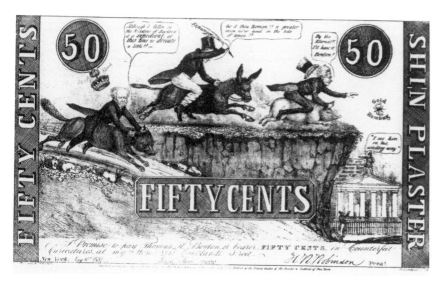

Fig. 45. H. R. Robinson, *Gold Humbug,* caricature of a shinplaster, United States, 1837. At the right, Andrew Jackson chases the "gold humbug." American Antiquarian Society, Worcester, Massachusetts.

money, with fecal deposits, which issue from the backside.)[61] These American cartoonists worked within a tradition that includes France in the 1790s and Germany in the 1920s. "Bombario" of eighteenth-century Europe, who is named on the idealist Don Quixote's saddles in cartoons from the John Law paper money fiasco (fig. 46), became the gold humbug of nineteenth-century America.

Thomas Nast's cartoon *A Shadow Is Not a Substance* (fig. 47), which appears in Wells's *Robinson Crusoe's Money* (1876), depicts the relation between reality and idealist appearance as both monetary and aesthetic; and it helps to explain many American artists' and economists' association of paper money with spiritualness, or ghostliness,[62] and their understanding of how an artistic appearance is taken for the real thing by a devilish suspension of disbelief. Congress, it was said, could turn paper into gold by an "act of Congress," like the devilish *Tat* (deed) at issue in the paper money scene orchestrated by Mephistopheles in Goethe's *Faust*. Why could not a Faustian artist turn paper with a design or story on it into gold? Thus Nast's cartoon *Milk-Tickets for Babies, in Place of Milk* (fig. 48), also from Wells's book, shows one paper bearing the design of a milk cow and the inscription "This is a cow by the act of the artist" and another

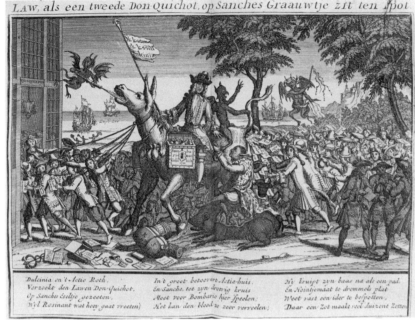

Dulcinia en 't Actie Roth,
Verzoekt den Lawen Don-Quichot,
Op Sanchos Eseltje gezeeten,
Wil Rosinant wat hoov gaat vreeten)

In't groot betoovert Actie-huis,
En Sanche, tot zyn droevig kruis
Moet voor Bombario hier speelen;
't Kan den bloed te zeer verveelen;

Zy kruipt zyn baas na als een pad,
En Heintjemaat te drommels plat
Weet rast een ider te bespotten,
Daar een Zot maakt veel duizent Zetten

Fig. 46. Cartoon, *John Law as Don Quixote,* Netherlands, 1720. "Law, als een tweede Don-Quichot, op Sanches Graauwtje zit ten Spot" (Law, like another Don Quixote, sits on Sancho's ass, being everyone's fool). The engraving shows John Law riding an ass. On the flag is "Ik koom. Ik koom Dulcinea" (I come. I come Dulcinea). A coffer filled with bags of money is inscribed "Bombarioos Geld kist 1720" (Bombario's [humbug's] money box, 1720). Behind Law is a devil, the "Henry" of the text; he holds up the tail of the ass. The ass voids papers inscribed 1000, 0, 00, and so on. From *Het groote tafereel der dwaasheid* (Amsterdam, 1720). Buffalo and Erie Country Library, Buffalo, New York.

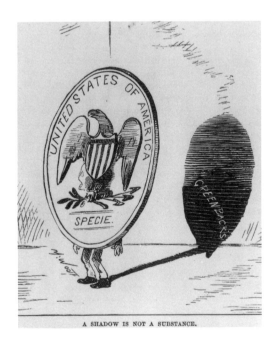

A SHADOW IS NOT A SUBSTANCE.

Fig. 47. Thomas Nast, *A Shadow Is Not a Substance,* 1876. Wells, *Robinson Crusoe's Money.* Harvard College Library.

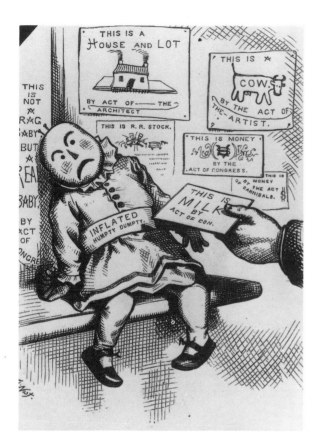

Fig. 48. Thomas Nast, *Milk-Tickets for Babies, in Place of Milk,* 1876. Wells, *Robinson Crusoe's Money.* Harvard College Library.

paper that reads "This is money by the act of Congress"; his *Ideal Money* has similar inscriptions reading "Soft-Soap / by an / Act of Congress / This is Money" and "By an Act of Congress this Dipper Full is $10,000" (fig. 43). (Some *Notgeld,* or "emergency money," from Germany of the inflationary 1920s quotes *Faust* and includes the inscription: "One liter of milk for 550 billion German marks;" fig. 49. Other German emergency bank notes ironically quote passages from *Faust* like "Such currency . . . bears its value on its face"; fig. 50.)

The American debate about paper money was concerned with symbolization in general, hence with both money and aesthetics. Symbolization in this

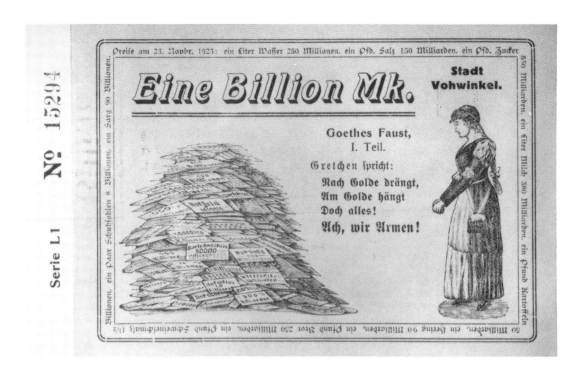

Fig. 49. Emergency money (*Notgeld*), bank note,
Eine Billion Mk. (American, one trillion German
marks; British, one billion German marks), Stadt
Vohwinkel, November 1923. Quoting Goethe's
Faust, 2802–4: "For gold contend, / On gold
depend / All things and men . . . Poor us!" In right
border, beginning at top: "550 Milliarden, ein Liter
Milch" (American, one liter of milk for 550 billion
German marks). Sammlung Albert Pick (Hypo-
bank, Munich). Museum des Deutschen Bundes-
bank, Frankfurt.

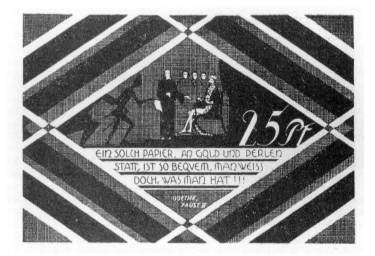

Fig. 50. Emergency money (*Notgeld*), bank note,
Schleswig-Holstein, 1920s. Quoting the paper
money scene from Goethe's *Faust,* 6119–20:
"Such currency, in gold and jewels' place, / Is neat,
it bears its value on its face" (trans. Arndt). Samm-
lung Albert Pick (Hypobank, Munich). Museum des
Deutschen Bundesbank, Frankfurt.

context concerns the relation between the substantial thing and its sign. Solid gold was conventionally associated with the substance of value. Whether or not one regarded paper as an inappropriate and downright misleading "sign," that sign was "insubstantial" insofar as the paper counted for nothing as a commodity and was thus "insensible" in the economic system of exchange. (The French symbolist poet Stéphane Mallarmé, who was much interested in the international Panama financial scandal—during the decade of the 1890s when Americans were focusing on the Cross of Gold presidential campaigns—wrote in this context that "everything is taken up in Aesthetics and in Political Economy."[63]

The American debate about aesthetics and economics connected the study of the essence of money with the philosophy and iconology of art. Joseph G. Baldwin thus explored how paper money asserts the spiritual over the material;[64] and Albert Brisbane, in his midcentury *Philosophy of Money,* provided an "ontology," as he called it, for the study of monetary signs. Clinton Roosevelt, a prominent member of the Locofocos (a political party of the period), argued in his *Paradox of Political Economy* in 1859, when the "gold bug" Van Buren had lost the presidency, that the American Association for the Advancement of Science should establish an "ontological department for the discussion and establishment of general principles of political economy."[65]

Such a discussion already existed in Germany in the shape of a far-ranging debate between the proponents of idealism and the proponents of realism. It was this debate that Thomas Nast brought to American newspaper and book readers in the second half of the century in such Germanic cartoons as his devilish *Ideal Money* (fig. 43, above). For Nast and his collaborator Wells—as for many Americans living during the heyday of paper money controversies and trompe l'oeil art—paper could no more be money than "a shadow could be the substance, or the picture of a horse a horse."[66]

The problem, from the viewpoint of aesthetics, involves representation as *exchange.* A painting of grapes, a painting of a pipe, or a monetary inscription generally stands for something else—it makes the implicit claim: "I am edible grapes," "I am a pipe," or "I am ten coins." Sometimes observers are trumped into taking the imitation for the real. For example, birds are said to have pecked

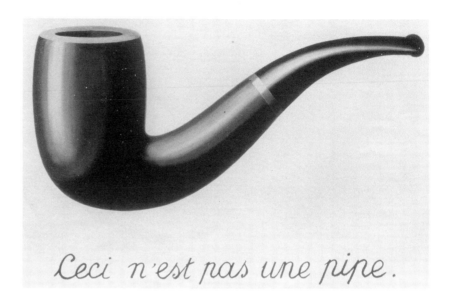

Fig. 51. René Magritte, *This Is Not a Pipe,* 1926. Photothèque René Magritte-Giraudon. © 1994 C. Herscovici/Artists Rig. Herscovici/Artists Rights Society (ARS), New York.

themselves to death on the grapes painted by the ancient Greek artist Zeuxis. (He was the first artist known to become very rich.)[67] People who read the inscription under Magritte's trompe l'oeil (trumping, or fooling the eye) pipe may never roll up the canvas and smoke it like a cigar (fig. 51),[68] but Magritte here plays with our "commonsense" suspension of disbelief when we approach an artistic representation. We take the painting for a pipe on some level. But pipes and grapes, however much they are representable by artworks, are also more or less "original" objects.[69] Money, on the other hand, is not. A piece of paper money is almost always a representation, a symbol that claims to stand for something else or to be something else. It is not that paper depicts and represents coins, but that paper, coins, and money, generally, all stand in the place of something else.

(Just as bank notes sometimes visually suggest that they represent or are coins, as do the American bank notes in figure 52[70] and various Chinese bills that depict rolls of coins,[71] so postage stamps often depict monetary tokens, as

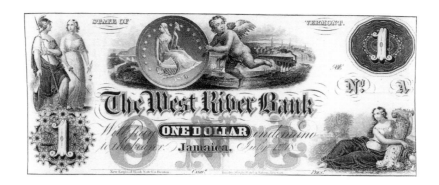

Fig. 52. Bank notes, the West Ridge Bank of Jamaica, Vermont; issued jointly by Rawdon, Wright, and Edson and the New England Bank Note Company, nineteenth century. American Numismatic Society, New York.

Fig. 53. Stamps showing coins or paper money: Hungary, 1974, 1975, and Grenadines of St. Vincent, West Indies, 1976. Courtesy of Tom Telicki, South Hadley, Massachusetts.

do those in figure 53, and issuing postal authorities frequently claim the banker's prerogative to issue regular currency.[72] Similarly, some playing cards suggest visually that they represent or are coins, much as the coins they represent suggest specie: examples would include the round coinlike cards from the "suit of coins" in figure 54 and the tarot knight holding a coin in figure 55.[73] Playing cards as such are linked with the historical beginnings of paper money, and even in the modern era playing-card money has been issued during periods of financial crisis.[74] In gambling card games, moreover, the relation between what is played with and what is played for—the playing card as numeric marker and as money—is like that in such coin games as "heads or tails" [*croix et piles*]. Blaise Pascal used this game to help explain why it is best to bet on the existence of God and the true *croix,* or cross; and probability theorists and econometricians generally have used this game to explain the link between likelihood and likeness—the likelihood that a perfectly weighted coin will land heads or tails, say, and the likeness, bordering on infinitesimally close identity, between coins of the same denomination.[75])

Nast's cartoon *Milk-Tickets for Babies, in Place of Milk* (fig. 48) displays most clearly the gold bug's characteristic thinking about representation as exchange. It illustrates quite literally the tendency to confound artistic confidence with political or economic credit to the point where money becomes art and art becomes money. One of the cartoon's bank notes reads, "This is a cow by the act of the artist," where the word "cow" appears inside the picture of a milk cow. Another paper, "This is milk by the act of con," suggests the *con*gressional *con*fidence game by which Americans are *con*ned and recalls for us Calvin's remark about lactary relics that "had Mary been a cow all her life she could not have produced such a quantity." "This is money by the act of cannibals" recalls

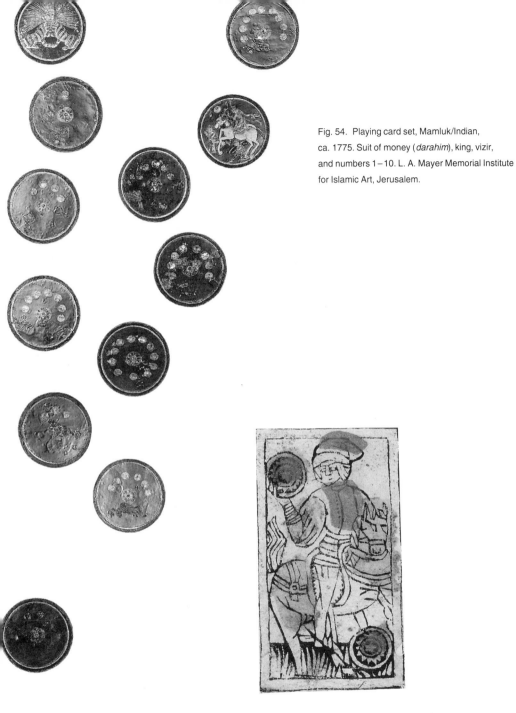

Fig. 54. Playing card set, Mamluk/Indian,
ca. 1775. Suit of money (*darahim*), king, vizir,
and numbers 1–10. L. A. Mayer Memorial Institute
for Islamic Art, Jerusalem.

Fig. 55. *Knight of Coins,* from uncut sheet of
taroochi (tarot cards), fifteenth or sixteenth century.
Coins is a feminine suit. Bequest of James C.
McGuire, Metropolitan Museum of Art, New York.

similarly the association of coins with communion tokens and the Eucharist. Still another bank note reads, "This is not a rag baby but a REAL BABY by act of Congress."[76] Carlyle wrote about such "rags" in his *French Revolution:* "Bank paper, wherewith you can still buy when there is no gold left; Book-paper, splendent with Theories, Philosophies, Sensibilities, —beautiful art, not only of revealing Thought, but also of so beautifully hiding from us the want of Thought! Paper is made from the *rags* of things that did once exist; there are endless excellences in Paper."[77] More important, the paper money inscription "This is money by the act of Congress," appearing as the work of an artist, suggests an identity, indeed rivalry, between the authority of the artist and that of the banker or statesman. Both artist and politician seem able to take an apparently valueless piece of paper and, by virtue of words or drawings, make it as valuable as exchange note or the valuable "original" for which the note is purportedly exchangeable.

The tension is that between political nation and individual imagination, as suggested in Paul Cotton's joke note drawn on "the Bank of the Imagi-Nation" (fig. 56). Latin American artists of the modern period, working in postcolonial

Fig. 56. Paul Cotton, *Check Drawn on the Bank of the Imagi-Nation,* Wells Fargo Bank, 1970. "This check is a detail in a collaborative drawing by the Trans-Parent Teachers Incorporated. Uncashed, its value is twelve times the written amount to be paid by the collector." Courtesy of Jürgen Harten, Städtische Kunsthalle, Düsseldorf.

84

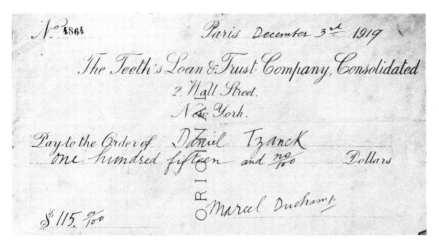

Fig. 57. Marcel Duchamp, *Tzanck Check*, Paris, 3 December 1919. Enlarged manuscript version of a check, 8 × 15 in. Handwritten in black. Vertically, in red: ORIGINAL; printed with rubber stamp in red, as background: "The Teeth's Loan & Trust Company, Consolidated." From *Boîte en valise*, Galleria Schwarz (Milan, 1963 ed.), Coll. S.C., Montreal. © 1994 Artists Rights Society (ARS), New York/ADAGP, Paris.

contexts rife with political tyranny and monetary inflation, similarly consider money as fiction and fiction as money: in Jac Leirner's *Os cem* (1986–87), for example, "the bank note is," as Leirner herself says, "almost an absence." (The pun on *cem* and *sem*—"hundred" and "sign"—is crucial to her title.)[78]

Can the artist, in a regime of paper money manufacture money as if he were a bank? Some artists would have it that way. Many artists in the twentieth century thus draw, or draw on, checks as a conceptual jest. Marcel Duchamp, for example, paid his dentist Daniel Tzanck with a hand-drawn check that presumably enabled the bearer to draw on funds at "The Teeth's Trust Company"; the artist later repurchased the check for more than he had drawn it for (fig. 57).[79] Duchamp hints at the same exchangeability of paper for money in his reworking of a label for photographic paper; he cut the label so that it reads "papier au . . . d'argent," or "silver paper."[80]

Instances where monetary value is similarly linked to originary signature include the artist Daniel Spoerri's opening his checkbook one day, writing out a series of checks payable to cash at ten deutsche marks each, and selling them as art for twenty deutsche marks apiece. "In exchanging art for money," Spoerri explained, "we exchange one abstraction for another."[81] Don Judd likewise paid

a bill to the fortuitously named art collector Henry Geldzähler with a photo-copied five-dollar bill.

In such gestures the combination of representation and value derives from the imprimatur or signature of the artist, not the state. It is the artist who certi-fies, who sug*gests*—from *sur-gere,* "to carry over," as in a metaphorical convey-ance. Hence the signature is fetishized—as hinted in Carl Reuterswärd's *The Great Fetish,* which reproduces Picasso's signature as a cult object.[82] A signature is like a thumbprint guaranteeing the aura of the authentic, as Galton says in his nineteenth-century American work on detection and fingerprinting. Edward Kienholz's watercolors, described in *Life Magazine*'s "Paper Money Made into Art You Can Bank On," are each signed with his thumbprint. The watercolors sold for the amount of money stamped on the face—ranging from one dollar to ten thousand dollars (fig. 58). Kienholz wrote in an exhibition essay, "What I have done is, in effect, to issue a kind of currency which is not dependant [*sic*] on the normal monetary system."[83] "The fetish of the art market," says Walter Benjamin in his 1937 study of Eduard Fuchs and the mass cult of the leader, is "the old master's name."[84]

Fig. 58. Edward Kienholz, *The Commercial No. 3,* 1972. Kunsthalle, Hamburg. Photograph courtesy of Jürgen Harten.

Visual Trumps

> Trompe l'oeil (if indeed there is such a thing) does not
> belong to the realm of painting. It is rather a "playful
> physics."
>
> Magritte (1963)[85]

In seventeenth-century Europe, especially in commercial centers like Amsterdam, painters of "still life" works often depicted artful arrangements of "lifelike" monetary tokens together with leaves, playing cards, letters, letter racks, and myriad other objects.[86] The focus here was not on the unique status of coin or bank note as money but on its mundane position as one visible thing among others—not its role as "metaphysical" *intellectus* but its general standing as "physical" *res*.[87] Though there are a few European works where the trompe l'oeil depiction of money is the whole issue—F. G. Schumann's *Reichs Thaler Note*,[88] for example, and trompe l'oeil drawings representing the *assignats* of the French Revolution (figs. 59 and 60)[89]—trompe l'oeil paper money became a predominant and widespread art form only in America.[90] American trompe l'oeil paper money painting was exhibited widely in saloons, probably the most important forum for art distribution and exhibition in nineteenth-century America;[91] trompe l'oeil tried to turn the money changers' tables in the "secular" saloon that is the modern political economy.

The first United States monetary trompe l'oeil painting was done in the eighteenth century by Raphaelle Peale,[92] but the genre did not reach full stride until the latter part of the nineteenth century. Highlights in the history of this sort of painting would include William Michael Harnett's oil painting *Five Dollar Bill* (fig. 61), which was, like other works of trompe l'oeil money art, the subject of a legal case conducted by the Federal Bureau of Investigation.[93] The FBI was concerned with counterfeiting, the inevitable bugaboo for trompe l'oeil artists who worked the money angle.[94] (Until recently Victor Dubreuil's *Barrels of Money,* like others of his works, was kept in a safe at the Department of the Treasury.)[95]

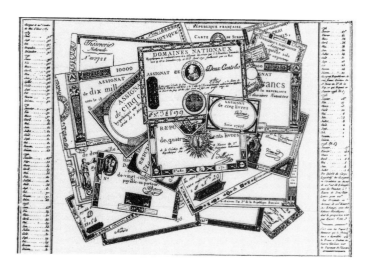

Fig. 59. Trompe l'oeil bank notes, France, 1797. Grand-Carteret, *Vieux papiers*. Harvard College Library.

John Haberle's *Can You Break a Five?* (fig. 62) depicts an American five-dollar bill together with a newspaper clipping, presumably by an art critic, that reads, "'Imitation' . . . , by John Haberle, is one of those clever pieces of artistic mechanism showing an old greenback and other objects."[96] His painting *Reproduction* generally could be reproduced only by permission of the Secretary of the Treasury. J. D. Chalfant's meticulously painted *Which Is Which?* pastes on the canvas a "real" stamp beside his "original" painting of a stamp;[97] his *Perfect Counterfeit* was refused a showing in Philadelphia in the aftermath of the Secret Service's fuss over a display of trompe l'oeil money artworks by Harnett. Ferdinand Danton's *Time Is Money* depicts "an alarm clock and a stack of $10 bills, and painted between them, as if incised in the door, is the word *is*." Below is a painted ticket punningly inscribed "time is money" (fig. 63).[98]

Victor Dubreuil, who generally painted only money themes,[99] was deeply concerned with the dematerialization of economic tokens in Christian context. His *Cross of Gold* (1896), for example, depicts trompe l'oeil bank notes arranged in the shape of a cross and held in place with gold tacks (fig. 64). Art historians have noted that this work suggests William Jennings Bryan's "Cross of Gold" speech at the Democratic national convention of 1896. ("You shall not crucify mankind upon a cross of gold," said Bryan, during the "Gilded Age" of America.)[100] Beyond this, however, is the *Cross of Gold*'s specific interaction

with the campaign's debate about whether the United States should use real "hard money" (gold) or ideal "soft money" (paper). Marc Bloch's story, in his sketch of the monetary history of Europe, about the melting down of Saint Willigis's gold cross may be relevant here: "Willigis, archbishop of Mainz, had given a gold crucifix to the church of Mainz. One of his successors removed a leg from the cross to pay for his woolen vestment; another successor removed a second leg to support the war against his vassals."[101] How many legs does a quadruped cross have to lose before it stops being a cross of gold and becomes instead only the idea of a cross?[102] The material cross's dissolution in its own idealization is the jest and gist of Dubreuil's *Cross of Gold*.[103] (The biblical inversion of the tale of Willigis's cross would be the story of apostate or convert Jews melting down "secular" Egyptian jewelry to fashion a "sacred" graven image: the golden calf.)[104] A Bulgarian legend has it that "when the great cross was cut up, the sawdust and little pieces were collected in a cloth. The king [Constantine] mixed them with gold and silver, melted all down together and caused them to be struck as pieces of gold and silver money."[105]

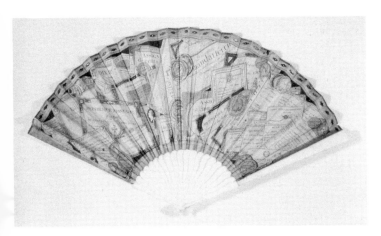

Fig. 60. Fan, with trompe l'oeil bank notes, France, 1795. One side shows trompe l'oeil reproductions of assignats; the other side shows *Jean qui rit* "making" money and *Jean qui pleut* "losing" wealth on account of that money. Musée Carnavalet, Paris.

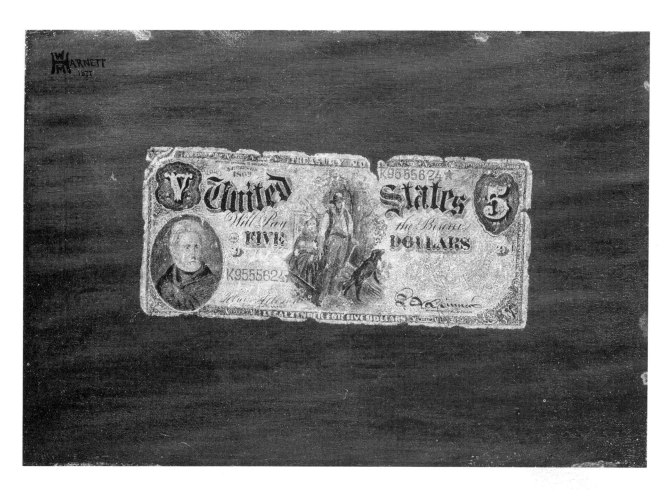

Fig. 61. William Harnett, *Still Life: Five Dollar Bill,*
1877. Oil on canvas, 8⅛ × 12 in. Alex Simpson, Jr.,
Collection, Philadelphia Museum of Art.

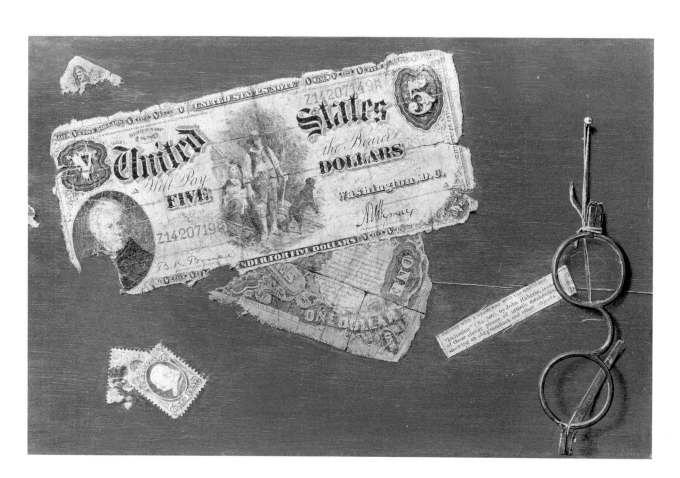

Fig. 62. John Haberle, *Can You Break a Five?*
ca. 1888. Amon Carter Museum, Fort Worth,
Texas.

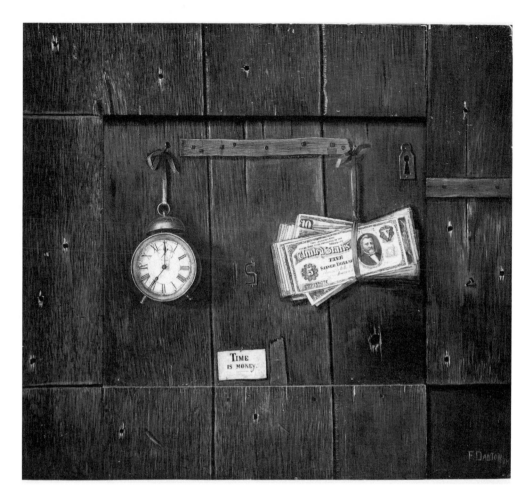

Fig. 63. Ferdinand Danton, Jr., *Time Is Money,* 1894. Oil on canvas, ca. 17 × 21 in. Ellas Gallup Sumner and Mary Catlin Sumner Collection, Wadsworth Athenaeum, Hartford Connecticut.

Dubreuil extends monetary trompe l'oeil's representational house of mirrors a step further in his *Don't Make a Move!* (plate 6). Here a man with one eye closed points the barrel of a revolver at the viewer. A woman bank robber grabs trompe l'oeil paper money bills from the money drawer. You, the viewer, are absorbed into the painting as the teller in this pawn shop or money changer's stall.

In the larger composition of *Don't Make a Move!* the pull ring on the money drawer answers to the gun's barrel or the looter's eye. This eye, or *oeil,* is the trompe l'oeil of the piece, figuring both the *eye* of the robber whose mate with-

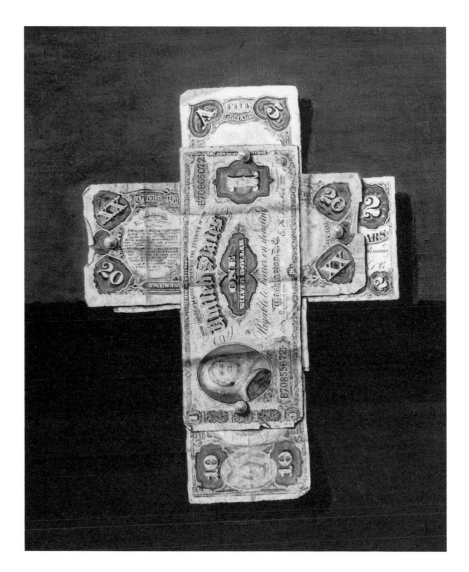

Fig. 64. Victor Dubreuil, *The Cross of Gold,*
ca. 1896. Oil on canvas, 14 × 12 in. Berry-Hill
Galleries, New York.

draws paper money from the drawer and also the *I* of the artist who draws his material from the visual realm. It is the same eye that stares from the "hole" in Dubreuil's *Eye of the Artist* (fig. 65) and from the pyramid in many American dollar bills.

"US of A—Revolution" is the headline in Dubreuil's fictional newspaper *Sport.* However, in *Don't Make a Move!* not everything is in jest. ("Pas un geste!" would be the suggestive French translation of "Don't make a move!")[106] Many people in the 1890s complained bitterly that capitalist robber barons, backed by bank tellers and revolver barrels, routinely extorted barrels of money from working people. (Dubreuil depicts these barrels in his *Barrels of Money.*)[107] The capitalists, they claimed, used financial institutions to inflate the workers' salaries. That thus cheating the people was "as easy as lying" was Nast's insight in his cartoon about the "counting house" (fig. 66). William Carlos Williams, one of the "Social Credit poets," was later to write, "Money : Joke / could be wiped out / at stroke / of pen / and was when / gold and pound were / devalued."[108] Just so, goes the jest, counterfeiters faked paper money and artists like Dubreuil parodied it.

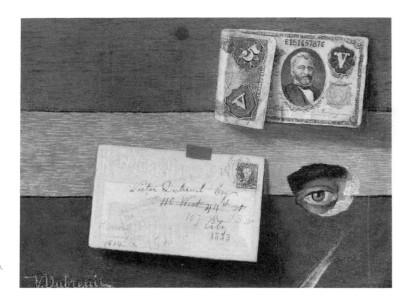

Fig. 65. Victor Dubreuil, *Eye of the Artist,* ca. 1896. Oil on canvas, 10 × 14 in. Courtesy of Butler Institute of American Art, Youngstown, Ohio.

94

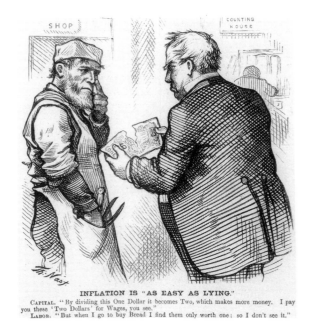

INFLATION IS "AS EASY AS LYING."

CAPITAL. "By dividing this One Dollar it becomes Two, which makes more money. I pay you these 'Two Dollars' for Wages, you see."
LABOR. "But when I go to buy Bread I find them only worth one; so I don't see it."

Fig. 66. Thomas Nast, *Inflation Is "as Easy as Lying."* In *Harper's Weekly*, 23 May 1874. CAPITAL says to LABOR: "By dividing this One Dollar it becomes Two, which makes more money. I pay you these *Two Dollars* for Wages, you see." LABOR responds: "But when I go to buy bread I find them only worth one; so I don't see it." Harvard College Library.

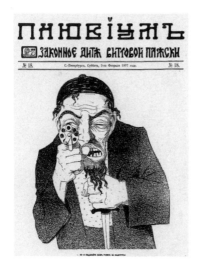

Fig. 67. Cover of *Pluvium*, 1907. Harvard College Library.

Dubreuil's themes—theft of paper money and theft by means of paper money—often include the usual anti-Semitic element. Some Christians, after all, regularly hypothesize God as a numismatic being. (*Christ Is Money,* a sculpture by Daniel Spoerri, teases this formulation out of works like Dubreuil's *Cross of Gold*.)[109] And sometimes, as we have seen, they project onto "others"—principally the Jews and other money devils—those beliefs in monetary adequation and representation and those actions in the economic realm that they fear to acknowledge as their own. At the turn of the century in America, populist Christians had only to update the traditional procedure. Now, they said, revolutionary Jewish bank robbers were in league with Jewish capitalist robber-bankers; the Jew was taking aim at rich and poor alike. The cover of the anti-Semitic, pro-czarist Russian journal *Pluvium* put the skullcap on Dubreuil's stickup man (fig. 67).

One motif that informs Dubreuil's *Don't Make a Move!* is the commonplace of the man and woman at a banker's counter with open journal and money. It is

a general device, revealed also in such works as Uccello's anti-Semitic *Profana-tion of the Host* (plate 1), discussed above in "Eucharist Wafer," and Petrus Christus's alluring *Saint Eligius and the Lovers* (fig. 68). Another example would be Quentin Metsys's *Money Changer and His Wife* (plate 8), which I discuss below in "Accounting for Art." In Metsys's work, which is informed by a familiar double triangulation (with the man on the left and the woman on the right), the "wife" seems to look away from an illumination of Mary—the Christian found-ing mother—in order to steal a look at the money changer's coins, much as the "woman" in *Don't Make a Move!* steals paper money bearing the type of Martha Washington—the American founding mother—and you and I at the counter are at once money changer and trumped *I*.

Among more recent American trompe l'oeil money artists is Otis Kaye, who knew the gestural work of Marcel Duchamp and the Dada artists. (Born in Michigan in 1885, Kaye moved to Germany in 1904. He began making images of currency upon his return to the United States in 1916 or 1917, and he con-tinued in this practice until the 1950s.) His *Rembrandt's Etching of Jan Lutma, the Elder, with Half Dollar and Penny* (ca. 1931) displays painted coins held down by illusionist cellophane tape over the face of a print that includes a real silver dollar. "Kaye [here] takes the question *What is an original work?* into yet another dimen-sion, transforming it into a double sided conundrum, painting an original copy on top of a copy of an original." Kaye's later works are "life size meticulous reproductions of specific bills which, if they had not been signed and dated by the artist [says one critic], might easily be mistaken for counterfeit notes."[110] Two more examples are Kaye's *Ten Dollar Bill* (fig. 69) and *One Thousand Franc Note* (1950). His *Rembrandt's Etching of Faust in His Study* recalls the same themes (fig. 70).

Bank notes by Kaye foreshadow by some thirty years the drawings of J. S. G. Boggs, who has been arrested for making trompe l'oeil money (fig. 71). Robert Krulwich notes, with reference to Boggs's exchange of money drawings for actual goods and services, that "it's all a fiction, there's nothing backing it, it's all an act of faith." According to Krulwich, drawings and currency both depend on the same suspension of disbelief.[111]

Fig. 68. Petrus Christus, *Saint Eligius and the Lovers*, 1449. Oil on wood. Robert Lehman Collec-tion, Metropolitan Museum of Art, New York.

96

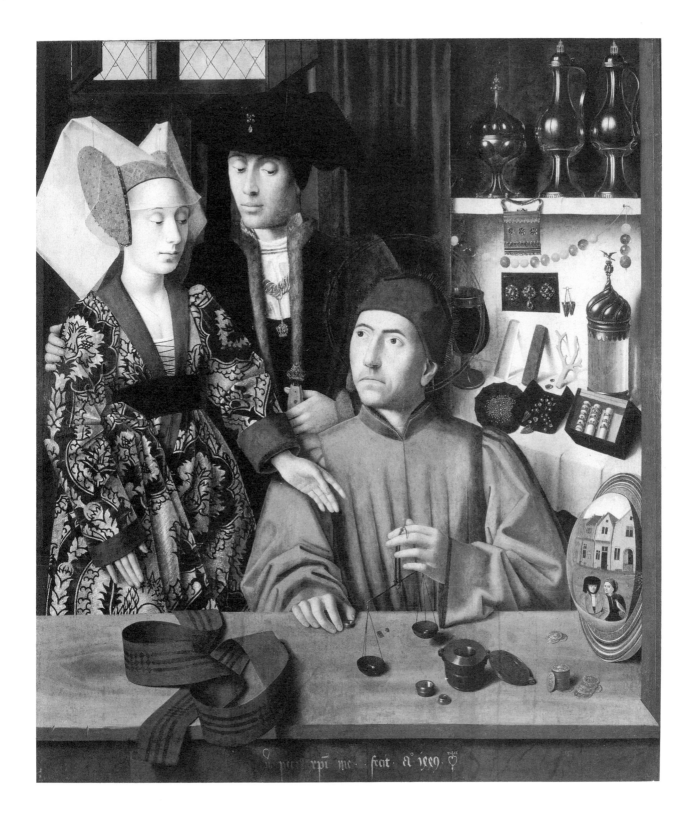

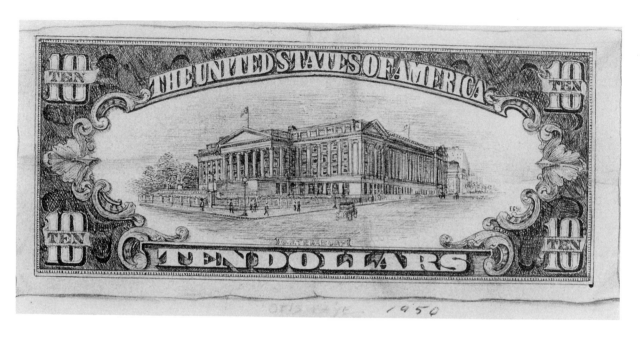

Fig. 69. Otis Kaye, *Ten Dollar Bill* (verso), 1950.
Black ink and pencil on paper, 3½ × 7¼ in. Berry-Hill
Galleries, New York.

Fig. 70. Otis Kaye, *Rembrandt's Etching of Faust
in His Study, Watching a Magic Disk with Two Pen-
nies and a Quarter*, 1930s. Etching and oil on pa-
per, 9⅜ × 7½ in. Berry-Hill Galleries, New York.

Fig. 71. J. S. G. Boggs, *Dinner for Eight*, 1987.
Five pieces, mixed media; size varies with place-
ment. Henry Feiwel Gallery, New York.

Counterfeits

Though the popularity of trompe l'oeil paper money in the nineteenth-century
United States is partly explicable by the "American love of filthy lucre" during
the Gilded Age, such artists as William Harnett were generally concerned less
with valuable coin or paper money than with valueless notes like the "shin-
plasters" issued during the Civil War. At the time Harnett painted them, "these
bills had [already] been repudiated [in 1875] and were worth exactly nothing
either as legal tender or as collectors' items. . . . Their very name indicates that
they were . . . valueless."[112] German artists in the 1920s were later attracted to
similarly valueless bank notes, as in the case of those who imitated the genuine,
if fantastically hyperinflationary, one hundred billion German mark note of
1924; this bank note's value and valuelessness amounted to pretty much the
same thing (fig. 72).

Fig. 72. One hundred billion mark Reichsbank note, Berlin, 1924. Photograph reprinted by permission of the Deutsche Bundesbank, Geldmuseum, Frankfurt.

By fooling or pretending to fool the viewer into thinking that things unreal were real, trompe l'oeil paper money in America played on and upset the commonsense distinction between real and ideal. In the economist's land of "the real thing," [113] trompe l'oeil paper money matched a Barnumlike "humbuggery." The terms "humbug" and "Barnum" were then common in the trompe l'oeil paper money genre, as in Haberle's painting *Imitation* (fig. 73) as well as in joke notes (fig. 45) and in political discourse generally. [114]

It is but a step from such aesthetic trumping to economic trickery—and counterfeit money. Understanding the relation between substance and sign was complicated in America by the known existence (and frequent acceptance in exchange) of counterfeit bank notes—illegal copies of legitimate money. Indeed, Haberle was suspected of being the famous counterfeiter "Jim the Penman." [115] More significant for understanding the attraction of such aesthetic movements as American symbolism, [116] in an age when literally thousands of private banks issued their own monies there were even notes in circulation drawn on entirely fictive banks. "There were no real banks, no officers, or actual assets of any kind to make these notes by 'phantom' banks of any real value—except the ability to *pass* them on some unsuspecting person." [117] The monetary papers issued by "the Phenix Bank," for example, refer to a bank that

Fig. 73. John Haberle, *Imitation,* ca. 1887. Oil on canvas, 10 × 14 in. Berry-Hill Galleries, New York.

Fig. 74. "Ghost" bank note representing itself as having been issued by "The Phenix Bank" of "Phillipsburgh, Lower Canada," which did not exist, 1857. National Currency Collection, Bank of Canada, Ottawa.

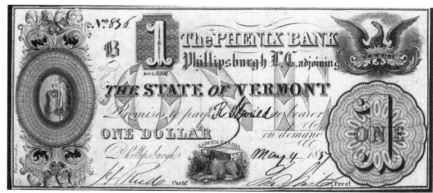

did not exist (fig. 74). Such papers—with their fictional designs, insignia, signatures, and even ciphers—passed for solid specie. Even the "Bank Note Reporters" and "Counterfeit Detectors"—serial booklets purporting to list both counterfeits and ghosts—were themselves counterfeited or fabricated entirely from scratch by confidence men.[118] Ghost notes, counterfeit ghost notes, and phantom notes all passed alike, as in Melville's diabolical *Confidence-Man*.[119] The detective Allan Pinkerton in his *Thirty Years a Detective* writes: "Counterfeiting at the present day is literally one of the advanced arts."[120]

The most economically motivated artist-counterfeiters in nineteenth-century America used printing presses, not oils. They worked on special papers, not canvas. And, we might suppose, many were never found out.[121] They worked not only at the aesthetic expense of their subjects (all representational artwork is, to some extent, an imitation that robs its subjects of their "originality")[122] but also at their economic expense. As an inflationary factor, counterfeits literally robbed their originals of value in the system of monetary exchange.

The authorities drew such a zealous distinction between official and illicit paper that they called even trompe l'oeil works *fraud*—"the use of false representations to obtain an unjust advantage" (or, as Aristotle might say, to obtain an unnatural usurious supplement). They impounded not only counterfeit bank notes but also hundreds of trompe l'oeil artworks, including oil paintings by John Peto and Charles Meurer.[123] Congress even passed a law in 1909 prohibiting all nonofficial copies of monetary tokens except those made by the Treasury, including even those in the form of cookies and hooked rugs (fig. 75). The problem continues to the present day, as popular magazine articles about Boggs's profitable exploits and legal problems love to report.[124]

Artists who play on public confidence by reproducing physical aspects of bona fide monetary tokens (as do trompe l'oeil artists) or by altering the physical aspects of those tokens (as does Wewerka in *Five Mark Piece;* fig. 76) are not, of course, always essentially counterfeiters or clippers. Since humorless or fearful state authorities often prosecute such artists as criminals, however, many would-be trompe l'oeil artists avoid litigation by sculpting or etching mainly fictive pieces that present or represent no existent monetary tokens but instead

Fig. 75. Dorothy Greubenak, *Two-Dollar Bill,* 1965. Hooked wool rug. Collection of Mr. and Mrs. John G. Powers.

Fig. 76. Stephan Wewerka, *Five Mark Piece,*
1973. A part has been cut off. Jürgen Harten Col-
lection. Photograph by Walter Klein, Städtische
Kunsthalle, Düsseldorf. © 1993 The Andy Warhol
Foundation for the Visual Arts, Inc.

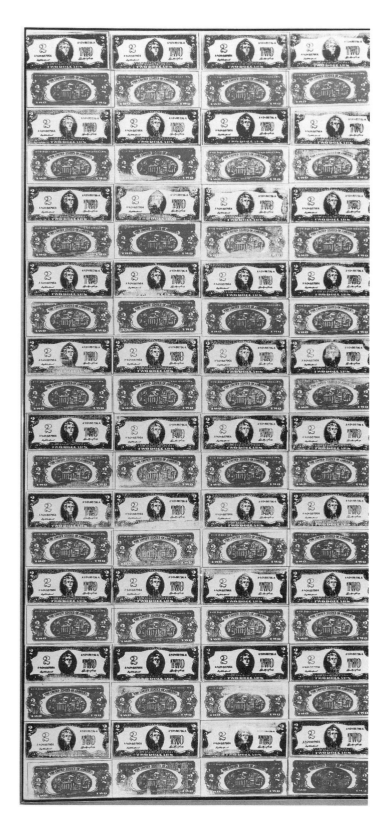

Fig. 77. Andy Warhol, *Eighty Two-Dollar-Bills*
(front and rear), 1962. Museum Ludwig, Cologne.
Photograph from Rheinisches Bildarchiv.

"typify" or "idealize" all of them. Well-known examples appear in Holbein's *Portrait of Jean d'Anvers* and the Swiss illuminated manuscript *Chronicle of Diebold Schilling*.[125] Twentieth-century modifications of such work would include money pieces by Len Lye and perhaps also Andy Warhol's *Eighty Two-Dollar-Bills* (figs. 77, 82). Likewise, there are such artworks where a single bank note occupies an entire canvas as Larry Rivers's *French Money* (plate 7), Roy Lichtenstein's *Ten Dollars,* Robert Dowd's *Van-Gogh Dollar* (fig. 78), Malcolm Morley's *Regatta* (fig. 79), and Pablo Picasso's *Banknote of 10,000 Francs Bearing the Sign, Bank of France* (5 May 1958).[126] The prettiness of this sort of artwork easily deflects attention from the problems of political authority and representation that haunt trompe l'oeil.

Fig. 78. Robert Dowd, *Van-Gogh Dollar,* 1965. Acrylic on canvas, 18 × 36 in. Joni and Monte Gordon Collection, Los Angeles. Courtesy of Newspace, Los Angeles.

Fig. 79. Malcolm Morley, *Regatta,* 1972.
Oil on canvas, 48½ × 96¾ in. Pace Gallery,
New York.

Fig. 80. Carl Frederik Reuterswärd, *Fine Art of
Banking,* 1974–75. (With the electrical engineer
Hans Bjiekhagen.) Bronze and holograph, 57 cm
high × 36 cm diam. Collection of the artist. Photo-
graph courtesy of Städtische Kunsthalle,
Düsseldorf.

The End of the Matter

Money does not draw its value from the material of
which it is composed but rather from its form, which is
the image or mark of the prints.

John Murphy, title of a collage (1976–77)

I should be able to trade in just the ideas rather than the
physical presence.

Edward Kienholz[127]

Laser technology helps to fulfill the aesthetic telos of two-dimensional trompe
l'oeil paper money in that it allows for a near-perfect visual imitation or meta-
physical projection of physical metal and paper tokens.[128] One early example of
this monetary "virtual reality" in the visual realm is Carl Frederik Reuterswärd's
holographic *Fine Art of Banking* (fig. 80).[129] Another is *Laser Art You Can (Al-
most) Spend,* a holograph of a $10,000 bill listed in the mail-order catalog of
America's trendy Sharper Image store.[130] Such artwork is partly the refined out-
come both of the tendency of nineteenth-century trompe l'oeil art toward ever
more accurate reproduction and also of the tendency of twentieth-century art
toward "gestural" money or investment art. Such work figures visually as a de-
materialization of the artwork—an iconoclastic "disenchantment" of art to the
point where art appears, if at all, only as invisible form.

The trend toward dematerialization has been a telling hallmark of
twentieth-century economics as well as visual aesthetics,[131] but it has compelling
historical counterparts in the ancient world. For between the time of the *electrum*
money of ancient Ephesus and that of *electronic* money racing through the
golden circuit boards of the modern bourse (or stock exchange), there has oc-
curred a momentous change. The exchange value of the earliest coins, we have
seen, derived wholly from the material substance (electrum) of the ingots of
which the coins were made, and not from the inscriptions stamped into these
ingots. The eventual development of coins whose politically authorized inscrip-

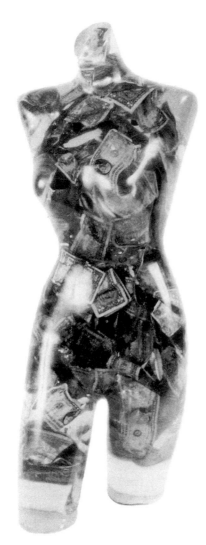

Fig. 81. Arman (Armand Fernandez), *Venu$* (*Venus aux dollars*), 1970. United States dollar bills cast in polyester/polyurethane, 92 × 31 × 27 cm. Collection of the artist. © 1994 Artists Rights Society (ARS), New York/VG Bild-Kunst, Bonn.

tions were inadequate to the weights and purities of the ingots—the origin, says Clemens-August Andreae, of conceptual art as fiduciary object—precipitated awareness of quandaries about the relation between *face* value (or intellectual/ metaphysical currency) and *substantial* value (material/physical currency). This difference between inscription and thing grew greater with the introduction of paper money. Paper, the material substance the engravings were printed on, was supposed to make no difference in exchange; and metal or electrum, the material substance the inscriptions referred to, was connected with those inscriptions in increasingly abstract ways. With the advent of electronic fund transfers the link between inscription and substance was broken. The *matter* of electric money does *not matter*. When presidential decrees took the United States "off gold" domestically in 1933, Budget Director Lewis W. Douglas exclaimed, "This is the end of Western civilization!"[132] (Richard Nixon took the United States "off gold" for international settlements in 1971.)

The electronification of money in the late twentieth century has meant that monetary procedures and transactions are now tracked at the almost non-interest-bearing—because nearly instantaneous—speed of light. (If time is money, electrification means the end of old money.) In the realm of twentieth-century art, this express "enlightenment" has its counterpart in the disappearance of the material from numismatic art—and from art generally. Priscilla Colt thus writes that Ad Reinhardt "push[es] the visible toward the brink of the invisible, . . . logic toward the brink of illogic, . . . the material to the verge of immateriality, inevitably suggest[ing] a link with a transcended level of existence."[133] In Arman's *The Content Is the Money*—dollar bills embedded in a slab of clear plastic[134]—money is the apparent content, as also in his *Venu$* (fig. 81) and his *Yen for Yens* (1990).[135] In Abraham Lubelski's bale of money borrowed at interest, however, it is significantly ambiguous whether it is the visible bale of money or the invisible interest "drawn" from the bale that is the artwork (fig. 82). In Lubelski's work money is at least visible one way or the other. But as Jean Lipman suggests, "in the most radical form of monetary art, called "investment pieces [as exemplified below by Les Levine and Robert Morris], the art is in the transaction—buying stock, receiving interest—and the money itself

Fig. 82. Abraham Lubelski, *Sculptural Daydream*, 1968. A bale of 250,000 one-dollar bills borrowed at interest from the Chelsea National Bank (which in turn borrowed them from the Federal Reserve Bank). The sculpture, exhibited for five days, ran up a bill of three hundred dollars in interest. Exhibition at Chelsea National Bank, New York. The dollar-bill drawing in the background is by Andy Warhol. Photograph from *Time-Life* 67, no. 2 (1969).

may never appear."[136] The money "itself" does not appear because the art is in the supposedly transcendent monetary transaction and leaves no material trace.

This material erasure distinguishes conceptualist money art from the allegorical money of the mind that satirical artists with "social conscience" disparage or praise. The mind is moneyed thus in Nast's *The "Brains"* (fig. 83) and H. L. Godall's cartoon (fig. 84), and the brain is filled with money in Robert

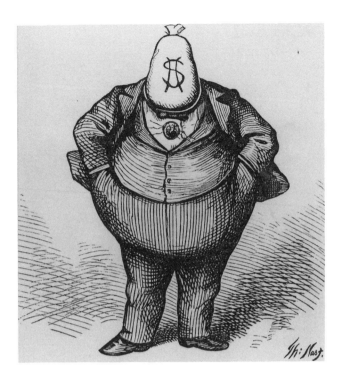

Fig. 83. Thomas Nast, *The "Brains" That Achieved the Tammany Victory at the Rochester Democratic Convention, Harper's Weekly,* 21 October 1871. Courtesy of Library of Congress, Washington, D.C.

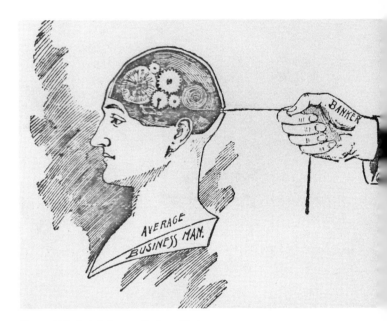

Fig. 84. H. L. Godall, *Average Business Man's Mechanical Brain Being Controlled by Banker,* 1896. Harvey, *Coin's Financial School,* 116. Harvard College Library.

Fig. 85. Robert Morris, *Brain,* 1963–64. Leo Castelli Gallery, New York.

Morris's *Brain* (fig. 85). The entire ghostly *corpus Christi* becomes a piggy bank or purse for monetary tokens in Sergey Eisenstein's project for a safe (fig. 86).[137] "Credit is to business," said John Law, "what the brain is to the human body."[138] "Where thy treasure is, there will thy heart be also"—that inscription, says William Blake in his 1789 annotations to *Lavater's Aphorisms on Man,* "should be written in gold letters on our temples."[139]

Investment art itself is represented in Morris's anti-material and pro-procedures work *Money* (fig. 87). It exhorted artists "to renounce the object because of its commercial commodity value"—as did also Morris's "Notes on Sculpture: Beyond Objects."[140] As Lipman writes, the procedures for the artwork titled *Money,* exhibited at the Whitney Museum's show *Anti-illusion: Procedures / Materials* in Spring 1969, were: "arranging a $50,000 loan from a collector to the Whitney Museum; the museum's transferring the sum to the Morgan Guaranty Trust as a time certificate of deposit; and the company's paying 5 percent interest for the duration of the show to the collector, and the collector to the artist. The materials consisted of the exhibited framed series of letters involved in the transaction with the Whitney's nonnegotiable promissory note to the lender for $50,000 plus 5 percent interest."[141] Les Levine's artful stock transaction *Profit Systems One* (fig. 88) is similar to Robert Morris's work. According to Levine, his "post object work . . . has no visible form."[142] The essay "Prophets with Capital Ideas" points out that Levine too intended to leave no trace; he made the profit, garnered from an "actual" economic transaction, into art. Lipman writes: "The publicity release describing Levine's investment in 500 shares of Cassette Cartridge Corporation stock and the confirmation slip for the securities transaction were mounted on a large sheet of paper, which was signed by the artist and then photographed for reproduction. This piece, however, is only a by-product of the transaction; the press release states that "the profit or loss of the transaction will become the work of art."[143]

Similar to such artworks are those whose only material is the receipt or bill for (other) materials that have disappeared or dematerialized. Rafael Ferrer's entry for the Whitney's *Anti-illusion* show thus consisted of "fifteen large cakes of melting ice." Ferrer commented that "if anyone complains that it's not collectible art, I'll send them the bill for the ice as a kind of drawing." (In this line

Fig. 86. Sergey Mikhaylovich Eisenstein, untitled.
Pen-and-ink drawing, 28 × 22 cm. In *Aus dem Le-
ben der Apostel* (Mexico, 1931). Moscow State
Archives.

Fig. 87. Robert Morris, *Money,* 1969. Eight typewritten letters and one bank check. Leo Castelli Gallery,
New York.

Fig. 88. Les Levine, *Profit Systems One,* 1969.
Photograph courtesy of Collection S.C., Montreal.

FEBR. 1977 ISSUE OF **engels & es mind-shares**
$ 100.- or $ 1000.- or $ 10.000.-

by
ES' worldwide wandering GALLERY postbox 9140 amsterdam
on behalf of

ENGELS & ES (BRAIN-SQUAD AGAINST MASS-COMMUNICATION & MEDIOCRITY) B A M M

WHAT ABOUT INVESTMENT WITH 101 MENTAL PROFIT GUARANTEED
right on the moment you really do this action — instead of your usual investment
with the one and only purpose to gain substantial profit/

+
– BE A REAL SNOB/
 or
– BE A REAL ARTLOVER/

+
/ do not waste your money by buying a mondriaan or an yves klein, because
you did not invest in these beautiful artists but in an (art) trade and be aware
of the fact you did not see them (it) in time/

+
/ ENGELS & ES will give you the opportunity to 'correct' your conditioned
attitude or your (possible) earlier mistake and they will let you invest in an idea
in a mentality of artists which have as an aim to do their art in an uninhibited
exuberant way and averse to dictated or fashionable waves/

+
/ besides your signed and registered share (S 100.–. or S 1.000.–. or S 10.000.–).
you do not get any further material — on purpose — because ENGELS & ES
will guarantee you a profit on an other level — the level of your mind/

+
/ so — be a real snob be a real artlover and return the enclosed card to ES'
(worldwide wandering) GALLERY and mention which MIND-SHARE you
want to purchase and the reason why/

$ 10.000,-
101% mental profit

name buyer/

reason of purchase:
／I am a real snob
／I am a real artlover
／I am sure this share will bring money
／(mark your choice)

issued febr. 1977 by ES' worldwide wandering GALLERY

mind-share
to support

engels & es
(brain-squad against mass-communication & mediocrity)
B A M M

$ 1.000,-
101% mental profit

name buyer/

reason of purchase:
／I am a real snob
／I am a real artlover
／I am sure this share will bring money
／(mark your choice)

issued febr. 1977 by ES' worldwide wandering GALLERY

mind-share
to support

engels & es
(brain-squad against mass-communication & mediocrity)
B A M M

$ 100,-
101% mental profit

name buyer/

reason of purchase:
／I am a real snob
／I am a real artlover
／I am sure this share will bring money
／(mark your choice)

issued febr. 1977 by ES' worldwide wandering GALLERY

mind-share
to support

engels & es
(brain-squad against mass-communication & mediocrity)
B A M M

Fig. 89. Pieter Engels, *Mind-Shares,* 1965–
sued February 1977 on behalf of Engels & E
(Brain-Squad against Mass-Communication
Mediocrity). Worldwide Wandering Gallery, A
sterdam. Artist's collection. Photograph cour
Jürgen Harten.

there are also such works as Pieter Engels's *Mind-Shares,* which are marked "$10,000—101% mental profit" [fig. 89], and Yves Klein's check-paintings titled *Zones de sensibilité picturale immaterielle.).*[144] Likewise, performance art involving begging for money or freely distributing money seems to disrupt ordinary economic exchange: "To distribute money," says Jonier Marin, "is for me a form of art. My program MAS [Money Art Service] aims both to sell money at half price and to throw it into the streets. When I give a bank note to a passerby, I create a contact between the person who receives the money and myself, and this act is simultaneously an artistic and a critical fact."[145]

Such art does not, of course, eliminate the monetary aspect from art, even in its most extreme transactional form:[146] the aesthetic asceticism of conceptualism proves impossible to sustain, or the dematerialist goal of conceptualism proves inherently contradictory. The early work of Hans Haacke is instructive here, since it attempts to eliminate the artwork as "object" or "commodity" even as it idolizes that work. Haacke's "surreal estate" panels often display the history of ownership of particular real estate plots or artwork. (One museum director refused to display Haacke's work about the ownership of a painting that a member of the museum board had obtained under purportedly suspicious circumstances; the director protested, perhaps too much, that "a museum knows nothing about economic power; it does indeed, however, know something about spiritual powers.")[147] Haacke's general tendency to deal with the "ills of capitalism" by parodying them helps to explain why his later work has fallen to satirizing commercial advertisements and conservative economics.

Likewise the minimalist sculptor Carl Andre, once notorious for selling minimalist sculpture at high prices, defended himself against the conceptualists who argued that he was in effect getting something for nothing—maximum for minimum. Andre called his critics hypocritical: "The most farcical claim of the conceptualizing inkpissers is that their works are somehow antibourgeois because they do away with objects. In fact, doing away with objects and replacing them with such reifications of abstract relations to production as stockshares, contracts, and paper money itself (which is nothing but the fetishization of the idea of exchange value severed from even the dream of production) is exactly the final triumph of the bourgeois revolution."[148] (Nowadays one rallying cry

115

of self-styled conceptual artists who attempt to put their artwork on the stock market is: "Art as stock. Stock as art.")[149]

In the "art world" of the 1960s and 1970s many artists did thus attempt to "decapitalize" art. But predictably, what followed the ascetic critique of art as money was a frenzy of buying in which art was comfortably traded or treated as money.[150] The reeling prices of artworks in the 1980s—a period of excess capital and demand for nonascetic goods—recall those of the traditional relic-and-icon markets in medieval Christendom.[151] But instead of the esoteric Christian linkage between art and wafer-god, there was now a pseudosecular esoteric legitimation of art as money. That legitimation had been tracked—and willy-nilly encouraged—by a purportedly iconoclast art movement's own critique of all art, including itself, as surreal money.

The mysterious fortunes of the aurally sacrificing van Gogh—a single one of his paintings sold in the 1980s for $82 million—may be instructive here for studying the extravagance that followed iconoclast asceticism.[152] Van Gogh had shunned the capitalist mammon of the marketplace: he dedicated his painting to "ordinary people" and tried to found "a cooperative community of artists" where painters would exchange paintings with one other as a sort of currency.[153] Likewise he shunned chrysography or gold painting.[154] He used instead various shades of yellow—not so much because he could not afford liquid gold (though he probably could not) as because gold leaf represented a medieval, ecclesiastical tradition that had conflated the "extrinsic" value of color with its "intrinsic" quality in the pictorial tradition.[155] Yet the light of the sun and its haloed apostle the sunflower auratically suffuses his work[156]—and where it does not, van Gogh sometimes recommends a gilt frame.[157] "A sun flood[s] everything with a light of pure gold," he writes to brother Theo of his sun-suffused painting of the wheatfield behind the mental asylum where he was a patient;[158] the solar color is golden even as the sun is a Grail-like source of all wealth.[159] Van Gogh's work helped to change the aura of art even as the art markets of the 1980s turned his painted suns and flowers into best-sellers and cultural criticism turned his lopped-off ear into intellectual fodder.

In his catalog essay for the 1968 exhibition *Anti-illusion: Procedures/Materials*

at the Whitney Museum, James Monte wrote that "materials alone possess . . . shamanistic artistic properties." For Monte, it is sometimes as if the money devil's combination of spirit and matter would be destroyed simply by purging art of anything material or any material thing. Matter is unlikely to be expunged from the realm of art, however. And art is unlikely to get over its quandary even in the realm of external economics until art—as if it could—redefines itself in relation to spirit in such a way that art still matters.

F O U R

C O N C L U S I O N

No Kapital on art has yet been written.

Meyer Schapiro[1]

Accounting for Art

*A*rt & Money, as it gathers together impressions and representations of artworks and artifacts generally kept separate, may appear to some readers like an outlandish catalog—a museumlike repository of trivial anecdotes and facts or a Ripley's "Believe It or Not." I might go so far toward razzing this aspect of *Art & Money* as to compare it with Barton Benes's *Money Museum* (fig. 90), a framed cabinet displaying sixty-four kinds of monetary objects, or with Guillaume van Haecht's seventeenth-century *L'atelier d'Apelle* (fig. 91), a painting that exhibits myriad paintings for potential sale or exchange (fig. 92). In fact, van Haecht's *L'atelier* has a relation to *Art & Money* very much like that of David Teniers's painting *Gallery of the Archduke Leopold of Brussels* (with its scattered collection of artworks) to André Malraux's art book *La monnaie de l'absolu* (The money of the absolute), for which "museum without walls"—a bibliothecal gallery of paintings—Teniers's work provides the appropriate frontispiece.[2]

One of the paintings-in-the-painting displayed in *L'atelier d'Apelle* is Quentin Metsys's *Money Changer and His Wife* (plate 8).[3] (A photograph of the original appeared on the dust jacket of my book *Money, Language, and Thought*.) *The Money Changer and His Wife* expresses the celebrated antagonism between religion and commerce—on which timeworn idea depends much analysis of seventeenth-century Netherlandish, Belgian, and northern French painting[4]—less than it indicates a delicately balanced confusion of them.

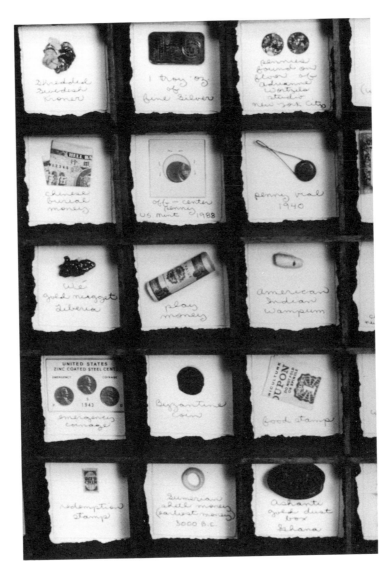

Fig. 90. Barton Benes, *Money Museum* (detail),
1990. Mixed media with money, 42½ × 42½ × 3¾ in.
Photograph courtesy of the artist.

The commonplace motif of a man and woman at a shop counter informs *The Money Changer and His Wife* just as it conditions Uccello's *Profanation of the Host* and Dubreuil's *Don't Make a Move!* (plates 1 and 6). However, Metsys's *Money Changer* not only presents both a religious "desk scene" and a secular one but also challenges customary distinctions between religious and secular realms—that is, between what is God's and what is Caesar's. On the one hand, typical desk scenes show a wife helping her husband to track commercial deals, like the bargain the two people in the door frame in *The Money Changer and His Wife* may be discussing,[5] or to keep an account book, like the tome on the shelf. (Account books—a subject I will soon turn to—are important in such other desk scenes as Bassano's *Portrait of Orazio Lago and His Wife* and Jacobsz's *Portrait of a Merchant and His Wife* as well as Marinus's allegorical *Two Tax Gatherers* and parodic *Banker and His Wife;* figs. 93 and 94.)[6] On the other hand, religious desk scenes often present a devout woman balancing a child arm-in-arm with a sacred book, as does the mother in the gilt-framed illumination in the wife's book, or they show a contemplative person by a window frame with church spire, like the person reflected in the gilt-framed mirror in Metsys's work,[7] or they represent a human being or God weighing out the sins of humankind in the balance, like Saint Eligius in Petrus Christus's painting (fig. 68).

However, the main attraction of *The Money Changer and His Wife* is neither its profane aspect nor its sacred, but rather the way Metsys frames a balance of mammon and God taken together. In the painting as a whole, for example, the twinlike figures of man and woman are balanced against each other on the left and right. Various segments of the painting have the same triangulated composition. Thus the wife's gaze oscillates between profane money balance on the left and sacred religious book on the right. (She turns from book to money in much the same way that the tax collector Saint Matthew, in Hendrik Terbrugghen's *Calling of Saint Matthew,* turns from the money he was counting to the god-man he will follow.)[8] Similarly, the balance and book present identical mechanical triangulations: the man operates a hingelike scale, allowing its left or right arm to rise or fall; and the woman, with markedly kindred fingers, operates a hingelike book binding, turning the page to the right or left. (Or do the balance's arms and the book's pages rest motionless?)

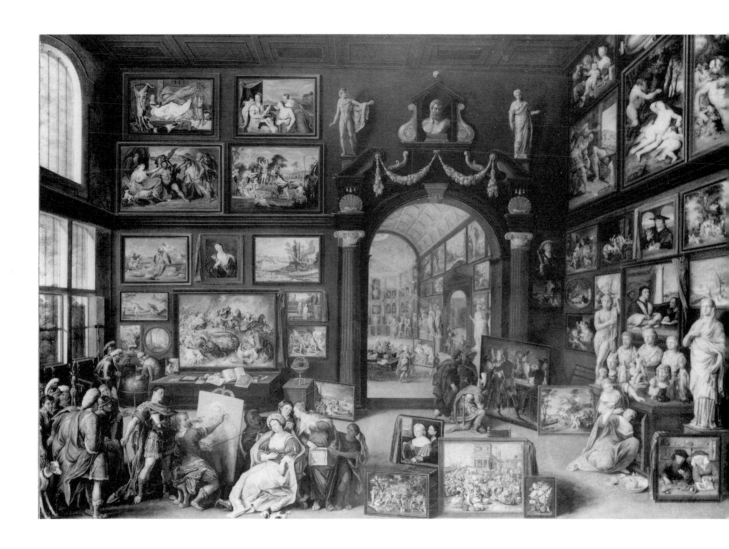

Fig. 91. Guillaume van Haecht, *L'atelier d'Apelle,* 1628. Museum of The Hague (House of Prince Maurice).

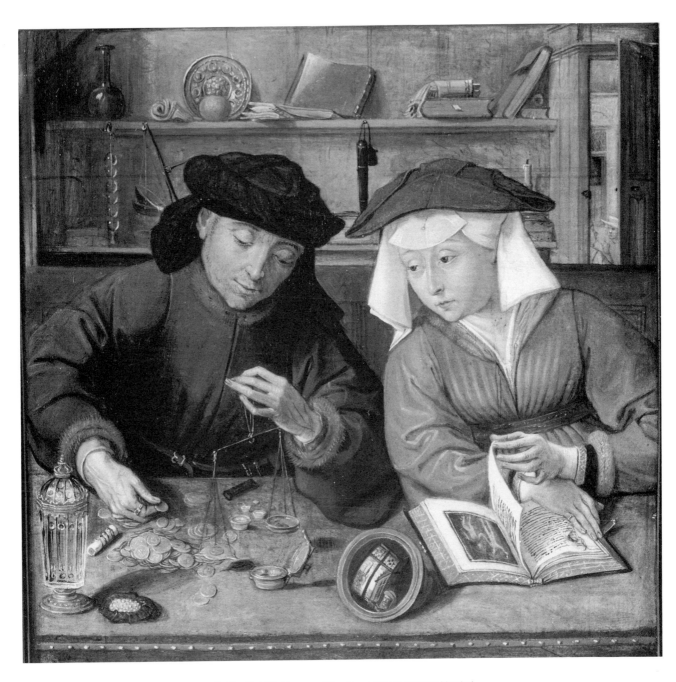

Fig. 92. Guillaume van Haecht, *L'atelier d'Apelle* (detail), 1628. Museum of The Hague (House of Prince Maurice).

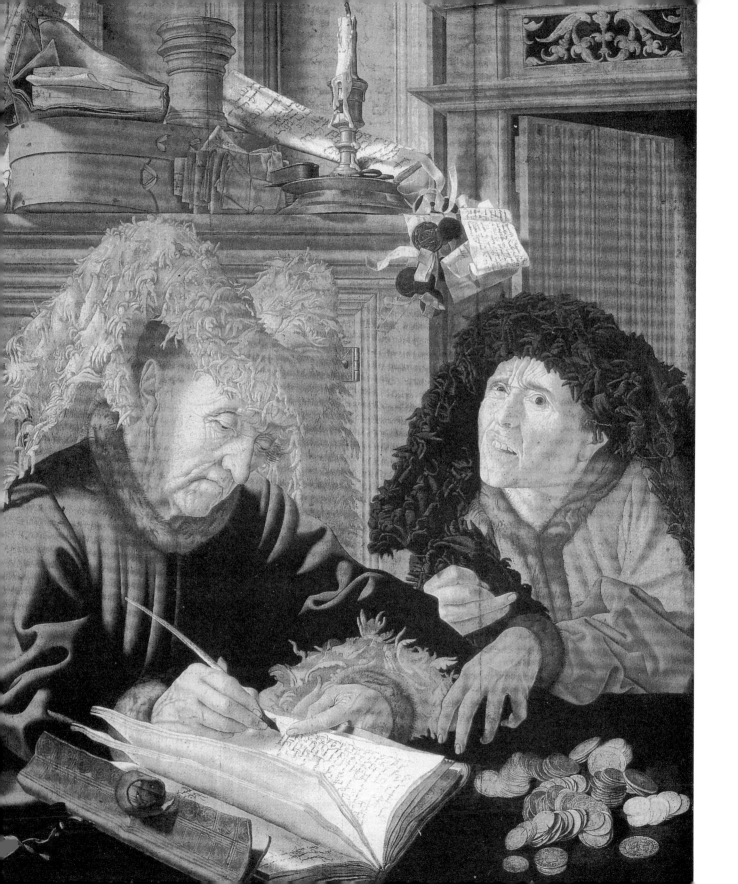

Fig. 93. Marinus van Reymerswaele, *Two Tax Gatherers* (*Two Bankers in Their Office*), 1526. Oil on wood, 92.1 × 74.3 cm. National Gallery, London.

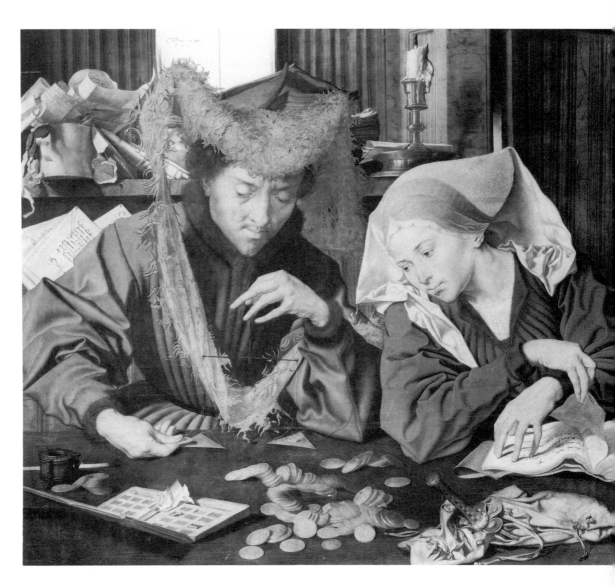

Fig. 94. Marinus van Reymerswaele, *The Banker and His Wife,* 1539. Oil on wood, 93 × 111 cm. Museo del Prado, Madrid.

The extraordinary mirror in *The Money Changer and His Wife* is also hinge-like, a fulcrum helping to redirect not mass but light. And for the eye's line of sight it has a trick or two: many viewers are trumped by the mirror's variable angles and some cannot tell whether its surface is convex or concave.[9] This balanced ambiguity suggests, without actually requiring, that the mirrorlike object be understood not only as a mirror surrounded by a gilt frame but also as a painting-in-a-painting of a trompe l'oeil mirror together with a trompe l'oeil frame. The golden color and round shape of this frame, near the intersection of the painting's horizontal axis (the hingelike fold in the green fabric on the desk) with its vertical axis (the crease in the middle of the canvas), links visually the gold coin (*aurum*) of the husband with the gilt halos (auras) of Mother and Child.[10]

Metsys's Mother (in the illumination) contrasts markedly with the wife: the Mother balances her sacred book arm-in-arm with the Child while the wife, who is conspicuously childless, hardly manages her ocular seesaw between sacred book and money. Perhaps the wife's equivocal attention to unnatural money business explains her natural childlessness. (Churchmen and medical doctors of the fifteenth century—the likely period for this painting's anachronistic clothing and moneyer's equipment—believed that moneylenders' wives were often childless because usury, or the unnatural production of monetary offspring, ruled out natural production of human offspring.)[11] Yet the wife's attention to auriferous coin also recalls, as we have seen, the Virgin Mother's mysterious generation of an auratic god-man who is both natural and nonnatural, or supernatural. In this way Metsys's variation on the sacred or profane (offertory or financial) desk scene motif dovetails with a simultaneously divine and numismatic permutation of the Mother and Child motif.

The Money Changer and His Wife invokes not only secular paintings of numismatists and bankers[12] but also such religious paintings of holy men with minters' scales as Petrus Christus's *Saint Eligius and the Lovers,* with its gilt-haloed mint master weighing out gold coins (fig. 68).[13] In keeping with the saintly tradition of such works, the painting that is Metsys's balancing act originally had a gilt frame with some such Old Testament inscription as "You shall have just

Fig. 95. South German manuscript, fifteenth century. Wellcome Institute Library, London.

balances" or "A just balance and scales are the Lord's—all the weights in the bag are his work."[14]

Balances were among the instruments Jesus cleared from the temple, but they were also often considered sacred, as when the true cross appears in the form of the holy balance in fifteenth-century manuscripts (fig. 95).[15] Such appearances recall how a scorekeeping angel with a scale kept track of the victim's suffering on the cross—"measuring each individual wound and writing down the passion of the martyr Romanus [in an account book] while it [was] in progress."[16] ("Oh that my vexation were weighed, and all my calamity laid in the balance," says Job in the Old Testament book that tells the account of his Christ-like suffering.)[17]

127

The Christian God is not only the Son whose sufferings on the cross have to be counted and crossed out. (Christ died to redeem sins and cancel debts.) He is also the Father, or chief accountant. Fifteenth-century thinkers identified the relation of a sinner to God with that of a customer to a shopkeeper,[18] drew parallels between a trader's epistolary correspondence with an unseen foreign customer and a prayerful person's petitioning God for eternal life,[19] and suggested that God is essentially a money-changing banker.[20] (In this context God is sometimes understood as the creditor of life—or death: "We owe God a death.")[21] A frequently cited text is the parable of the talents, where the masterful banker-God entrusts money to his servant and then demands both the principal and monetary interest (*tokos*).[22]

The sacrificial lamb—appearing in *The Money Changer and His Wife* in the decorated initial in the wife's illuminated manuscript—is the linchpin of Christianity's spiritual economy of debt and guilt. The celebrant at the Eucharist puts it thus: *Agnus Dei, qui tollis peccata mundi*—"Lamb of God, who sublates the debts of the world." (The verb *tollere, sublatum*—much admired by German idealist philosophers, who translated it as *Aufhebung*—has economic meaning as "cancellation and cashing in" and alimentary meaning as "incorporation and transcendence.")[23] When Christ chases the money changers from the temple, he sublates all debts, as suggested by the cancellations in the money changer's account books in *The Cleansing of the Temple* (fig. 96).[24] But beyond this cancellation of the temple tax, God the Father cancels all obligation to provide "redemption money"—the tax paid by fathers for the birth of their firstborn sons, not the assessment paid by sinners for indulgences—when he provides his Son.[25] This reassuring mix of numismatic and divine categories helps dispel the old tension between God and mammon and, in Metsys's *Money Changer and His Wife,* it spells out to a degree its delicately unfamiliar balance of wife with husband or Mother with Child.

The Money Changer and His Wife, with its trompe l'oeil depiction of books and counters, is markedly akin to artworks "meant" to cover account books—that is, intended as account book covers. Among these are the painted wooden covers of the old treasury registers of the medieval commune of Siena known as

Fig. 96. Northern French school, *The Cleansing of the Temple,* ca. 1470. Sold at Sotheby's 28 March 1979. Photograph in author's collection.

the *Tavolette dipinte della biccherna e della gabella.* At first the account books of the gabella, or excise office, were "bound in plain boards with leather thongs. In the middle of the thirteenth century, the plain surfaces of these boards—curiously enough," says a puzzled Diringer, "on books dealing with taxes, fines, contracts, salaries, and wages, etc., on which nobody today would expect illumination or decoration—gave place to a series of painted decorations."[26] (Many are desk scenes showing accountants, scribes, and payment of wages; fig. 97.)

At Siena the series of book covers spans half a millennium, beginning in the early thirteenth century, and it includes works by such well-known painters as

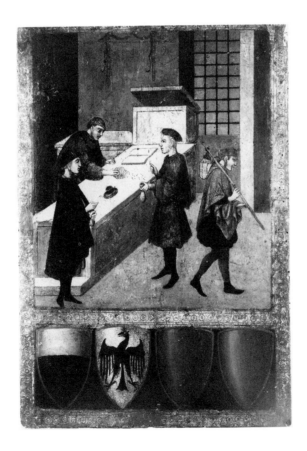

Fig. 97. Sano di Pietro, *Payment of Wages,* 1430. Archivio di Stato, Siena.

130

Ambrogio Lorenzetti.[27] Over the decades and centuries, the miniature portraits of Sienese accountants were enlarged, removed from the covers where they seemed "properly" to belong, and hung on walls. The moment of wall hanging was significant to the historical development of portraiture.[28] A classical analogue would be the appearance, on the widespread works of art that are coins, of "portraits" of human figures who are neither royal, like the European kings, nor divine, like Christ and the saints.[29]

The *tavolette* are linked with the subject contents of the books they cover, or are "meant" to cover, in much the same way that monetary inscriptions are linked with the material content in which they are inscribed, or are meant to be inscribed. Understanding a cover thus requires considering it in relation to the thing covered, much as understanding an inscription requires considering it in relation to the thing inscribed, as Lessing suggests in his essay on epigrammatology.[30] However, some inscriptions are written on one material but might also stand "properly" on some other material. For example, Wordsworth's poem "Lines Left upon a Seat in a Yew-Tree" belongs better to a seat in a yew tree than to the paper where we usually see it. In the same way, a book cover might find itself pinned to the wall but pining for its real or ideal book. (The contradiction here between "actual" and "proper" location gives rise, as we have seen, to such devilishly iconoclast artworks as Magritte's *This Is Not a Pipe;* fig. 51.) By the same token, a monetary inscription like "This is one pound" may be printed on a piece of paper together with which it becomes paper money, or it may be impressed into a metal ingot together with which it becomes a coin. The transformation into money by virtue of some such apparently absurd inscription as "This is one pound" is the brunt of the ninth-century Stephen's iconoclasm and the twentieth-century Duchamp's jesting; it is a transformation that encourages writers like Clemens-August Andreae to see the essence of art in a lack of adequation between spiritual *intellectus* and material *res.*[31] It is not surprising that conceptual artists should view the first coin engraved with the numeral 2 as the earliest conceptual art. In minting a coin, after all, a fiduciary dissociates symbol from thing: the inscription 2 merely underlines the distinction, as expressed visually in Stankowski's *One Becomes Two* (fig. 1). (One practical political aspect of this monetary "twinning" is emphasized in Nast's

Inflation Is "as Easy as Lying"; fig. 66.)[32] Be that as it may, a coin, like a number—a *nummus,* like a *numerus*—is always both an intellectual symbol and a real thing: as a monetary unit it has ordered symbolic properties, as has a numeral; but as an ingot it has material properties, as do all things—or perhaps all things but One.[33]

The Money Changer suggests, by virtue of its opposition of chrysographic book to golden coin, or its artful balance of them, the numerical *ordo*[34] of Renaissance Neoplatonism, especially in its biblical formulation as balanced economy and equilibrium: "Omnia in mensura et numero et pondere disposuisti" (You, O God, arranged all things by measure, number, and weight).[35] Leonardo da Vinci, a contemporary of Metsys and an admirer of the painter Piero della Francesca's fifteenth-century *Treatise on the Abacus,*[36] says in his *Treatise on Painting:* "Let no one who is not a mathematician read my words."[37] Often in such works as Metsys's *The Money Changer* we are struck by what Baxandall calls the "continuity between the mathematical skills used by the commercial people and those used by the painter to provide . . . lucid solidity."[38] This continuity is a subject of *Divine Proportion* (1509), a work addressed to painters and mathematicians by the theorist of accountancy Luca Pacioli.[39] Pacioli's *Summa de arithmetica, geometria, proportioni et proportionalita* (1494) had introduced the theory and practice of double-entry bookkeeping.[40] Goethe, considering the aesthetic implications of economic form, called Pacioli's intellectual creation of double-entry bookkeeping one of "the finest inventions of the human mind"[41]—and Oswald Spengler, looking to the cultural dimension of changes in business computation and its theory, agreed.[42]

Pacioli suggests in his "On Computation and Writing" that there is an aesthetic and fictive quality to what bookkeepers and coinkeepers have called the "personification of accounts."[43] His observation bears on understanding how account books, in their numerical and visual presentation of material, constitute an "*artificial* mirror" comparable to such paintings as those that adorn the *gabella* and *biccherna.* Colinson in his *Idea rationaria* writes that bookkeeping gives a statement "to men of trade, that in ane Instant [they] can see (as he doeth his Person in a *mirror*) his whole estate and in what posture it is in at the time."[44]

North in his *Gentleman Accomptant* argues that "Arithmetick to Book-keeping is, as Language to Oratory."[45] North would pack off the economics of the balance sheet as an aesthetic activity. The accountant art dealers in Guillaume van Haecht's *L'atelier d'Apelle* (fig. 91) similarly would pack away for some sort of commercial exchange Metsys's *Money Changer and His Wife*.

What Still Matters

> But this rough magic
> I here abjure.
>
> Shakespeare, *The Tempest,* 5.1.49–50

How art and commerce came habitually to be regarded as symmetrical or commensurate involves both the aesthetic anxiety (linked with beliefs about God) that monetary form is intrinsic to art and the economic anxiety (linked with theories of adequation and representation) that aesthetic form is intrinsic to money. Christians, we have seen, believe generally in a God both universal (like the Jewish and Moslem God) and incarnate (like the Greek gods); and so for many Christians money, which is both an inscription and an inscribed thing, was not easy to understand in terms other than as a Christlike iconic principle competing like the Gygean devil for God's place in the world. It is thus not surprising that Europeans were often incredulous about and fearful of such institutions as the Arabic *sakh* (or blank check) in much the same way that they were credulous about and desirous of the Holy Grail; or that Philip II, awestruck by the gold specie of his South American empire, claimed to understand nothing about what he called "ghost money."[46] Because of this general resistance to fiduciary modes of representation and production, the past millennium is the story of the introduction and acceptance of aesthetic and capital institutions and intellectual processes involving both *confiance* and finance. The story, just now ending, would take a reluctant Christendom, restive in religion and invention, from the age of electrum to that of electricity.

133

But electricity hardly marks the end of the matter. In defining the relation between art and money in terms of the epigrammatic interaction between spiritual *intellectus* and material *res,* I have shown how it comes to seem that money becomes, or is, art and that art is, or becomes, money; and I have also suggested how, in the theological terms that masquerade as "secular," the iconology of money and the economics of visual art converge. "There are in all only two ways into which our needs divide," wrote Stephane Mallarmé during the Panama financial crisis of the 1890s, "that is, aesthetics, on the one hand, and also political economy."[47]

Grand-Carteret wrote in the 1890s that "it is better to idealize commercial things than to commercialize aesthetic things."[48] And many critics in the twentieth century have gone very far in this idealization. Thus Lewis Hyde, in an uncanny aesthetization of the principles of Mauss's *The Gift,* adapts the "two separate realms" theory (God versus mammon); he substitutes for the hypothesis of a free and infinitely large gift emanating from God that of the artwork residing in the individual artist, and thus defines "art" in opposition to "market exchange" in such a way that art provides (as he supposes) a solution to the alienating problems of market exchange. In similar fashion, Robertson suggests that "it was the aesthetic . . . abstraction of profit that first made the concept of capital possible."[49]

The hypothesis of art as a blank check to be drawn by the artist on "the Bank of the Imagi-Nation" (fig. 56)—much as blood might be drawn from the body of God—also informs artists of wit. Campbell Mac Phail produced his *Bank of Anti-money* stamp in 1973[50] and Jeannet manufactured his *Monnaie d'artiste* in 1976 (fig. 98). In May 1968, even as workers and students "demonstrated" in Washington and Paris, the magazine *Avant Garde* held its "prophetic" paper money contest, for graphic artists to "revaluate the dollar." *Avant Garde*'s description of its subsequent exhibition reads: "Here are what you might call some new species of money, coin of another kind of realm—the artist's imagination."[51] (One of the "winners" was James Spanfeller's psychedelic hippie depiction of flowers growing up through a dollar bill; fig. 99.) And in 1988 Collaborative Projects, Inc., held its *Check Show,* a collection of "artist-made

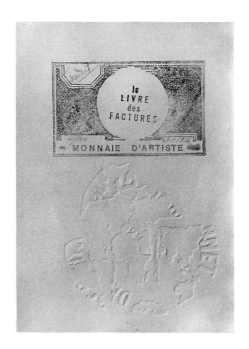

Fig. 98. Jeannet, *Le livre des factures—Monnaie
d'artiste,* 1976. Book edition, Paris. Private collec-
tion. Photograph courtesy of Städtische Kunst-
halle, Düsseldorf.

checks" at Citibank of New York.[52] In a misbegotten trashing of all "culture,"
everything appears diminished.

As doctrinal religion withers, its nexus of money with art remains, but it
remains misunderstood. Like ancient beliefs in the rivalry between God and
mammon, customary convictions about the difference or sameness of art and
money remain habitual approaches to the very problems that these convictions
create—including versions of the puzzle that art is both an "ideal" object and a
"real" commodity.[53] Lucid commentators since the development of coinage in
ancient Greece have sought in various ways to discourage careless thinking in
this domain. Aristotle, for example, calls the numismatic impression (*charaktēr*)
on a coin both natural and conventional: it is both a "natural" likeness of the
original punch die—in the same way that mental impressions (*pathēmata*) are the
natural likenesses (*homoiōmata*) of the soul—and a "conventional" epigram-

135

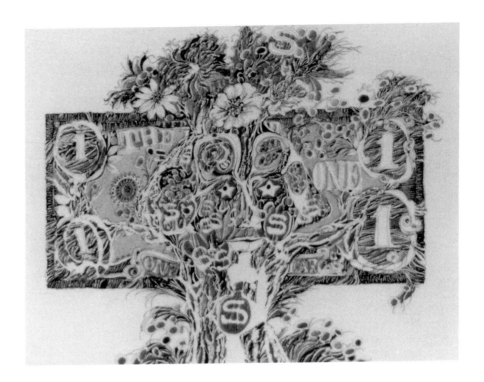

Fig. 99. James Spanfeller, *Psychedelic Bank Note*. 5 × 5 in. From *Avant Garde,* May 1968, 5. Amherst College Library. Photograph by Don Milliken.

matic symbol (*seméion*) of the issuing authority.[54] Confusion about coin (*nomisma*), Aristotle suggests, perverts nature and reflects convention (*nomos*).[55] Although Moses Mendelssohn in Enlightenment Germany works from no such view of nature, he nevertheless warns in his *Jerusalem* that coins as monetary signs—much like words as alphabetical signs—are too easily made into idols of the mind.[56] In this broad historical context Walter Benjamin, in his "Work of Art in the Age of Mechanical Reproducibility," only seems to leap out of bounds when, instead of focusing on the mechanical reproduction of coinage in the ancient and modern worlds, he explicitly relates photography to statistics and tries thus to pinpoint one articulation of "superstructure" (artistic production) with "substructure" (economic production).[57]

Benjamin wrote "Mechanical Reproducibility" in the 1930s, during a period of mass anti-Semitism that affected, sometimes to the point of death, such

136

other thinkers whose views help to inform *Art & Money* as Marc Bloch, Sigmund Freud, Max Friedländer, Marcel Mauss, Erwin Panofsky, and Meyer Schapiro. In this essay, Benjamin examines fascism's particular way of aesthetizing politics and confusing economic with aesthetic representation.[58] (It is in this timbre that Grand-Carteret discusses "idealiz[ing] commercial things.")[59] Benjamin wrote the other work I have cited, "Tax Advice," some years earlier in the 1920s, during a period of outlandish monetary inflation (see the bank notes in figs. 49, 50, and 72) and philosophical attention to the link between money and authentic intellectual validity (*Geld* and *Geltung*).[60] In "Tax Advice" Benjamin quips about the "genuine" bank notes of Europe that "nowhere more naively than in these documents does capitalism display itself in solemn earnest."[61]

The same is true about "genuine" artwork. The representative artists I have considered in *Art & Money* toe a boundary line both separating and joining the realms of aesthetics and economics, some seeking to erase or rise above the line and others selling their artful check marks at face value. In contemporary art, as we have seen, dissociations of ideal from real have become cherished conceits. The outcomes, unfortunately, are often more cute than acute.

Some contemporary artworks would put into focus traditional misunderstandings of art as money as art, as we have seen, and others would present monetary tokens as symbols within a process of general exchange. However, whether art itself is up to the task of enlightening us about—hence loosening—the various knots of aesthetic, political, and economic belief is hardly an open question. Nor will there be what Schapiro calls a "*Kapital* on art," no matter the presence of "cultural histories" of money with titles like *Art as Capital Investment*[62] and artworks with titles like *Art = Capital* (fig. 100).[63] (Marx's *Kapital* is already artful, and art is not exactly capital.) In ways not generally understood, art and money are both at odds with each other and at one.

This vexed relation between visual art and money is no small affair. It reaches to the heart of intellectually and psychologically freighted preoccupations with associations of mind to matter (the main subject of chapter 2) and of representation to exchange (the subject of chapter 3). And for millennia—from the eras of Roman god-men and Byzantine iconoclasts to those of Flemish

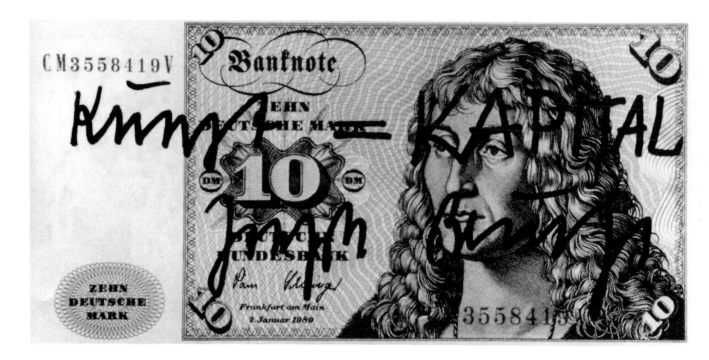

Fig. 100. Joseph Beuys, Art = Capital (*Kunst = Kapital*), 1979. Editions Klaus Staeck, Heidelberg. © 1994 Artists Rights Society (ARS), New York/ VG Bild-Kunst, Bonn.

money changers, German philosophers, and American trompe l'oeil and conceptual artists—it has had extravagant political significance. It variously informs the rhetoric that defines money expeller against image rejector (Christian against Semite) and religious world against secular world (God against mammon), encouraging recurrent transformations of the fear that God is monetary (or the desire for him to be monetary) into ruinous enmities toward self and others and supporting frequently calamitous institutions of financial and political confidence.

For all that, the issue of images—the expression of the aesthetic iconology of money together with the economics of art—remains a life-and-death matter. The need is urgent for reworking the history and theory of art and of money. If the vexed relation between aesthetics and economics discussed in *Art & Money* is to be better understood, the first step may be to resist, where art and money are concerned, coming to easy terms.

NOTES

One Introduction

1. "One thing is clear: when vast sums of money are attached to works, their artistic merit becomes confused with their value as commodities" (Young, "Masterpieces and Millions," 41). Precisely how that confusion occurs, if it does not already exist, is not so clear.

The current record high price for a work of art sold at auction is $82.5 million, the amount Ryoei Saito paid for van Gogh's *Portrait of Dr. Gachet* at Christie's auction in May 1990. "The artist Sandro Chia would consider the weirdness of a system where a painting which consists of a few square inches of paper can cost more than a building" (Baldessari, "Making Art," 138).

2. Exhibitions of "money art" would include: the Chelsea National Bank's exhibition featuring work by Abraham Lubelski ("Paper Money Made into Art You Can Bank On"); the Whitney Museum's *Anti-illusion* exhibition; Harvard University's *Popular Views of Money, Credit, and Speculation: Sixteenth–Nineteenth Centuries* (at the Bleichroeder Collection of the Kress Library of Business Economics); the Berry-Hill Gallery's *Old Money* exhibition; the *Geldmuseum* exhibition at the Düsseldorf Kunsthalle (Harten, *Museum des Geldes*) and the related exhibition *Musée des sacrifices, musée de l'argent* at the Centre Georges Pompidou in Paris (Harten and Kurnitzky, *Musée*); much of a recent exhibition at Ikon Gallery, Manchester (Brett, *Transcontinental*); Hofstra University's *Realm of the Coin: Money in Contemporary Art;* the Musée de la Poste's *Les couleurs de l'argent;* and the Collaborative Project's *Check Show* at New York's Citibank.

3. See "John Ruskin," in Shell, *Economy of Literature*.

4. Gadamer, introduction to "Origin of Work of Art" (in *Kleine Schriften*).

5. Robert Hughes comments on the significance of rising picture prices that "whereas works of art before had been like strangers with whom one could converse, and gradually get to know, they now assume the character of film stars with the museum as their limousine." He then adds that "the price spiral leads to the discouraging paradox that works of art, once meant to stand apart from the realm of bourgeois luxury and display their flinty resistance to capitalist values, now became among the most eagerly

sought and highly paid for" (*Shock,* 384). What the paradox is, and whether it is discouraging, is the object of the present book.

6. Grampp, *Pricing the Priceless.*

7. Wagenführ, *Kunst als Kapitalanlage,* 222–41.

8. Muensterberger, *Collecting.*

9. Danto, *Encounters and Reflections,* 290.

10. Baudrillard writes that "the museum acts as a guarantee for the aristocratic . . . exchange . . . ; just as a gold bank . . . is necessary in order that the circulation of capital and private speculation be organized, so the fixed reserve of the museum is necessary for the functioning of the sign exchange of paintings" (*Political Economy of the Sign,* 121).

11. Shell, "Forked Tongue."

12. Yamey, *Art and Accounting.* See chap. 2, n. 201, below.

13. Bruno Corradini and Emilio Settimelli, "Weights, Measures and Prices of Artistic Genius" (= "Futurist Manifesto 1914" [Milan, March 1914], in *Futurist Manifestos,* pp. 135–50), remark that "now[adays] genius has a social, economic, and financial value"; they hope for "a new financial organization" where "art-as-ideal" and "art-as-sublime-holy-inaccessible" are matters of the past (146–47).

14. Jacquiet, "Über die Preisbildung von Kunstgütern."

15. Cf. Macfie, *Economy and Value.*

16. "Art Finger," 65–67.

17. Cf. Rossi-Landi, *Semiotica e ideologia.*

18. For examples of such histories relevant to the visual arts see Veit, *Das Liebe Geld;* Niemer, *Das Geld;* Joswig, *Das Geld;* Wagenführ, *Der goldene Kompass* and *Kunst als Kapitalanlage;* Italiaander et al., *Geld in der Kunst,* Gramberg, *Das Buch vom Geld;* Samhaber, *Das Geld: Eine Kulturgeschichte;* and such journals as *Aureus.*

19. Simmel, *Philosophy of Money.*

20. On the term "root metaphor" see Turbayne, *Myth of Metaphor,* and Pepper, *World Hypotheses.* Often monetary topoi can be replaced or deleted from a painting without much loss: a painter depicts a coin but might (just as well) have depicted a medal or an apple (that is, without changing the "significance" of the work).

21. For Proust on Ruskin and political economy, see his *Contre Sainte-Beuve,* 106. For various practical critiques of the "two separate worlds" theory, see Harten, "What Should the Artist Do in Relation to Industry and Commerce?"

22. Motherwell, "Modern Painter's World," 31. Mark Rothko in his *Personal Statement* claims similarly, "I adhere to the material reality of the world and the substance of things . . . but I love both the object and the dream far too much to have them effervesced into the insubstantiality of memory and hallucination" (Rose, *Readings,* 136–37).

23. Fried, *Three American Painters,* 7. The ellipsis in the quotation represents these words: "of the new modus vivendi between the arts and bourgeois society gradually arrived at during the first decade of the present century."

Two Art and Money: Christianity

1. Shell, "Ring of Gyges," in *Economy of Literature*.

2. Apparent counterexamples would involve the iconoclasm of Calvinist Geneva and ninth-century Byzantium ("Icon and Inscription," below). Cf. Moses Hess, "Über das Geldwesen" (On the essence of money), in *Schriften*. Many people disapprove of general statements distinguishing Jews from Christians: in the name of religious tolerance, for example, some would-be universalists assert that all religions—including Judaism and Christianity—are "essentially" the same; others ignore or deny even such rudimentary differences between Judaism and Christianity as the latter's claim that God is incarnate in the body of a man—or the former's claim that he is not—and the latter's persistently recurrent definition of its doctrines in opposition to the former's doctrines (see Shell, *Children of the Earth,* 186–89).

3. For Jews, "he who denies idols is called a Jew" (Megillah 13A, cf. Dan. 3:12); for them, as for Muslims also, abstention from worshiping all idols—including the golden calf—is "equivalent to the fulfillment of *all* the Commandments" (Horayot 8a). For Christianity and the general significance of Jesus's expulsion from the temple of the money changer (*kermatistēs*) and his changing coins (*kermata*), see below, "Money Devil," as well as figures 22 and 96.

4. Minton, *John Law,* 81n. Clough lived in the nineteenth century.

5. Mendelssohn, *Jerusalem,* trans. Jospe, 82. "Am Bild des Juden, das die Völkischen vor der Welt aufrichten, drücken sie ihr eigenes Wesen aus" (Adorno and Horkheimer, *Dialektik,* 151; trans. Cummings, 168–69).

6. It is as if, in an erratic twist, self-styled modern Europeans—and Americans—were identifying themselves with the sort of fetishism that they generally claim belongs properly only to so-called primitive peoples. On fetishism and iconolatry, see also below, the first paragraphs of chap. 3, "Representation and Exchange: America."

7. Martin, *Iconoclastic Controversy,* 164–65.

8. The same God who disallows the graven image [*pesel*] commands Moses to engrave the stone tablets of the law. "And the Lord said unto Moses: 'Hew thee [*pisal-licha*] two tables of stone like unto the first'" (Exod. 34:1).

9. Lessing, *Zerstreute Anmerkungen über das Epigramm* (1771); trans. Hudson, *Epigram in the English Renaissance,* 9–10. Cf. Herder, *Epigramm*.

10. Shell, "Language of Character," in *Economy of Literature,* 62, 65; and Shell, "'What Is Truth?'" in *Money, Language, and Thought*.

11. In Rose, *Readings,* 245. Smith's statement was made in 1953: "a Symposium on Art and Religion."

12. Heidegger, who criticizes this definition of truth as specious "common sense," projects onto Judaism the problems in the traditional Christian view of truth. Thus he carefully suggests in *Being and Time* that Thomas Aquinas took the idea and phrase *adequatio res et intellectus* from the Jewish Isaac Israeli (ca. A.D. 855–955). And Heidegger blames Isaac Israeli—more than Aquinas or Avicenna (Abu Ali al-Husayn ibn Sina)—for

the subsequent widespread use of the term *adequatio*. See Heidegger's discussion of "Dasein, Disclosedness, and Truth" in *Sein und Zeit,* 214; English translation, 257. (Israeli is mentioned explicitly in the text.) Cf. Aquinas on *adequatio; Quaestiones disputatae de veritate,* qu. 1, art. 1. See "What Is Truth?'" in Shell, *Money, Language, and Thought.* Cf. Lyotard, *Heidegger.*

13. See *Oxford English Dictionary* (OED), s.v. "real" and "rial." On the *sang real,* see below.

14. Cf. Andreae, "Mögliche Zusammenhänge zwischen der Entwicklung des Geldwesens und der Erkenntnissen der Konzeptkunst," 76.

15. Brett, *Transcontinental,* 40.

16. Broodthaers, interview with journalist, in his *Sale of a Kilogram.*

17. Christian thinkers were aware of an apparent violation of the Fourth Commandment in the Christian doctrine. In this regard Tertullian's *De idolatria* was influenced by Avodah Zarah (in the Talmud). Cf. Weitzmann, *Icon,* 7.

18. Mendelssohn, *Jerusalem,* trans. Jospe, 84.

19. See, for an example, Didron, *Christian Iconography,* 4–6.

20. Mendelssohn, *Jerusalem,* trans. Jospe, 83.

21. "Die Münze war zugleich Waare, die ihren Werth als Münze verkennen und unrichtig angeben konnte" (A coin, for instance, was simultaneously a symbol and a piece of merchandise which was useful in its own right; Mendelssohn, *Jerusalem,* 78; trans. Jospe, 82).

22. Cf. Malraux's discussion of Celtic coinage in *Monnaie.*

23. As the nonmaterial God is a material man, so the material icon is the nonmaterial God. "The image [of the emperor]," writes Athanasius of Alexandria, "might well say: 'I and the emperor are one.' 'I am in him and he is in me.' . . . Who therefore adores the image adores in it also the emperor. For the image is the form of the latter and the idea" (Athanasius, *Oratio III contra Arianos,* 5, in Migne, PG 94:1405; cited by Freedberg, *Power of Images,* 392; cf. Ladner, "Concept of the Image," 8).

The bloodier battles of the war took place in A.D. 726–843. Freedberg, *Power of Images,* 402–3, summarizes thus the iconological problem in Christianity: "If God is divine, not material and uncircumscribable, how is it possible—indeed, how can it be legitimate—to represent him in material and circumscribed form? This is the argument used by all those who are hostile to images; but the counterargument depends on the fact that Christ, the image of his Father, was made incarnate as a man. That is not only how he is to be grasped, it is the only way to apprehend his divinity in his fleshly, visible, and material presence. This not only justifies images of Christ . . . but also all images of the absent and unknowable signified."

24. John of Damascus, *Orations on the Holy Icons,* 3.26, in Migne, PG 94:1345, quotes Heb. 1:3; Pelikan, *Imago Dei,* 176, cf. 39. See also Moshe Barasch's recent book on John of Damascus (*Icon*). On Abelard's summary of the numismatic quality of the Holy Trinity, see "The Holy Grail," below.

25. *Vit. Steph.* 1145A ff.; quoted in Martin, *Iconoclastic Controversy,* 58. Cf. Barasch, *Icon.* On canting badges, see Shell, *Economy of Literature,* 68–69.

26. Weitzmann, *Icon,* 8. On the general question of icons in John of Damascus, see also Barasch, *Icon.*

27. Blackman, *Journal of Egyptian Archaeology* 10 (1924): 47.

28. Didron, *Christian Iconography,* 3, citing *Adversus Constantinum Cabalinum oratio,* 10:619.

29. Weitzmann, *Icon.* Gauthier, *Highways,* 202, defines *imago clipeata* as "a half length representation of the human figure in a circular field resembling the round Roman shield or clipeus; used particularly in funerary decoration, where it symbolized the portrait of the deceased destined for eternal life and glory." Cf. Grabar, *Islamic Art.*

30. Weitzmann, *Icon,* 9. See the roundel in the ninth-century psalter in the Moscow State Historical Museum (Cod. gr. 129, fol. 67 [fig. 2]).

31. Sometimes this appears as *In Hoc Signo Vinces* (You will be victorious by this sign). These words occur on a coin issued by the emperor Vetranio (ca. A.D. 350) with a Victory crowning the emperor Constantine, who holds a *labarum* bearing the Christian monogram. The inscription, a loose translation of the Greek legend *En Toutōi Nikē* (By this conquer), which is associated with Constantine's vision of the flaming cross before the battle of the Milvian Bridge (A.D. 312), recalls how Constantine became master of the Western Empire and its customhouse.

32. Fol. 67r, Chludov Psalter, State Historical Museum, Moscow; Cormack, "Painting after Iconoclasm," fig. 30. The text illuminated is: "They gave me also for my meat, and in my thirst, they gave me water to drink." Cf. Weitzmann, *Icon,* 7–8.

33. For the paintings: Chludov Psalter, fol. 67v, cf. fol. 35v; Grabar, *Iconoclasme byzantin,* figs. 145, 146. On the iconology of both iconodule and iconoclast emperors, see "The Numismatic God," below, and Grabar, *Iconoclasme byzantin,* 115–42.

34. Quoted by Desmonde, *Magic, Myth, and Money,* 21–22. For an English exposition of Laum's views, see Einzig, *Primitive Money.*

35. "There is an old Rhythym or saying," writes John Aubrey in his seventeenth-century *Remaines of Gentilisme and Judaisme,* "A Soule-cake, a Soule-cake, Have mercy on all Christen soules for a Soule-cake" (23). The term *soul-cake* refers to the biscuit eaten on All Soul's Day.

36. The Lateran Council of 1215 held that "the body and blood of Jesus Christ are truly contained in the sacrament of the altar under the species of bread and wine, the bread and wine respectively being transsubstantiated into body and blood by divine power, so that in order to the perfecting of the mystery of unity we may ourselves receive from his [body] what he himself receives from ours" (*Encyclopaedia Britannica,* 9:873). The Corpus Christi feast, instituted by Pope Urban IV in 1264, gives expression to this view. See, too, Luchaire, *Innocent III,* and Dickson, "Burning." The *Oxford English Dictionary* defines "utter" as meaning both "to give currency to (money, coin, notes, etc.)" and "to send forth as a sound."

37. Pusey, *Real Presence*, 3:330: "People have profanely spoken of 'wafer gods.' They might as well have spoken of 'fire gods,' of the manifestation of God in the flaming fire in the bush." Cf. Butler's remark that "certain thieves have stolen the Silver Box wherein the Wafer-Gods used to lie" (Butler, *Feminine Monarchie*, 17).

38. In Neal, *History of the Puritans*, 1:93.

39. OED, s.v. "wafer" and "cake."

40. *IHS* records the letters of "Christ" in Greek. See Di Paseale, *Bardonecchia*.

41. Martin, "Numismatique," 126–27.

42. Grand-Carteret, *Vieux papiers*, 378, shows the note of the Banco di Sancto Spirito di Roma that circulated in 1796 in the Vatican states.

43. In some versions of the tale the Jew is a usurer, like Shakespeare's Shylock, and he procures the host—which somehow *figures* Christ's flesh and blood—during the course of moneylending; in a few older versions, the host is miraculously transformed *literally* into Christ's flesh and blood when the Jew tries to destroy it, and the Jew then becomes a Christian believer. (For Jean de Thilrode's tale of literal transformation, see Tervarent, "Tapisseries," 89–94, and Lavin, "Altar of Corpus Domini.") On Shakespeare's play, see "The Holy Foreskin," below.

44. Blumenkranz, *Juif*, esp. 97–98, includes miniatures depicting Judas receiving his salary.

45. See Tyndale's *Obedience of a Christian Man* (1536), 245: "After the common saying, 'No peny, no Paternoster.'" Dykes, *English Proverbs*, 200, claims that this proverb refers simply to indulgences ("Whence came this comical saying, *No peny, no Paternoster,* but from pecuniary Indulgences?"). But Herrick's poem "The Peter-Penny" ("No penie, no Pater Noster") refers to the Roman see's claim to the patrimony of Peter: before the Reformation landowners and others who were judged economically sufficient had to pay the "Peter-penny" as a tax to Rome. Cf. the French proverbs "De main vide, vide prière" and "Point d'argent, point de Paternoster."

46. For the term, see Littré, *Dictionnaire*.

47. *Dictionary of Numismatic Names*, 52. Calvin's term is *marreaux*. See also Rouyer, "Méreaux" and "Notes."

48. Tenney and McWhorter, *Communion Tokens*, 13. Cf. the Greek and Roman *tessera*.

49. A similar interchangeability of Christian wafers with coin is suggested in such traditional nursery rhymes as "Good Friday comes this month, the old woman runs / With one or two a penny hot cross buns" (*Poor Robin's Almanack*, 1733; in Brand, *Observations on the Popular Antiquities of Great Britain*, 1:154); the term *cross bun* refers to a flour "bun indented with a cross, commonly eaten on Good Friday" (OED).

50. The other side of this communion token reads *Scio Cui Credidi* (I know him whom I have believed; cf. 2 Tim. 1:12). For French Protestant, or Huguenot, examples, see Tenney and McWhorter, *Communion Tokens*, 18.

51. The classical Latin *patina* means a broad shallow dish or pan. In medieval Latin the term refers to the plate used in the Eucharist (cf. the current English "paten"). The other meaning of "patina"—as the film or incrustation produced by oxidation on the surface of old bronze, marble, etc.—comes from the French term of the eighteenth century, *patine,* often used in describing old coins. Walter Pater refers to the "inestimable patina of ancient smoke and weather and natural decay" (*Works,* 7:227). James D. Butler (in his "Judas and the Shekels," 365), remarking that shekels as money were likely not worth much in Jesus' time and that none had been minted since 135 B.C., says that Judas, like a modern coin collector, may have "valu[ed] a coin at ten times its intrinsic worth for time blackened *patination* and ador[ed] its rust" (my emphasis); thus he responds ironically to biblical "commentators who could not . . . account for the apostate's [Judas's] selling his Lord so cheap."

52. Woodside, *Communion Tokens,* 6. It is worth remarking that the term *offertory* refers both to the Eucharist and to money—specifically, both to the cloth veil used to cover the Eucharist wafer and to the church's collection of coins. American communion tokens would often include inscriptions like *The Bush Was Not Burned* or *Nec Tamen Consumebatur* (with a picture of a burning bush; see Warner, "Communion Tokens," 7).

53. Woodside, *Communion Tokens,* 7n.

54. McLachlan, *Canadian Card Money.*

55. See Gibbons, *Physics and Metaphysics of Money.*

56. Muscalus, *Christ on Paper Money.*

57. *American Journal of Numismatics* 24, no. 1 (1887): 8.

58. Brett, *Transcontinental,* 40.

59. An anti-British Thomas Jefferson wrote in the 1780s that the mark of the currency of the new United States should be familiar. The sign of the new dollar had a form noticeably like that of the problematically creditable—because generally Catholic—*IHS;* see fig. 7. Some scholars have noted that the dollar mark has the general form of the familiar *8* of Spanish currency—which was trusted—except that the *8* supposedly became an *S* just as the two lines distinguished it from the peso. Others suggest that the origin of the dollar mark involves the way Spanish or Mexican silver "was stamped on one side with what we suppose to be a representation of the pillars of Hercules, and from which came the typical or arbitrary sign of the dollar mark *$,* or *$,* which some suppose to be a monogram of, or a gerrymandered *U.S.*" (Welch, *Recollections,* 168).

60. On the economic anthropology of the gift, see below, chapter 3, "Pretty Money."

61. For these etymologies see also Spitzer, "Name of the Holy Grail"; Nitze, "Spitzer's Grail Etymology"; and Kahane and Kahane, *Krater.* Merlin calls the Holy Grail "grace" itself: "And these people call this vessel from which they have this grace [*grâsce*]—Grail [*Graal*]"; see Jung and Franz, *Grail Legend,* 118.

62. Shell, "The Blank Check," in *Money, Language, and Thought.*

63. An influential etymology derives "Holy Grail" (*Saint Graal*) from the "real/royal blood" (*sang real*) of Jesus. On the Eucharist and the Grail tales generally, see Antichkopf, "Saint Graal et les rites eucharistiques."

64. In one Grail tale (*Estoire du Saint Graal,* 2:306) a man says, "For my thoughts are completed since I see the thing [the Grail] in which all things are," but the man fails to say whether one of the things he sees in the container is the container itself.

65. Abelard, *Theologia,* in Migne, PL 178:97–102.

66. On manna, "the bread of heaven," see Exod. 16:4 and Ps. 105:40, cf. Yoma 75–76.

67. On the *sakh,* see Braudel, *Mediterranean World,* 2:816–17. The authors of the earliest Grail tales lived in trading centers, such as Troyes, where Knights Templar and Jewish merchants gathered. The Templars were financiers as well as crusaders, and their patron saint, Bernard, was associated with the Knights of the Round Table and with the argument that charity is the principal agent of redemptive conversion. Scholars have argued that Chrétien of Troyes and Kyot—who Wolfram says told the original Grail story—were Jewish converts (Holmes, "New Interpretation," and Levy, "Quest for Biographical Evidence").

68. Herford, *Literary Relations of England and Germany,* 208.

69. On the topos of the inexhaustible purse—and also on the story of Fortunatus—see Grimm and Grimm, *Teutonic Mythology,* 871 and 976.

70. Richard, *Dialogus de scaccario.*

71. Luke 1:34 attributes these words to the Virgin Mary as she learns of the role she is to play in "incorporating" God on earth.

72. For the Greek and Roman terms: Lycophron, *Lycophronis Alexandra,* 838; Ovid, *Metamorphoses,* 5.250. See also Horace, *Odes,* 3.16, and *Metamorphoses* 4.611–12; Hyginus, *Fabula,* 1.63; and note 81 below.

73. "Si Danaë auri pluvia praegnans a Iove claret, / Cur Spiritu Sancto gravida Virgo non generaret?" (Franciscus de Retza, *Defensarium inviolatae virginis Mariae;* quoted by Panofsky, *Problems in Titian,* 145).

74. *Ovide moralisé,* esp. 129 (lines 5596–5619). It may be worth considering Saint Teresa's description in her *Autobiography* of the "golden darts" of Christ entering her body.

75. On depictions of the Holy Ghost as a dove entering Mary through her ear, see Hartland, *Legend of Perseus,* esp. 1:131–32.

76. Martorell's panel is part of the C. Morgan Bequest at the Museum of Fine Arts in Montreal. On the genealogy of Rembrandt's *Danaë* and Titian's, see Panofsky, "Der gefesselte Eros."

77. On Veronese's work—in the Royal Gallery, Turin—see Martin, "Numismatique," 43. Compare *Danaë in a Shower of Jewels and Gold* by Gerard de Lairesse; Collection Baszanger, Geneva.

78. Cf. the *Danaë* by Max Slevogt, Munich City Hall.

79. Titian made more than one *Danaë;* the one illustrated here is in the Prado (Madrid). The association of Danaë with prostitution is made mainly in nineteenth- and twentieth-century works.

80. "Bulla fulminante," poem 131a in *Carmina burana,* vol. 1, pt. 2, p. 218; trans. Blodgett and Swanson, 188–89. Cf. Schapiro, "From Mozarabic to Romanesque in Silos," 327n. The poem's author—possibly Philip the chancellor of Paris, who was active in the early thirteenth century—continues thus his play on the sound *or:* "Nothing is more powerful or / more pleasing than gold, / than which Cicero does not plead [*perorat*] more eloquently."

81. For this variation of the Danaë story—which goes beyond the version of Apollodorus *mythographus* (2.34 ff.)—see sources cited in Woodward, *Perseus,* and Schwarz, *De fabula Danaeia.*

82. On the incestuous relationship between Jesus and Mary: Heuscher, *Psychiatric Study,* 207. On the Athanasian doctrine that Father and Son are not literally the same, so that the Son is the father of himself: the Council of Nicea in A.D. 325. For Tamar: Matt. 1:3 and Gen. 38:24–30. Rahab, a harlot, and Bathsheba, an adulteress, are included among the human ancestors of Jesus, whose mother was a kind of harlot, since his conception was extramarital. On the genealogy of Jesus: Santiago, *Children of Oedipus,* 50, and Layard, "Incest Taboo," 301–2. For the Magi: Rankin, "Catullus," 119, and Moulton, *Early Zoroastrians,* esp. 204, 249–50. For the Persians: Antisthenes of Athens, *Fragmenta,* cited in Ranken, "Catullus," 120; Sidler, *Inzesttabu.* See Nietzsche's remark that "an ancient belief, especially strong in Persia, holds that a wise magus must be incestuously begotten" (*Geburt,* sect. 9, 56–57; *Birth of Tragedy,* 60–61). On the theological issue, see Shell, "Want of Incest."

It is also worth noting that from the Christian doctrine that "all ye are brethren" it follows that incest and celibacy are the only human possibilities. Hence the Corinthians practiced incest on the literal plane—which is why Saint Paul, always invoking the boundary between literal and figural, had them killed. See 1 Cor. 5:1; the Corinthian sect's acts of incest were not "deed[s] done secretly out of weakness but . . . ideological act[s] done openly with the approval of at least an influential sector of the community" (Collins, "'Excommunication' in Paul").

83. Aeschylus, *Persae,* 79.

84. In one vision of the Perseus tale, Danaë takes up her abode on the spot where Rome was afterward built (Servius *Aeneidos,* 8.315); see Smith, *Dictionary,* s.v. "Perseus."

85. Song of Songs Rabbah 7:8; cf. Yoma 69B; *Encyclopedia Judaica,* s.v. "idolatry," 1234–35. On incest and economic exchange, see "Pretty Money," below.

86. *Auslegung und Beschreibung der Anathomy,* "Von der Mutter"; cf. Laqueur, *Making Sex,* 63.

87. See Schapiro, "Ascension," in *Late Antique Art.*

88. Panofsky, *Netherlandish Painting,* 142.

89. Calvin, *Treatise on Relics,* 46. See also MacCulloch and Smith, "Relics," 655, on "the extraordinary mystical ideas associated with this relic."

90. For blood: Calvin, *Treatise on Relics,* 264, discusses blood preserved with the prepuce. For tears: Thiers, *Dissertation,* tells how the Benedictines of Vendôme persuaded the local people that the tear they guarded was so valuable it would bring in a good deal of income. For teeth: Saintyves, *Reliques,* 192. For the umbilical cord and hair: Collin de Plancy, *Dictionnaire,* 2:45, 62. For other materials: Calvin, *Treatise on Relics,* hints at beliefs about relics of Christ's urine and feces (Collin de Plancy, *Dictionnaire,* 3:264).

91. Geary, *Furta Sacra.*

92. See Freud, "Character and Anal Eroticism"; and Shell, "Money Complex of Psychoanalysis," in *Money, Language, and Thought.*

93. Jesus' circumcision eight days after his birth is celebrated at the Feast of the Circumcision of Our Lord (Bentley, *Restless Bones,* 141). Jesus was probably circumcised as Jew: "And when eight days were fulfilled for his circumcision, his name was called Jesus, the name given him by the angel before he was conceived in the womb" (Luke 2:21). Jesus is said to be the Son of God as well as the son of Joseph; so there is discussion among the church fathers on whether Joseph circumcised Jesus, as would have been done by regular Jewish fathers.

94. For this term, which translates the French *saint prépuce,* see Collin de Plancy, *Dictionnaire,* 47. The term was used in the Middle Ages to refer to the foreskin at Coulombs. There is said to have been a Saint Praeputius (Laurent and Nagour, *Magica sexualis;* cited by Bryk, *Circumcision,* 25).

95. "Take, eat: this is my body" (1 Cor. 11:24). "And he took bread, . . . and gave unto them, saying, "This is my body" (Luke 22:19). In "Down the Rabbit-Hole," Alice eats "a very small cake . . . on which the words 'EAT ME' were beautifully marked" (Carroll, *Alice in Wonderland,* 12).

96. The parish priest of Calcata, Italy, exposed the sacred *carne vera* as late as 1 January 1983 (Bentley, *Restless Bones,* 141).

97. Birgitta, *Reuelationes,* chap. 37, reads as follows: "Now she feels on her tongue a small membrane, like the membrane of an egg, full of superabundant sweetness, and she swallowed it down. . . . And she did the same perhaps hundreds of times. When she touched it with her finger the membrane went down her throat of itself" (cited by Bryk, *Circumcision,* 28).

98. "De tout ce que Jésus-Christ a laissé sur la terre, rien ne serait plus digne de notre vénération que le sang qu'il a répandu. . . . Rien ne méritait donc d'être recueilli et conservé avec plus de soin" (Baillet, *Histoire de la Semaine sainte*). It is worth considering here one supposed difference between the blood of the crucifixion and the flesh of the circumcision: that the sacrifice of blood saved all humankind (it was done, as Baillet says, "pour le salut du genre humain"), but that of flesh merely marked Jesus as a Jew.

99. On the *translatio* of relics, see Geary (*Furta Sacra*). Christian medical doctors were

especially interested in obtaining the Holy Foreskin. Eliade, *Encyclopedia,* 279, points out that the foreskin at Coulombs was "venerated by pregnant women hoping for an easy childbirth."

100. I am grateful to M. Coscuella—the excellent chef at the Ripa Alta Restaurant (Plaissance-dans-Gers, France)—for his explanation of the centuries-old debate among French gastronomes about whether there is any "true" taste without a little consumption. This was during a long disquisition on the traditional way to remark and enjoy the changing flavors/aromas of Armagnac.

101. "At the beginning of the last century, the Bishop Noailles at Châlons-sur-Marne, considering that the foreskin [in his Church of Notre Dame en Vaux] was the object of an often scandalous cult—especially on the part of women—and believing that it was a false relic, wanted to have it tested. The foreskin was wrapped in a piece of red velvet. A surgeon, after opening the velvet, found therein only a bit of powder. He put it on his tongue and declared that the supposed foreskin was nothing but dust from sand. Afterward everyone called this surgeon the foreskin muncher [*croque-prépuce*]; but there is no more foreskin at Châlons-sur-Marne" (Collin de Plancy, *Dictionnaire,* 2:47; my translation). The parallel French term *croque-monsieur,* which refers to a hot, crusty cheese and ham sandwich, dates from 1918. Cf. the practice of *metzitzah* (Hebrew)— the oral sucking of the tip of the penis to staunch the blood after circumcision (*Enciclopedia Judaica Castellana;* cited in Trachtenberg, "Circumcision," 467).

102. According to Buffon, for example, Persian women "swallow the part of the foreskin which a child lost in circumcision" (*Voyage,* 2:200). For these women, says Buffon, the foreskin was an infallible remedy against sterility (cf. Bryk, *Circumcision,* 31).

103. Examples would include churches at Charroux, Antwerp, Paris, Bruges, Boulogne, Besançon, Nancy, Metz, Le Puy, Conques, Hildessheim, and Calcata (Italy). See Müller, *Die "hochheilige Vorhaut,"* 24.

104. Calvin, *Treatise on Relics;* cited by Eliade, *Encyclopedia,* 278. Cf. Mély, "Les reliques du lait."

105. Nicquet, *Titulus sanctae crucis,* vol. 1, chap. 25; Hastings, *Encyclopedia,* 655.

106. Bentley, *Restless Bones,* 139.

107. *Dictionary of the Middle Ages.* See Guth, *Guibert.*

108. Cf. Coverdale, Jer. 4:4. Paul taught that "circumcision is a matter of the heart, spiritual and not literal" (Rom. 2:29) and that "in him [Christ] also you were circumcised with a circumcision made without hands by putting off the body of flesh in the circumcision of Christ" (Col. 2:11). Cf. Phil. 3:13; Gal. 5:6, 6:15.

109. For the theological investigation, see Müller, *Die "hochheilige Vorhaut."*

110. None of the patients studied by Mohl et al., "Prepuce Restoration Seekers," were Jewish. Cf. Greer, Mohl, and Sheley, "Foreskin Reconstruction," and Waring, *Foreskin Restoration (Uncircumcision),* which includes a chapter on "grief, depression, and resentment" as well as letters and statements from readers. For a history of circumcision written for medical students, see Remondino, *History of Circumcision.*

111. OED, s.v. "purse."

112. *Vitae Nicetae,* in *Acta Sanctorum,* ap. 1, app. 23, written 820/830; cited in Martin, *Iconoclastic Controversy,* 62.

113. Shakespeare, *Merchant of Venice,* 2.8.14–21.

114. "I say my daughter is my flesh and blood," says Shylock (*Merchant of Venice,* 3.1.29). The Christian gentleman Solanio challenges Shylock's paternity of Jessica. "There is more difference between thy flesh and hers than between jet and ivory; more between your bloods than there is between red wine and rhenish" (3.1.31–33). For *purse* as "scrotum," see OED, s.v. "purse," 8b; for the cognate French term *bourse* as "scrotum" as well as "bag"—and also as a "place where bankers assemble"—see Bouchet, *Sérées,* 1:96 (cited by Laqueur, *Making Sex,* 62–63).

115. For remarks on the money devil's moneybags, see Gaidoz, "Diable d'argent," col. 209.

116. In Plato, *Republic,* 507, and Aristotle, *Politics,* 1258, the product of monetary generation—use—and the product of sexual generation—a child—are compared as *tokos,* or offspring. Aristotle's insistence that making money breed is unnatural was an important influence on the church fathers' thinking. On the identification of natural with economic offspring in Shakespeare's *Merchant of Venice,* see Shell, *Money, Language, and Thought,* 47–83.

117. For Montenegro, see Krauss, in *Münchener Medizinische Wochenschrift;* for Sicily, see Dulaure, *Die Zeugung,* 184 (cited by Bryk, *Circumcision,* 107–8). On the Holy Foreskin of Christianity in *mystisch-erotische* anthropology generally, see esp. Stoll, *Geschlechtsleben,* 683–87.

118. See Lindschotten, *Ander Theil;* in Stoll, *Geschlechtsleben,* 505.

119. Shakespeare, *Merchant of Venice,* 3.2.54–55, 4.1.419.

120. Cavell, *Claim of Reason,* 480, remarks that the forfeit that is to be "cut off and taken / In which part of [Antonio's] body pleaseth [Shylock]" (1.3.146–47) suggests the foreskin that is cut during circumcision and also the testicles that are cut off during castration (which many people interpret as the significance of circumcision or fear as its result). Cf. Reik, *Fragments of a Great Confession,* esp. 336. Just as Shylock in act 1 once intended to circumcise the bodily part of Antonio (and hence turn him into a Jewish brother), so Antonio in act 4 intends to circumcise the spiritual part of Shylock (and hence turn him into a Christian). For Paul, a Christian is a Jew whose heart is circumcised: "For he is not a real Jew who is one outwardly, nor is true circumcision something external and physical. He is a Jew who is one inwardly, and real circumcision is a matter of the heart, spiritual and not literal" (Rom. 2:28–29).

121. In 1939 Freud wrote that "among the customs by which the Jews made themselves separate, that of circumcision has made a disagreeable, uncanny impression, which is to be explained, no doubt, by its recalling the dreaded castration, and along with it a portion of the primeval past which is gladly forgotten" (*Moses and Monotheism,* 91). Already in 1909 Freud had written that "the castration complex is the deepest unconscious

root of Anti-Semitism; for even in the nursery little boys hear that a Jew has something cut off his penis—a piece of his penis, they think—and this gives them a right to despise Jews" ("Five Year Old Boy," 36). For an elaboration of the psychoanalytic view here, see Trachtenberg, "Circumcision, Crucifixion, and Anti-Semitism."

122. Martin Luther writes that "there is a common error, which has become a widespread custom, not only among merchants but throughout the world, by which one man becomes the surety for another" (Luther, *Von Kaufshandlung und Wucher,* in *Werke,* 25:298–305).

123. Shakespeare, *Merchant of Venice,* 4.1.114.

124. Cf. Kökeritz, *Shakespeare's Pronunciation,* 354–55.

125. See Shell, *Money, Language, and Thought,* 79.

126. On the topos of the inexhaustible purse and on the story of Fortunatus, see Grimm and Grimm, *Teutonic Mythology,* 871 and 976.

127. *The Circumcision* is discussed briefly in Fuchs, *Die Juden in der Karikatur,* and Seiden, *Paradox of Hate.*

128. Birgitta, *Revelationes,* chap. 37; and Bryk, *Circumcision,* 24–25. Other authorities say that Mary left the Holy Foreskin in the care of Mary Magdalene.

129. "In his temple was Charlemayne, when the aungell broght him the prepuce of oure Lord, when he was circumcised" (Maundeville, *Buke,* 11.42).

130. Discussed in *Trésors des églises de France;* De Linas, "Reliquaire"; Gauthier, "Trésor de Conques" and *Emaux;* and Taralon, *Trésors,* 293–94, 204–8.

131. Gauthier, *Highways,* 18.

132. One would also consider pouches, pockets, handbags, and pocketbooks as well as bodices and codpieces. The history of the shape of piggy banks might supplement this research. On these see Samhaber, *Das Geld,* 142; Harten, *Museum des Geldes,* 2:162ff.; Brueghel's various depictions of banks; Henkel and Schöne, *Emblemata,* 1286; and the frontispiece to Veit's *Liebe Geld* (which shows one of the oldest piggy banks in the world).

133. The halo is based partly in local Roman and other "pagan" practices and motifs. L'Orange, *Iconography,* discusses the Greek *aspis* and the Roman *clipeus,* showing that in many early pictures Christ is placed in the *clipeus* instead of the apotheosized dead pagans. For the view that the Christian nimbus and halo derives from the Roman emperor's golden wreath (*aurum coronarium*), see Kostof, *Orthodox Baptistery,* 90.

134. In the seventeenth century Cesare Ripa, Bernard de Montfaucon, and Johann Nicolai studied the matter (Krucke, *Nimbus,* 104).

135. Matthew writes: "Jesus . . . was transformed before them: and his face did shine as the sun, and his raiment was white as light" (Matt. 17:2). See Krucke, *Nimbus,* 135. Weitzmann connects the *clipeus,* or *tondo,* with the transport of the soul to heaven; cf. the term *aspis.*

136. Krucke, *Nimbus,* 101 ff.

137. Cf. Pauly, *Realencyclopädie*, s.v. "Nimbus," esp. 623.

138. On *corona*, see Krucke, *Nimbus*, 103. Cf. the pun on *corono*. The history of royal "coronation"—the placing of a crown or garland on the head—would be worth considering in this context. *Aurum*, a Latin generic term for "money," was linked with *aureus* (the Roman gold coin) and *obrussum aurum* (meaning "pure gold," the inscription on the solidus issued after the reign of Constantine the Great); in the medieval period *aurum* meant "gold coin" (*Medieval Latin Word-List*, 38–39).

139. Krucke, *Nimbus*, 120 ff.; Ferguson, *Signs and Symbols;* and Didron, *Christian Iconography,* 163, 29 ff.

140. For shapes, see Krucke, *Nimbus,* 130, 70.

141. Didron, *Christian Iconography,* 28 ff. For the significance of the various letters and monograms on the nimbus, see Ferguson, *Signs and Symbols,* 89–90, and Krucke, *Nimbus,* 123 ff., 66.

142. Boeckler, *Das goldene Evangelienbuch Heinrichs III.*

143. Alexander, *Book of Hours for Engelbert of Nassau.*

144. Randall, in her discussion of images in the margins of old books, considers depictions of Jesus' expulsion of the money changers from the temple in terms of halos (*Images in the Margins,* 131).

145. Christian legend has it that it was Terah—Abram's idol-worshiping father (whom Abram left to become the Jewish forefather Abraham)—who fashioned the thirty shekels that were paid to Judas. Exactly how those coins came to Judas is the stuff of many literary works. Medieval histories often tell the history of these shekels throughout time—generally beginning with how Terah made them; see Godfrey of Viterbo's *Pantheon* (in du Méril, *Poésies populaires latines,* 321), Solomon's *Book of the Bee,* Joannes of Hildesheim's *Liber de gestis,* and also a few English works (including MS Laud Misc, 622, fol. 65; Bodleian Library); for details, see Mély, "Les deniers de Judas," and Hill, *Thirty Pieces,* 91. There has been considerable debate about the proper "look" of the so-called Judas pennies: in a painting sometimes ascribed to Lucas van Leyden at the Uffizi (Florence), they are shekels with censers, inscribed in Hebrew (Hill, *False Shekels,* 87; ill. *Reliquary and Illustrated Archeologist* [1904], 135); elsewhere they are coins of Rhodes.

146. Blumenkranz, *Juif médiéval,* 18.

147. Pietro's *Penny* is in the Staatsgalerie, Stuttgart.

148. See, for example, the *Head of John the Baptist* of the seventeenth-century Lombardy school in the Musée des Beaux-Arts in Chambéry, France.

149. Some money devils illustrated in Gaidoz's "Diable d'argent" have halos. In Joseph Keppler's cartoon "The New Pilgrim's Progress—Enlightened Americans Paying Homage to 'Infallibility,'" a halo composed of many gold coins surrounds the head of the pope (in *Puck* 1 [5 September 1877]).

150. Friedländer, *On Art and Connoisseurship,* 52. In recent years the art frame has become an important focus for art history and exhibitions concerning curatorship. See Derrida, *Verité,* and Haacke, *Framing and Being Framed.*

151. Smith, *Wealth of Nations,* 1.v.9, 1.47.

152. See Shell, "Language of Character," in *Economy of Literature.*

153. For the Roman Caesar: Pauly, *Realencyclopädie,* s.v. "Nimbus," 617. For the Holy Roman kaiser: Krucke, *Nimbus,* 8 ff.

154. Benjamin, "Mechanical Reproducibility," 219–20.

155. Benjamin, "Mechanical Reproducibility," 116, 223. Berger (*Ways of Seeing,* 23) appears to follow Benjamin when he writes that "the bogus religiosity which now surrounds original works of art, and which is ultimately dependent upon their market value, has become the substitute for what paintings lost when the camera made them reproducible. Its function is nostalgic. It is the final empty claim for the continuing values of an oligarchic, undemocratic culture. If the image is no longer unique and exclusive, the art object, the thing, must be made mysteriously so." However, Berger's assumption of a simple opposition between a sham religiosity based on market value and a supposedly real religiousness partakes of the same nostalgia that he decries.

156. Benjamin mentions coinage only once in his essay ("Mechanical Reproducibility," 220). But coinage (whether stamped or cast) serves better than photography as a case study of the relation between or confusion of "superstructural" reproduction and "substructural" production. The aesthetics of coinage, after all, does not demand metaphorical reference to an apparently unrelated economic science like statistics. Coins are themselves both artful reproductions and active participants in the relations of production. They are things ontologically equal to each other as products of the same die; and money, which coins symbolize, equalizes in potentia all (other) things.

157. Fuchs, *Karikatur,* 1:19. Benjamin, "Eduard Fuchs, Collector and Historian," 385. Benjamin remarks that there were also terra-cotta figures in the ancient world.

158. Benjamin defines the aura of natural objects as a "onetime appearance of a distance, however near it may be": a subject, resting on a summer afternoon, "follows" a mountain range (*Gebirgskette*) on the horizon or a branch that casts its shadow on him. Cf. Benjamin, *Baudelaire,* and Baudelaire's "Perte d'auréole" (Lost halo).

159. Benjamin, "Mechanical Reproduciblity," 226. Compare Benjamin's interest in testing and the artwork's patina.

160. Quoted in Russel, *Coins,* 23. Dobson, English poet and man of letters, was principal clerk in the marine department of the Board of Trade from 1884 to 1901.

161. "Tax Advice" (*Steuerberatung*) is the title of a section in Benjamin's *One-Way Street.*

162. For various lists of seventeenth- and eighteenth-century paintings of these subjects, see Pigler, *Barockthemen,* 275–78 (the calling of Saint Matthew), and 330–32 (the tax penny); on a painting of the calling by Hendrik Terbrugghen (or by a member of his circle), see "Accounting for Art," below.

163. Thomas Aquinas, in his *Tractatus de regimine principium,* ends an interpretation of Jesus' tax advice with the words "quasi ipsum nummisma sit causa ut in plurbus tributa solvendi" (*Opera omnia,* 27:367 ff.).

164. PONTIF. MAXIM. CAESAR. DIVI. AUG. F. AUGUSTUS. See Snowden, *Coins of the Bible*. This denarius issued by Caesar Tiberius (A.D. 14–37) is illustrated in Shell, "Children of the Nation," 227. Some "tax pennies" produced by artists or counterfeiters as relics—and purporting to be the authentic item presented to Jesus—include on the obverse some such words as IMAGO CESARIS (Hill, *Thirty Pieces*, 113–14).

165. John of Jerusalem, *Against Constantine V*, 5, in Migne, PG 95:321; cited by Pelikan, *Imago Dei*, 39.

166. "Economy," says Cardinal John Henry Newman in *Arians of the Fourth Century*, 65, means "setting [the truth] out to advantage," as when "representing religion, for the purpose of conciliating the heathen, in the form most attractive to their prejudices," and the *disciplina arcani* is a "withholding [of] the truth" in the form of allegory, by which the same text may express the same truth at different levels to different people.

167. Redemption of the firstborn (*pidyon bekhor*) is discussed in the Mishnah, Bekharot, and Temurah; cf. Num. 18:16. Usually it was not paid by *kohanim* or Levites—hence perhaps not by Jesus' apparent consanguineous father Joseph. For the didrachma tribute, see Matt. 17:24–27.

168. Godfrey, *Italian Painting*, 56, writes of Masaccio's painting *The Tribute Money* that it depicts "the moment when Christ commands Peter to pay the required coin to the Roman soldier at Capernaum. With imperialist gesture He tells Peter to go to the Lake of Gennesaret and extract a coin from the mouth of the fish." "Saint Peter's fish" is sometimes the name given the fish caught for the tribute money. On the Jewish temple tax and its collection as depicted in Jewish artworks, see Wischnitzer, "Moneychanger."

169. Dobiache-Rojdestvensky, *Poésies des goliards*, 76 ff.

170. Mark 15:26; Luke 23:38. Already in the fourteenth century Wycliffe used "superscription" to translate the term *epigraphē*—both the writing on the cross and that on the coin (Luke 20:24, 23:38). The plank with the superscription became a treasured relic. After Saint Helena found it, the superscription was (we are told) lost sight of until the year 1492, when it was found in a vault in the Church of San Croce in Gerusalemme at Rome and Pope Alexander published a bull authenticating its true character (*Encyclopaedia Britannica*, 7:507). Collin de Plancy, *Dictionnaire*, 1:193–94, discusses its preservation in Rome and in Toulouse (Church of Notre Dame of Daurade). The superscribed plank was often venerated not only as a regular relic (like the true cross), but also as the body of Christ (like the Holy Foreskin); see Möbius, *Passion*, esp. pl. 95.

John implies that the inscription was put on the stake (John 19:19); Luke says that it was put on "him" or on "it," where "him" refers to Jesus and "it" refers to the cross (Luke 23:38); and Matthew indicates that the inscription was put above Jesus' head (Matt. 27:37)—as if the inscription were a kind of crownlike corona or royal halo.

171. See n. 167 above. Abraham sacrifices Isaac ("your one and only son") just as God sacrifices his "only begotten" son (Gen. 22:2, 12–16; cf. Heb. 11:17). Jews pay redemption money instead of sacrificing just as Christians raise sacrifice to the divine level in such a way that Jesus as surety becomes his own redemption money. The term *oblation* may be important here: By oblation—from the Latin *oblatum*—Christian par-

ents repaid God the Father for the gift, or "offering," of God's son Jesus or for God's help in providing these parents with (other) offspring of their own. Jews repay this gift of human life by donating to the temple tax money meant to represent the life given; but Christians literalize the law of talion and pay life for life. On oblation generally, see Shell, *Children of the Earth*, chap. 5.

172. The superscription is indicated by the upper crossbar on "patriarchal" crosses (two horizontal lines), "papal" crosses (three horizontal lines), and "Russian" crosses (two horizontal lines and one slanted line); Child and Colles, *Christian Symbols*, 18.

173. Epiphany would have meant the appearance of the divinity, from *epihaneia*, appearance or manifestation. The festival so called in Christianity celebrates the manifestation of Christ to the Gentiles in the persons of the Magi, celebrated on the twelfth day after Christmas.

174. Here too the impression of divine images on coins helped precipitate the divine aura and cult worship of the gods. See Shell, *Economy of Literature*, esp. chaps. 1 and 2.

175. For a discussion of such warnings, see Mantel, *Studies in the History of the Sanhedrin*, 277–78.

176. Athanasius, *Oratio III contra Arianos*, 5, in Migne, PG 94:140–45.

177. For the coins of Constantine, see Krucke, *Nimbus*, 8, 13. Del Mar notes that "Julius Caesar erected the coinage of gold into a sacerdotal [Roman] perogative" and discusses what it meant that, "when [Roman] emperor-worship was succeeded by Christianity, [coins eventually] bore the effigy of Jesus Christ." Discussing modern notions of the relationship between minting and sovereignty, Del Mar points out that Justinian broke off the peace of A.D. 686 with Abd-al-Malik—the caliph of Baghdad who established Arabic as the official language and was the first to mint purely Arabic coins—"because [Abd-al-Malik] paid his tribute in pieces of gold which bore not the effigy of the Roman emperor" (Del Mar, *Monetary Systems*, 74–75).

178. The inscription on the obverse replaces "Caesar Augustus" with "Christ"; instead of the traditional legend, D Iustinianus Pe[rpetuus] Au[gustus], it reads D Iustinianus Serv[us] Christi (see Wroth, *Catalogue of Imperial Byzantine Coins*, 331, nos. 11 ff.). On the "absolute" currency of this solidus—its metallic purity and weight matched, or were adequate to, the claims made for it by its inscriptions—see Lopez, "Dollar of the Middle Ages."

179. Oppenheim is quoted from "Paper Money Made into Art You Can Bank On."

180. *Catholic Encyclopedia*, s.v. "numismatics," 570–72. The popes began to issue coinage in the eighth century; no such papal coins were issued from 1049 to 1362, however.

181. For this inscription and its connection with the Christian emperor Constantine, see sections above.

182. See Sophocles, *Greek Lexicon*. The term *chrusographos* also occurs in the ninth century in Meletius Monarchus's *De natura hominis* (M. 64. 1076; cf. 1309B). Cf. Lampe, *Patristic Greek Lexicon*.

183. One of the first extant references to a chrysographic text occurs, as Diringer notes (*Hand-Produced Book,* 176), in Aristeas (*Aristeas Judaeus,* par. 176). When Ptolemy Philadelphus requested that the Pentateuch be translated into the Greek tongue, says Aristeas, the high priest of Jerusalem sent him a scroll of the Torah written in letters of gold. It is said that all of the seventy-two elders whom Ptolemy individually set to the task of translating the Hebrew book produced identical Greek translations of the sacred text. Whiston, in his notes to his edition of Josephus's *Antiquities* (12.2), refers us to the notes by Joannes Hudson and Hadrian Reland (Oxford, 1720), which concern the Talmudists and what Philo Josephus has to say about the gold lettering. See also the writings on this subject by Philo.

184. *Tractate for Scribes,* 1.8, in *The Minor Tractates;* also Higger, *Massekhet Soferim.* Although rabbis banned the use of gold illumination in ritual scrolls, the Talmud's Sabbath 103B (in the *Babylonian Talmud*) and Seferim 1:8 may indicate that more latitude was permitted with codices, or manuscripts that did not serve direct ritual purposes.

185. Diringer, *Illuminated Book,* 84.

186. Ruskin argues that the work of the goldsmith will never be truly artistic until the artist can be confident that the golden plates will not be melted down and recast to suit the taste of some future decade. See Ruskin, *Political Economy of Art,* in *Works,* 16: 45–47.

187. Gauthier notes that "the history of mines and precious or semi-precious metals . . . is only now beginning to take shape" (*Highways,* 91; cf. Gauthier, "L'or et l'église").

188. Bloch, *Esquisse,* 29n. Many wealthy institutions and individuals of the tenth and eleventh centuries did not keep separate accounts for coin and *objets d'orfèvrerie artistique;* they counted on eventually melting down such *objets* into ingots or coin, and so they accounted for them *as* ingots or coin.

189. On the term "treasure," see Werveke, *Annales,* 453.

190. Although manuscripts in gold could be executed on a white ground, manuscripts in silver, sometimes also called "chrysographic," were generally written on a purple ground. Concerning black ink on a gold background, see Diringer, *Illuminated Book,* 85.

191. Hill, *English Monasticism,* 285, writes about "the chrysography or writing in gold of the Greek manuscripts between the fifth and eighth centuries." The Fatimid Library possessed "several copies of the Coron [Koran] written in gold" (Diringer, *Illuminated Book,* 209–10). Chrysography was used in collections of prayers and poems of the caliph al-Mu'tamid.

192. The manuscript is discussed in *Richesse du patrimoine écrit.*

193. Among noteworthy exceptions here would be the sixteenth-century *Horae beatae Mariae Virginis, cum calaendario,* which was written in "humanistic" script on purple parchment with gold (Genoa, BB); see Bologna, *Illuminated Manuscripts,* 152.

194. For *Gellt* as *verbum diaboli,* see Luther, *Tischreden,* vol. 1, no. 391.

195. For *chrusos* as "coin," see Constantine VII Porphyrogenitus in the tenth century (*De ceremoniis aulae Byzantinae*, 379, 20) and Sophronius in the seventh century (in Migne, PG 87:3597b).

196. The First Book of Maccabees may refer to book illumination in gold: "And they [the followers of the Maccabees] laid open the book of the law concerning those things about which the Gentiles were accustomed to inquire, seeking the likenesses of their idols" (3:48); see Diringer, *Illuminated Book,* 67.

197. Saint Jerome, esp. the preface to his translation of the Book of Job into Latin, and his *Letterae familiares* (no. 18). Jerome knew little Hebrew and felt the burden of the past—the golden words that the high priest sent Ptolemy after translating the Pentateuch into Greek.

198. For Christian *chrusographia* in this context, see the Byzantine dictionary of Dionysius the Aeropagite (pseud.), apparently an imitator of Proclus, in Migne, PG 3; see also Charax of Pergamum, *Apud Eust.,* 232.13.

199. No such scrolls have survived, even among the Dead Sea scrolls, so far as I know.

200. Fisher, "Johns," 339. *Tennyson* is a work of 1958.

201. Alpers, *Rembrandt's Enterprise,* 112–13, argues that Rembrandt's *Berlin Money Changer* (1627) is distinguished from "the type of Antwerp banking paintings" of the sixteenth century by "the way its design and execution sustain and extend an aura of contemplation." According to Alpers, the painting "deals with satisfactions which Rembrandt shared." In Rembrandt's works, incidentally, we find not the "halo" properly so called but rather a peculiar linear radiance by which Christ is surrounded. In some of Rembrandt's works, however, including the *Tribute Money* of 1634 and the *Expulsion of the Money Changers* of 1635, there is only a "normal" halo (Rotermund, "Motif of Radiance," esp. 101).

Artists' account books and contracts are becoming increasingly important in art historiography. Account books are of interest for "the artist's discovery of himself as a bourgeois seller and buyer" (Introduction to Farinati, *Giornale,* ed. Puppi, esp. xl; cf. Rosand's review, 409). The account books of Albrecht Dürer, Hyacinthe Rigaud, Joseph Wright of Derby, Sir Joshua Reynolds, Guido Reni, Arthur Pond, Giovanni Francesco Barbieri (Il Guercino), and Paolo Farinati have been considered (Yamey, *Art and Accounting,* 126–27; Lippincott, *Selling Art*). Zampetti claims that Lorenzo Lotto's neurotic character comes through in his account books (Zampetti, *Lorenzo Lotto,* xxv–xxvi). Rembrandt made memorable account entries on a drawing of *Susanna and the Elders* (Benesch, *Rembrandt,* vol. 2, no. 48). Carlo Dolci recorded receipts from a patron on the stretcher of a painting he had commissioned (McCorquodale, "Carlo Dolci's David").

202. On John Chrysostom, see Photius, *Bibliotheca,* cod. 277 (Migne, PG 104:280).

Three Representation and Exchange: America

1. See OED, s.v. "fetish," 1a. Cf. De Brosses, *Culte des dieux fétiches*. Some eighteenth-century writers use the term "fetish" to mean something that is both humanly produced and divinely magical (cf. Latin *factitio* and Portuguese *fetisso*). This conjunction of human and divine qualities is not, of course, alien to European Christendom itself. For various etymologies, see Pietz, "Problem of the Fetish," 5.

2. Cf. Mitchell, *Iconology*, esp. 188, 197; Simpson, *Fetishism and the Imagination*. By 1853 Lewes's view was that "the earliest attempts in all the fine arts, not excepting poetry, are to be traced to the age of Fetishism" (Lewes, *Comte's Philosophy of the Sciences;* from Feldman and Richardson, *Modern Mythology,* 169–70).

3. Marx comments that "forms of social production that precede the bourgeois form are treated by [bourgeois political economy] in much the same way as the Fathers of the Church treated pre-Christian religions" (*Capital* 1:81).

4. Marx, *Kapital,* in Marx and Engels, *Werke,* 23:146–47; *Capital,* 1:132–33; discussed in Shell, *Money, Language, and Thought,* 45–46. Though Marx would not have characterized himself as a Protestant, his modes of argumentation—including sarcastic invocation—suggest an inherent information by Christian doctrine much like that in the argumentation of Hegel and Goethe; see Shell, "Language and Property," in *Money, Language and Thought,* 84–130.

5. See Moses Hess, "Über das Geldwesen," in *Schriften,* 346. "In German thought," writes Hess, "God is merely idealized capital, and heaven the theorized merchant" ("Geldwesen," 337). Cf. Goux, *Iconoclastes,* 162. Fontenoy, *Figures juives* (esp. 61–65), discusses whether Marx was a "plagiarist." In Rhenish Prussia in 1824, Karl Marx's father arranged to have his six-year-old son Karl baptized as a Protestant.

6. For Mitchell, iconophiles would include Gombrich and Arnheim and iconoclasts would include Goodman and Baudrillard (*Iconology,* esp. 151 ff.).

7. Mitchell, *Iconology,* 158.

8. Chapter 3 also considers intermediating kinds of monetary tokens—including those that are partly artworks, like the beautiful coins of ancient Greek, or that are used partly as artworks, like West Frisian coins suspended from the neck as jewelry, or that depict artworks, like nineteenth-century American paper money. Similarly, it considers intermediating kinds of artworks—including those that depict monetary tokens or illustrate stories about monetary exchange and coins attached to the margins of medieval manuscripts.

9. For allegories of commerce: Pigler, *Barockthemen,* 470 ff.; Rücker, "Eine allegorie des Handels"; Tomkiewicz, "'Alegoria Handlu Gdanskiego'"; Markx-Veldman, "Een serie allegorische prenten"; and Garas, "Oeuvres de Schönfeld et de Heiss."

10. See Hessler, *Paper Money,* 16, and Muscalus, *Famous Paintings Reproduced on Paper Money.*

11. The coins that Eugénie Grandet donates to Charles Grandet are called "veritables morceaux d'art" (Balzac, *Eugénie Grandet,* 112–13).

12. In those games of heads-or-tails where the items played with and played for are the same, the coin functions as both money and thing—as both the political authority's inscription and the artfully balanced ingot. Eighteenth-century discussions of marginal utility, of the psychology of risk, and of probability theory saw in this match a way to link the material *likeness* between a coin's two sides—or between one coin and another—with the *likelihood* of the outcome and thus developed a way to calculate various rationales for players of different incomes to scale their wagers. In France the game was generally called *croix ou pile,* and here religious and secular skeptics cast the *croix*—the "milled," or mechanically reproduced, "cross" or *louis d'or* first minted by Nicholas Briot in 1640 (Carson, *Coins of the World,* 242, 244, 261, 291). Literally, they flipped to win the cross as coin; figuratively, they flipped to win the cross as image of the divine surety.

At one time confidence in God had made even the idea of the secular insurance industry sacrilegious, but in terms of the finance of the spirit, it now became good business to believe in God—as argue both the religiously skeptical Pascal and the pragmatically secular William James. Writes Balzac: "'Oh!' he continued, "I wouldn't mind giving five francs to a mathematician who could prove to me the existence of hell by means of an algebraic equation.' He threw up a coin and shouted: 'Heads that God exists!' . . . 'Don't look to see,' said Raphael, seizing the coin. 'How can you know? Chance is such a joker.' . . . 'Alas!' Emile continued with a comically sad air. I don't know where to treat between the geometrical conclusions of the skeptic and the paternoster of the Pope'" (Balzac, *Wild Ass's Skin,* 77–78; see Shell, "Les lis des champs").

13. See the cover of the *Boston Museum Bulletin* (1970).

14. See Rauschenberg's 1973 money collage (two one-dollar bills and one twenty-dollar bill) in the collection of Hisachika Takahashi, Paris.

15. Grabar, *L'empereur dans l'art byzantin,* 7n, refers to the custom of attaching golden medals, often showing a portrait of the ruling emperor, to letters from emperors.

16. Boeckler, *Das goldene Evangelienbuch Heinrichs III.*

17. *Life Magazine,* 12 September 1969.

18. Zelizer calls "pretty money" those monetary tokens "earmarked" for gift exchange (God)—as when a coin is framed in a pretty presentation box (Zelizer, "Earmarked Money," 8). In my view, however, understanding monetary tokens as art-gifts involves consideration less of "earmarking" than of how money actually becomes—or is—artwork and artwork becomes—or is—money. Cf. Sombart, *Moderne Kapitalismus,* and Simmel, *Philosophy of Money.* That the arrival of a monetary economy has its counterpart in the aesthetic realm is a Japanese idea as well as a European one. Pastreich, for example, shows that in the late Edo period, when "the evolution of a monetary economy was threatening to turn all art into a commodity," the literatus Tanomura Chikuden "developed a theory of art in which the essence of a work cannot be reduced to material object" ("Sanchūjin Tanomura Chikuden"). See Akinari Ueda's eighteenth-century story "Wealth and Poverty" (*Himpuku-ron*); some editions have woodcuts of "the spirit of gold [who] comes in the night" (Ueda, "Wealth and Poverty," 199).

19. On Plato, see Shell, *Economy of Literature,* chap. 1 and conclusion.

20. Gauthier, *Highways,* and also *Ezekiel,* trans. Eisemann. Gyges is a subject of my book *The Economy of Literature.* Gog is a subject of Hanna Shell's essay "Book of Ezekiel," first delivered as a public address at the Jewish Community of Amherst, Mass., 6 October 1990.

21. For Hermes and Mercury: Gaidoz, "Diable d'argent," cols. 205–6, 120; De Meyer, "Diable d'argent." For the New Testament: Revelation 20.

22. On the expulsion from the temple, see Buchanan, "Symbolic Money-Changers," and Neusner, "Geldwechsler in Tempel."

23. Gauthier, *Highways,* 166–68.

24. Smolar and Aberbach, "Golden Calf," 100–101; cf. *Encyclopedia Judaica,* s.v. "golden calf."

25. In Honoré Daumier's cartoon *L'adoration de veau d'or* (in *La Caricature,* 1834), the "capital" that is the calf is depicted as a coin. For the connection of the term *capital* with cattle—including calves—see OED, s.v. "capital." Another important example of the treatment of the golden calf in Christian art is Nicolas Poussin's *Adoration of the Golden Calf* (1635; National Gallery, London).

26. On the *Trinkgeld* made with *Blattgold,* see Grimm and Grimm, *Wörterbuch,* 8:865; the best-known brand is Danziger Goldwasser. Compare the *feuilles d'ors* sometimes served with French desserts, various Indian dishes, and so forth.

27. See the story of how Marcus Licinius Crassus, called Dives (rich), was killed in 53 B.C.: the Parthian general Surenas poured molten gold down his throat (*Encyclopaedia Britannica,* 7:381).

28. For an early subject inventory of the money devil see Denis de Mathonière (1598), discussed in Wildenstein and Adhémar, "Images," 150.

29. "Toutes les nations de la terre cherchent le diable d'argent" (Gaidoz, "Diable d'argent"). Bryson, *Looking at the Overlooked,* 108, considers the mania for tulips as an aesthetic phenomenon, and he speculates on "the connection between flowers and actual cash, as opposed to their value as 'symbolic capital.'" On the tulip scandal—and the history of cartoon and caricature—see Gratama, "Caricaturen van den tulpenhandel." See too *Sale of Tulip Bulbs,* an oil painting on wood of the Flemish school (end of fifteenth century, beginning of sixteenth) in the Musée des Beaux-Arts et d'Archéologie (Rennes, France).

30. "Gellt est verbum Diaboli, per quod omnia in mundo creat, sicut Deus per verbum creat" (Luther, *Tischreden,* vol. 1, no. 391). See Barge, *Luther.*

31. "Das papierne Jahrhundert" (Büsch, *Banken und Münzwesen,* 221); quoted by McCusker, "Colonial Paper Money," 94.

32. "Shall we call it, what all men thought it, the new Age of Gold? Call it at least, of Paper; which in many ways is the succedaneum of Gold" (Carlyle, *French Revolution,* 1:24–25).

33. John Law is often credited with introducing paper money along the lines that we now know (Minton, *John Law;* Beach, "Monetary Theories of John Law"; and Kerschlagel, *John Law*). On John Law in the history of aesthetics, see also Groseclose, *Money and Man,* 120, 140–41.

34. The term "verbal usury" is used to refer to the generation of an illegal—the church fathers say "unnatural"—supplement to verbal meaning by such methods as punning and flattery. The Talmud reads, "R. Simeon said: There is a form of verbal interest" (see Baba Mezi'a 75a–b; Mishnah on 434, and Gemara on 435 in *Babylonian Talmud*). Hughes notes that "in the [Islamic] Traditions, Muhammad is related to have said: —'Cursed be the taker of usury, the giver of usury, the writer of usury, and the witness of usury, for they are all equal'" (*Dictionary of Islam,* s.v. "usury"; see also Sahihu Muslim, Babu 'r-Riba). "Spiritual usury," say the church fathers, refers to hoping for gratitude, or some other kind of binding obligation, in return for a loan that is otherwise given gratis. The *Glossa ordinaria* considers the "spiritual usury" that is approved by the parable of the talents (Matt. 25:14–30; Migne, PL 113, cols. 446, 478–79). Nelson notes that "Zwingli, like Luther and Melanchthon, seems loath to concede that a strict prohibition of usury might be inferred from Scriptures. [Zwingli declares that] to deny the name of Christians to those who extend loans with a hope of profit is to torture the texts [esp. Luke 6:34–35]" (*Idea of Usury,* 65; see Zwingli, *Sämmtliche Werke,* 6:589).

35. Joseph Alexandre Ségur is quoted by Soullié, *Critique comparative,* 14; my translation.

36. "Tout pour rien" (Gaidoz, "Diable d'argent").

37. For images of cornucopias with coins issuing forth, see Mâle, *Art religieux du VIIe siècle.*

38. *De eklips der zuider zon . . .* (The eclipse of the sun . . .), *Catalogue of Prints and Drawings* no. 1654, refers to "de drommel in specie" (the devil in specie).

39. *De verwarde actionisten torenbouw tot Babel* (The babel-tower of the confused stockjobbers), *Catalogue of Prints and Drawings,* no. 1672, has a cartoon of John Law with the inscription "Law, whose affairs have turned from something to nothing." The equation or balancing of all with nothing is a major theme here; Gaidoz, "Diable d'argent."

40. Defoe, *Chimera.*

41. Voltaire, *Oeuvres historiques,* 1309.

42. Voltaire, *Oeuvres historiques,* 1311; this was written about a later Dutch scandal.

43. Voltaire, *Oeuvres historiques,* 1309. Jonathan Swift wrote, "Ye wise Philosophers! Explain / What Magick makes our Money rise, / When dropt into the Southern Main; / Or so these Jugglers cheat our Eyes?" (quoted in Marlowe, *George I,* 1:163). Hasson, "South Sea Bubble," mentions also Charles Lamb's *Essays of Elia,* including "The South Sea House." See also Alexander Pope's "Cashier of South Seas Co.;" and *Catalogue of Prints and Drawings,* xxxi.

44. Montesquieu, *Persian Letters,* no. 142, in *Oeuvres complètes,* 351–53. *Bête,* or "beast," means something like stupid or silly.

45. In the paper money scene in *Faust,* part 2, what was presented in the *Schein* (seeming) of the previous masque scene as plenty of *Gold* issues as *Geldscheine* (paper money). When the paper money scene begins, we learn that the creditors of the emperor are somehow paid; the army is rehired, and there is fresh blood in the soldiers' ranks (*Faust,* 6047). The chancellor then explains what has happened when he reads aloud a text inscribed on a leaf of paper: "Be it known to anyone who desires it: the ticket here is worth a thousand crowns" (*Faust,* 6061–62). During the masque the emperor had set his signature to this negotiable paper with a feather pen (6064–70), just as Faust (in part 1) had set his signature to the contract with Mephistopheles with a feather.

Faust's words mocking Mephistopheles' demand in Part 1 that their contract be a written one—"An inscribed and sealed parchment is a ghost" (*Faust,* 1726–27)—make us leery of this "ghost money" in part 2. The monetary bargain in part 2, which promises delivery of assigned underground goods, is thus the foil to the contract between Mephistopheles and Faust, which seemed to promise delivery of a soul. As a "magic mantle" (*Faust,* 1122) seemed to redeem Faust's situation in part 1, so the "magic leaves" (*Faust,* 6157) of money seem to redeem the political economy of the empire in part 2. They are "gilded leaves"—like the "leaf" on which Faust wrote his pact.

On aesthetics, gambling, and the devil in *Faust,* see Fabian, *Card Sharps,* chap. 4, and my "Language and Property," in Shell, *Money, Language, and Thought.*

46. Minton, *John Law,* 261. For a French medal of 1720 commemorating John Law and the Mississippi System in which the topos of the windmill figures prominently, see Shell, *Money, Language, and Thought,* fig. 15, with explanatory legend. The term *kite* is commercial slang for "exchange bill." On the financial institution called "flying money" (*fei-ch'ien*) in China (ca. 750), see Yang, *Money and Credit,* 52, and idem, "Das Geld," 335.

47. *Catalogue of Prints and Drawings* no. 1689, playing card P: "Ik duisend-konst-nar van't wind-tent-balet der Fransen, Schreyeendende op de koord mey hoffd-wind-breuk ub 't dansen." *The Bubbler's Kingdom* is no. 1662; *The Bubblers Medley* is no. 1611; cf. no. 1642.

48. For Italy, see Gaidoz, "Diable d'argent," col. 54.

49. Holland's basing its finances on nonexistent lands, sometimes said to be the key to its particular "culture of money," was a favorite theme.

50. For Russia, see Ducharte, *Imagerie parisienne russe,* 41. The history of Russia's financial institutions in relation to its admiration of John Law is now waiting to be written in the post-Soviet era.

51. The goddess Fides is often depicted standing, her head veiled as a sign of the sacred nature of her tutelary function. "There is nowhere more sure or more sacred for depositors to place their money than under the protection of the public faith" (Titus Livy 24). Simmel writes that the Maltese numismatic inscription *Non aes sed fides* (Not brass but faith) indicates "the element of trust without which even a coin of full value can't perform its function in most cases" (*Philosophy of Money,* 178). However, the inscription probably also refers to the fact that the Roman colonies were generally allowed

to mint only the relatively base metals (*aes* often means bronze and copper as well as brass); and only Rome itself could mint gold (see Lenormant, *Monnaie dans l'antiquité*, 2: 120; cf. the Latin phrases *aes et libra* and *aes alienum*).

52. In nineteenth-century America, money devils were part of the caricaturist's common stock. Other examples would include H. R. Robinson's *General Jackson Slaying the Many Headed Monster* (1836, Library of Congress, no. 13 in *American Presidency)*; Leon Barrit's *The Commercial Vampire* (1898, Chicago Historical Society, no. 75 in *Image of America*); and William A. Rogers's *About Run Down* (1899, in Rogers, *Hits at Politics*).

53. Marx calls Hegel's thought "mind's coin of the realm" (*das Geld des Geistes*) in his *Critique of Hegelian Dialectic and Philosophy as a Whole* (Marx and Engels, *Werke*, Ergänzungsband, pt. 1, 571; trans. Marx, *Economic and Philosophic Manuscripts*, 174). Compare Marx's ironic quip that "money is the real mind [*Geist*] of all things" (MEW, Ergänzungsband, pt. 1, 564; trans. *Manuscripts*, 167). Schütz argues that in Goethe's *Faust* "idealism is paper money and paper money is idealism (*Göthe's "Faust,"* 236; my translation).

54. See Shell, *Money, Language, and Thought*, fig. 5. For illustrations of similar "Andrew Jackson lampoon-tokens," see Morison, *Oxford History*, 324–25.

55. On Reinhardt, see T. B. Hess, *Art Comics*.

56. Paper money had circulated in Europe at earlier times, as discussed by Adam Smith in *Wealth of Nations*. But historians generally distinguish the popular, long-term use of paper money in America from its restricted use by merchants and bankers in eleventh-century Italy, for example, or from its short-term use by the French during the paper money experiments of the 1720s. Historians also distinguish the common use of scriptural money from fiduciary money, which began its widespread, long-lived use in America. (See Wagenführ, *Der goldene Kompass*, 73–76; Braudel, *Capitalism and Material Life*, 357–72; and Newman, *Early Paper Money of America*.) Benjamin Franklin, that all-American, was already printing paper money for colonial governments in 1728. The next year he published the *Necessity of a Paper-Currency*, in which he discussed the money backed only by government commitment. In the Revolution, the Continental Congress issued "Continentals." After independence, commercial banks in the major seaports and the federal bank of the United States began issuing bank notes. With the nineteenth century came the "outburst" of private banks and bank notes in all parts of the nation.

57. Thomas Love Peacock, *Paper Money Lyrics* (1837), uses the term "paper money men." St. Armand writes that "the end of the nineteenth century the term 'gold bug' was [also] applied in America to scheming capitalists like Jay Gould ['gold'], who tried to corner the gold market, or to fanatical advocates of a gold standard over a silver standard" ("Poe's 'Sober Mystification,'" 7n). See also n. 60 below.

58. Braudel, *Capitalism and Material Life*, 357–58. On credit and belief, see Shell, "Les lis des champs."

59. "You sent these notes out into the world stamped with irredeemability. You put on them the mark of Cain, and, like Cain, they will go forth to be vagabonds and fugitives on the earth." Congressman George Pendleton (Ohio) thus opposed the is-

suance of legal tender on 29 January 1862 (*Congressional Globe,* 37th Cong., 2d sess., lines 549 ff.; reprint Samuelson and Krooss, *Documentary History,* 4:1276).

60. Robinson also made maps of the "gold regions" of the United States "embracing all the new towns and the dry and wet diggins" (Robinson, *Correct Map;* see the collection of Robinson's caricatures at the Bancroft Library, University of California, Berkeley). On the relationship of Robinson's "Gold Humbug" to Poe's story, see Shell, *Money, Language, and Thought,* 13. To the various meanings of "goldbug" I consider there should be added the *gul-baug*—"the money-like gold ring"—of Scandinavian sagas (Du Chaillu, *Viking Age,* 2:16, 476–77; Del Mar, *Monetary Systems,* 256–57).

For other cartoons about paper money in the United States, see Homer Davenport's *The Dollar or the Man?* (1900) and such cartoons as Walter McDougall's *The Royal Feast of Belshazzar and the Money Kings* (in *New York World,* 1884), Davenport's *Caricature of Mark Hannah* (with a suit covered with dollar signs; 1883), and John Tirney McCutcheon's *A Wise Economist Asks a Question* (1932; cited in Pogel and Somers, *Handbook,* 109–10). See also "All-American"; Carmon, *Red Cartoons;* Wynn Jones, *Cartoon History;* Murrel, *History of American Graphic Humor;* and White, "Caricature and Caricaturists." Cf. American joke coins (e.g., Hefferton's "Lincoln Memorial" and O'Dowd's "Silver Certificate," cited in Lipman, "Money," 80), various nineteenth-century German pseudo–bank notes (Harten, *Museum des Geldes,* 1:46, 2:142), and French joke bank notes (Grand-Carteret, *Livre et l'image,* 375–83).

61. Johnson's caricature of a shinplaster (1837) thus expresses visually the same link between the bug for gold and money grubbing that motivates Poe's story and that later in the century informed much psychologizing about money and feces. Many money devil cartoons, indeed, show the money devil defecating ducats—a psychoanalytic interpreter's delight. A few focus on the devil's much-talked-about tail. See my discussion of Poe's *Dukatenscheisser* and of medieval illuminations of hybrid creatures defecating into bowls held by apelike money devils (Shell, *Money, Language, and Thought,* 11–12, 18), and my summary history of the "money complex" in psychoanalysis since the publication of Freud's essay "Character and Anal Erotism" (Shell, *Money Language, and Thought,* app. 3, 196–99). For an illustration of Johnston's work (and historical background), see Johnson, *Great Loco Foco Juggernaut.*

62. In Goethe's *Faust,* the bank note (*Geldschein*) as ghost is a major theme; and in Karl Marx's works, paper money is frequently associated with the "shadow" of Peter Schlemiel. On this meaning of "ghost" (cf. German *Geist,* meaning spirit), see Shell, *Money, Language, and Thought,* 21, 84–130 passim; and for the American context, see William Charles's *The Ghost of a Dollar, or The Banker's Surprise* (ca. 1810, a cartoon in the collection of the American Antiquarian Society; in Murrel, *American Graphic Humor,* no. 74).

63. "Tout se résume dans l'Esthétique et l'Economie politique" (Mallarmé, *Oeuvres,* 656; see *National Observer,* 25 February 1893). Cf. Derrida, "Double séance," 292. French fiction writers—including Paul Claudel, Alphonse de Lamartine, Alphonse Daudet, Guy de Maupassant, and others—have long written for financial journals; much of this writing remains unstudied, but some is now being edited by Jean-Marie Thi-

veaud ("Claudel"). On the Panama scandal, see Bonin, *L'argent en France,* esp. 225–39 ("L'argent mythique") and 249–51.

64. Baldwin's *Flush Times of Alabama and Mississippi* concerns "that halcyon period, ranging from the year of Grace, 1835, to 1837 . . , that golden era, when shinplasters were the sole currency . . . and credit was a franchise" (1). Baldwin's narrator tells the story of a man who "bought goods . . . like other men; but he got them under a state of poetic illusion, and paid for them in an imaginary way" (4). "How well [he] asserted the *Spiritual* over the *Material!*" exclaims the storyteller (5). See Schmitz, "Tall Tale, Tall Talk," 473–77.

65. Roosevelt, "Paradox of Political Economy." See Dorfman, *Economic Mind,* 2: 660–61.

66. Wells, *Robinson Crusoe's Money* (1896), 57; cited by Michaels, *Gold Standard,* 146.

67. The story of Zeuxis trimming his robe with gold is also relevant (Bann, "Zeuxis and Parrhasius"). The business of exchanging images involves visual puns as well as linguistic ones. Félix Labisse's exchange of image for thing is the typical punning *gesture* in the modern period. One of his works, which depicts a hand, has the inscription, "Mon amour, vous m'avez demandé ma main, je vois la donne" (My love, you have asked me for my hand, I give it to you; Harten, *Museum des Geldes,* 2:67). On the tale of Zeuxis, see also Wagenführ, *Der goldene Kompass,* 222.

68. Cf. Foucault's *This Is Not a Pipe.*

69. Nevertheless, it is worth remarking again the old argument that, as Mitchell puts it, "when a duck responds to a decoy, or when the birds peck at the grapes in the legendary paintings of Zeuxis, they are not seeing images; they are seeing other ducks, or real grapes—the things themselves, not images" (*Iconology,* 17, cf. 90).

70. Hessler, *Paper Money,* 17.

71. Samhaber, *Das Geld,* 47. Likewise, much nineteenth-century Chinese playing card money depicts coins (Prunner, *Ostasiatische Spielkarten*).

72. In France the Musée de la Poste held its exhibition titled *Les couleurs de l'argent* in early 1992 just as the national postal service attempted, unsuccessfully as it turned out, to take over one of the traditional moneylending roles of regular banking institutions.

73. In many playing card systems there are suits signifying money. In the Indian and Persian systems, for example, there are the suits *safed* (for silver coin) and *surkh* (for gold coin) (Leyden, *Indische Spielkarten,* 8–9); in Mamluk cards there is the suit of *drachme* (Leyden, "Oriental Playing Cards," 16–17; cf. Mayer, *Mamluk Playing Cards,* 6–8); and in Italy there is the suit of *denari,* from which the French suit *caro* developed (Leyden, letter to author, 14 November 1979). Note the likely etymological link between the ace in card games and the *as,* or *aas,* in the Roman monetary system (Del Mar, *Monetary Systems,* 17–18).

74. Paper money made from playing cards was used in Canada in the seventeenth century (McLachlan, *Canadian Card Money*), in France during the Revolution, and in

Germany and Austria during World War II (Beresiner, "Legal Tender," 82 ff.). The history of playing card paper money, which is loosely connected with that of gambling as a type of early capitalism, is not well known. Chinese money playing cards may have inspired playing cards in Central Asia and Mamluk Egypt—and from there in Italy and the rest of Europe. The round form of other Indian playing cards, with gold foil used as decoration, is linked with their being made in the shape of coins (Prunner, *Ostasiatische Spielkarten*). On the tarot pack, see Moakley, *Tarot Cards Painted by Bonifacio Bembo*.

75. See "Likeness and Likelihood," in Shell, *Money, Language, and Thought*.

76. On the "bodiless and homeless Rag baby of fiat money," see Thomas Nast St. Hill's brief remarks in Nast, *Cartoons and Illustrations*, 96.

77. Carlyle, *French Revolution*, 1:25–25; my emphasis.

78. In the same punning vein are such works as Cildo Meireles' *Zero Cruzeiro* (1970s) and Waltercio Caldas's *Dinheiro para Treinamento* (1977).

79. "J'ai racheté ce cheque, vingt ans après, beaucoup plus cher que ce qui était marqué dessus," said Duchamp to Pierre Cabanne (Duchamp, *Entretiens*, 116). Concerning this check, see also Heinzelman, *Economics of the Imagination*, chap. 1. Cf. Duchamp's "L'obligation pour la roulette de Monte Carlo," in *Il reale assoluto* (Duchamp, *Complete Works*, no. 368); his *Czech Check* (*Complete Works*, no. 374); and his *Cheque Bruno* (*Complete Works*, no. 377).

80. Depicted by Clair, *Duchamp et la photographie*, 55. There is a pun on *au*. First, the French *eau* (meaning both "water" and "perfume") suggests that paper money is the perfume of silver. Second, *au* (as the English *owe*) suggests a relation to a credit economy dependent on checks. Compare the association with silver nitrate. Cf. Lyotard, *Duchamp's TRANS/formers*.

81. Weschler, "Onward and Upward with the Arts," 44.

82. For an example of the thematic of the signature as fetish, see Reuterswärd's *The Great Fetish: Picasso's Signature, a Sleeping Partner* (no. 2/2 1974–77, a steel and bronze sculpture, 172 × 482 × 90 cm). Reuterswärd's *L'art pur l'or* depicts the sign of an investment firm in Liechtenstein that sells artists' signatures. His question is "Wie wäre es, wenn wir uns auf den wichtigsten Teil des Kunstwerks konzentrieren, DIE SIGNATURE?" (An der Schlur/Oberbayen, 27 March, 1975); in Harten, *Museum des Geldes*, 2: 177–79.

83. The quotation is from the artist's essay in the Finnish catalog *Kienholz*. Kienholz's *Watercolors* were exhibited at the Eugenia Butler Gallery (Los Angeles), in 1969.

84. Benjamin, "Eduard Fuchs," 384, 386.

85. Quoted by Harkness in a note to Foucault, *This Is Not a Pipe*, 62n.

86. Examples would include Clara Peeters's *Still Life with Flowers and Goblets* (1612) and Jan Brueghel's *Still Life with Wreath of Flowers* (1618; Italiaander et al., *Geld in der Kunst* 67, 65). For other examples, see *Lexikon der Kunst*, s.v. "trompe l'oeil." For Metsys's *Money Changer and His Wife* as trompe l'oeil, see Mastai's relevant arguments in *Illusion in Art*. On fetishistic qualities of "still life" paintings generally, see Bryson "Char-

din," and Hal Foster, "Notes on Dutch Still Life," in Apter and Pietz, *Fetishism as Cultural Discourse*, 251–65.

87. On the link between flatness generally and trompe l'oeil, for example, see Frankenstein, *Hunt*, 43. Cf. Michaels's discussion of Greenberg's *Art and Culture* (Michaels, *Gold Standard*, 163–66).

88. Battersby, *Trompe l'Oeil*, 128, includes a reproduction of this work of 1797.

89. For French examples of 1796–97, see Grand-Carteret, *Vieux papiers*, 379, no. 327. Though Chambers (*Old Money*) seems able to locate only one painting of this sort made before 1877—an anonymous English royal of 1828—and Nygren, "Almighty Dollar," is similarly unable to find earlier examples, there is eighteenth-century German and French trompe l'oeil paper money.

90. Chambers writes that "from 1877 through the first decades of the twentieth century more than 20 painters addressed themselves to this theme, some to the exclusion of all else, while European artists continued to remain silent on the subject" (*Old Money*, 15).

91. Trompe l'oeil paper money was the "art of the people"; "second only to the Exposition as an outlet for art in America was the saloon" (Frankenstein, *Peto*, 21).

92. Peale "may have painted a bank note in his picture of 1795 entitled *A Bill*" (Frankenstein, *Hunt*, 31, 43).

93. On Harnett's legal problems with the secretary of the treasury, see Frankenstein, *Hunt*, 56, 82; and Bolger et al., *Harnett*.

94. See "Paper Money Made into Art You Can Bank On."

95. *Old Money*, 68; Frankenstein, *Hunt*, 151.

96. *Old Money*, 30–32.

97. Depicted on Chalfant's *Which Is Which?* (1888) is a trompe l'oeil newspaper clipping that reads: "Mr. Chalfant proposed to paste a real stamp on the canvas beside his painting, and the puzzling question will be 'Which is which?'" (Frankenstein, *Hunt*, 27, 125, and pl. 108; and Frankenstein, *Reality*, 152–53).

98. The punning spirit of this sort of art is reflected by the titles of popular essays on the subject in publications like *Time* ("Art Finger: Turning Pictures into Gold"), *Life* ("Paper Money Made into Art You Can Bank On"), and *Vogue* ("More Money Than Art").

99. Kurtz (correspondence) says Dubreuil "loved the symbol of currency, which he always included in his paintings"; Dubreuil also did a few portraits, however.

100. Cited by Hoogenboom and Hoogenboom, *Gilded Age*, 176–77. Compare contemporary cartoonists' mockery of "gold bug" legislation in the 1890s, including *Uncle Sam after Twenty Years of Peace and Gold Bug Legislation* (in Shibley, *Money Question*, 70). See also John Singer Sargent's painting *The Gold Bug* (De Young Museum, San Francisco).

101. Marc Bloch, *Esquisse*, 29; my translation. Bloch also reports that "a little before

A.D. 1146, the monks of Saint-Benoît-sur-Loire, in order to provide food for the poor during a period of famine, had melted down a silver crucifix."

102. Howard Bloch (professor of French at the University of California at Berkeley) posed this riddle during a conversation on 11 November 1990.

103. One might consider here the difference between representing money as a cross (as in Dubreuil's work) and representing money as the thing crucified (as in Alain Snyers's *Ten French Francs, Crucified;* fig. 30).

104. "And all the people brake off the golden earrings which were in their ears, and brought them to Aaron. And he received them at their hand, and fashioned it with a graving tool, after he had made it a molten calf: and they said, These be thy gods, O Israel, which brought thee up out of the land of Egypt" (Exod. 32:3–4).

105. These pieces are minted "with the images of Constantine and Helena, and the Cross between them. . . . We have these coins [called *santelene,* from the name *Saint Helena*] to the present day" (Schischmánoff, *Légendes religieuses bulgares,* 74–75; cited in Hill, *Thirty Pieces,* 107n).

106. Dubreuil's father, Aimé [or Amedée] T. Dubreuil, was born in Saint Etienne, France—an important silk textile center of the period. He emigrated to the United States in 1847. Victor too may have spent time in Europe: his *Five Hundred Franc Note* (1900) came to light with a dealer in Amsterdam, and the fictional newspaper *Sport* (dated 21 February 1900) in *Don't Make a Move!* features headlines from Derby, England, and Chantilly, France. Nygren, "Almighty Dollar," 146n, makes the too sweeping claim that all Dubreuil's titles are modern inventions.

107. Dubreuil made several of these, most in 1898. The Museum of Fine Arts in Saint Petersburg, Florida, has a good example.

108. Williams, *Paterson,* bk. 4, pt. 2, p. 217. Williams (b. 1883), like his fellow-poet Ezra Pound (b. 1885), was much influenced by the monetary goings-on during his youth. On Pound's view of economics and the link between aesthetics and economics—as expressed in his *ABC of Economics* (1933) and elsewhere—see remarks and references in Shell, *Economy of Literature,* 2, 42, 93.

109. Spoerri's sculpture, made of a crucifix and coins, is in the collection of Philippe Hämmerle in Vienna; *Couleurs de l'argent,* 21.

110. *Old Money,* 94–97; see La Borie, *Kaye;* Sotheby's, *American 19th and 20th Century Paintings,* 33A, and *Important American Paintings,* 68A, 83; and my forthcoming "Handel with Care."

111. Boggs himself tells the story: he goes to a restaurant and gives the owner the choice of taking as payment a real hundred-dollar bill or a hundred-dollar bill drawn by Boggs (*Old Money,* 94; cf. 17). Boggs's *Dinner for Eight* is composed of the documentary elements of a similar transaction between artist and restaurant waiter. Clockwise from upper right: the restaurant menu, the fake bank note that Boggs gave to the waiter (the waiter recognized this bank note as fake money but accepted it at face value, supposedly because he credited it as art), the genuine bank notes that the waiter gave to Boggs as his

change, a photograph of the exchange between artist and attendant, and the bill. Jackson Pollock also settled some of his bills in this manner; Picasso did the same (Weschler, "Onward and Upward with the Arts," esp. 44; cf. Weschler, *Shapinsky's Karma, Bogg's Bills*), and Boggs, *Smart Money*.

When his artworks were seized recently by the Secret Service, Boggs sued the government for return of his property. On 9 December 1993, Judge Royce C. Lamberth (United States District Court for the District of Columbia) ruled in favor of the government (Director of the Secret Service Eljay Bowron, Secretary of the Treasury Lloyd Bentsen, and Attorney General Janet Reno). In his "Memorandum Opinion" Judge Lamberth wrote: "This court believes that many of the Boggs Bills could be passed as genuine" (45). He concluded: "It is often said that 'a picture is worth a thousand words.' Unfortunately, Mr. Boggs' works are often worth a thousand dollars" (47).

112. Frankenstein, *Hunt,* 43.

113. Orvell, *Real Thing.*

114. Samuel Young's "Oration Delivered at the Democratic Republican Celebration of the Sixty-fourth Anniversary of the Independence of the United States" (4 July 1840) included the following statement about the struggle between shadow and substance, ideal and real: "The leaders of [the Federalist party], regardless of the liberty and independence of the Republic, sighed aloud, in lugubrious tones, for the golden days of commercial prosperity. The same false charges are now made against the present [Democratic] administration of the general government, and the same tones are now loudly uttered with the variation only of a single word, occasioned by the modern Whig [Federalist] discovery that *gold* is a *humbug,* and *paper* is therefore substituted for *golden.*" On the word "humbug," see also the section "The Issue of Representation," above.

115. Another "Jim the Penman" (a nickname for Emanuel Ninger) had operated in England earlier in the century (*Old Money,* 26–27). Cf. Bloom, *Money of Their Own.*

116. See Feidelson, *Symbolism and American Literature,* esp. 159.

117. Royal Bank of Canada, *Canada's Currency,* 13.

118. Weissbuch, "Confidence-Man's Counterfeit Detector"; and Dillistin, *Bank Note Reporters and Counterfeit Detectors.*

119. That there were well over three thousand "legitimate" banks in the United States made "ghosts" all the easier to fabricate.

120. See Glaser, *Counterfeiting in America;* Bloom, "Money Maker"; and "Cashiered."

121. For discussion of the artist/counterfeiter Ranson—together with an illustration of a caricature bank note—see Phillips, "Bank Note Collecting," 44 ff.

122. Fisher, "Johns," 320, writes that Johns's *Flag* seems almost to rob the American flag it imitates.

123. For Peto, see Frankenstein's catalog of his works.

124. On the 1909 law: Kerley, "Putting Snap into Life," and *Old Money,* 53. For the rug: Lipman, "Money for Money's Sake." For a list of magazine articles: Boggs, *Smart*

Money, 38–39. Boggs's unfortunate troubles with the American Secret Service roughly parallel those of the straightforwardly trompe l'oeil artists; see n. 111 above.

125. Holbein's work is in Windsor Castle. On the illuminated manuscript, see Martin, "Numismatique," 41.

126. Picasso's work, included in *Couleurs de l'argent,* is in a private collection. The artists Werner Hilsing and Anne Jud suggest other perspectives.

127. Weschler, *Kienholz,* 420. For Hilsing, see Italiaander et al., *Geld in der Kunst,* 131; for Jud, see Harten, *Museum des Geldes,* 2:117.

128. See Gibbons, *Physics and Metaphysics of Money.*

129. Cf. Reuterswärd's holographic *Head or Tail* (1975), which was made with help of the Carl Zeiss Corporation (Switzerland).

130. The Sharper Image catalog adds the following information: "Now, through the magic of modern holography you can hang the image of a $10,000 bill in your office or den. Technicians at a Philadelphia design firm expose a genuine 1934 A-series bill to the reflected rays of an argon laser." The holograph bill, we are told, depicts Salmon P. Chase, who as Lincoln's treasury secretary oversaw the printing of the nation's first "greenbacks," and looks so authentic that "the US government warns this holographic bill may not be used as legal tender—even though only the front shows."

131. For an early history of this dematerialization in the realm of art, see Lippard and Chandler, "Dematerialization of Art," and Lippard, *Six Years.* For remarks about the attempts of such conceptual artists as Douglas Huebler to determine in 1968 "how you could make work that was not an object"—and for a critique of the Lippard/Chandler thesis—see Hapgood, "Remaking Art History," esp. 119.

132. On electronic fund transfers, see Richardson, *Electric Money,* and Mattick, "Die Zerstörung des Geldes." For Douglas's "hard money" line, see Perkins, *New Age of Franklin Roosevelt,* 21.

133. Sandler, *Triumph of American Painting.*

134. See "Paper Money Made into Art You Can Bank On."

135. *Yen for Yens,* an accumulation of Japanese bank notes in Plexiglas, is in Arman's own collection.

136. Lipman, "Money for Money's Sake," 82.

137. See chap. 2, n. 132, above.

138. Cited by Green, *Eighteenth Century France,* 7. In the same context John Law argues that "money is the blood of the state and must circulate."

139. Blake, *Poetry and Prose,* 573. Cf. Blake's statement that "Where any view of money exists, art cannot be carried on."

140. See Morris, "Notes," pt. 4, 205.

141. In private correspondence with me (March 1991), W. J. T. Mitchell recalls that "Morris responded to a collector's nonpayment for a work by drawing up a 'certificate

of withdrawal of aesthetic value' (this certificate, unsurprisingly, was also bought and mounted for display next to the work from which the value had been 'withdrawn')."

142. Lipman, "Money for Money's Sake," 76–77.

143. Lipman, "Money for Money's Sake," 77.

144. For Ferrer: Lipman, "Money for Money's Sake," 88. For Klein: Harten, *Museum des Geldes,* 2:120; cf. Klein, *Il mistero ostentato.*

145. In French: "Distribuer de l'argent est pour moi une forme d'art. Mon programme MAS [Money Art Service] prévoit également de vendre de l'argent à moitié prix, et de jeter de l'argent dans les rues. . . . Quand je donne un billet à un passant, je crée un contract entre celui qui reçoit l'argent et moi, et cet acte est en même temps un fait artistique et critique" (Marin, "Distribution des billets"). Cf. Marin, *Money Art Service.*

146. As if a historical pendulum were swinging the other way, some recent artwork predictably stresses the material aspect of coins. Susan Stewart ("On the Work") reports of Ann Hamilton's art project *privatation and excesses* that "Hamilton took the budget for this project and converted it into 750,000 pennies. The pennies were arranged on a skin of honey defining a forty-five by thirty-two foot rectangle on the floor; this extraordinary multitude of copper pieces . . . seemed spaced in reptilian waves across the space." Among other aspects to the project was a motorized mortar and pestle at work in grinding a bowl of pennies and teeth. "At the conclusion of the project the pennies were cleaned and counted. Expenses were covered and then the remaining pennies were donated to fund a day-long dialogue on art as process."

147. For the quotation: Haacke, *Unfinished Business,* 118–19. Haacke's *Manet-Projekt '74* (part of the *Project '74* exhibition held at the Wallrach-Museum, Cologne) displayed Manet's *Bunch of Asparagus* together with panels listing details about all the previous owners of the work. Cf. Haacke, *Framed and Being Framed.*

148. Cited in Gilbert-Rolfe, *Immanence and Permanence,* 170–71. For Andre's high prices: In 1976 his *Equivalent VIII* (1966), consisting of 120 bricks arranged two deep in a rectangle, was vandalized at the Tate; there was an outcry about the alleged waste of public money on its purchase by the Tate Gallery.

149. These words of the self-styled conceptual artist Robert Cenedella are quoted by Miller, "Art of the Deal." In March 1994, Cenedella formed a partnership, called Contemporary Art Shares Incorporated, in order to sell stock in his own paintings. One of these, *2001, a Stock Odyssey,* depicts the New York Stock Exchange. Cenedella, whose collaborator is in the financial printing business, says, "Look, instead of a stock certificate you put in your drawer, you get a serigraph that you can put on your wall."

150. One project that confuses art and gift in much the same tradition as Hyde, *Gift,* is Jonier Marin's undertaking described above, which makes the distribution of money an artistic act. Among critics of all such projects, including those actually called anti-money, would be Jürgen Harten, curator of a large-scale exhibition dedicated to money art, who asks whether "the idea of anti-money [is] not the last, fruitless evasion of anti-

art, its gaze fixed on commerce, hypnotized into submission?" (Harten, "What Should the Artist Do in Relation to Industry and Commerce?").

151. Concerning this analogy between art market and relics market, Robert Hughes said in 1984 that "there is no historical precedent for the price structure of art in the late twentieth century" ("On Art and Money," 23); but Tom Wolfe was closer to the truth, despite his satirical edge, when he wrote, in the same year, that "today the conventional symbol of devoutness is—but of course!—the Holy Rectangle: the painting" ("Worship of Art," 63); cf. Montag and Stadler, "Artworks and Pricetags." On the frenzy of consumerism, see Danto's complaints about the "passionate and frenzied arbitragers" of the art market in the 1980s (*Encounters and Reflections,* 96–97).

152. On van Gogh's self-sacrifice of his ear, see Bataille, "Sacrificial Mutilation," 63.

153. "No result of my work could please me better than that ordinary people would hang such prints in their room or workshop" (van Gogh, *Letters,* no. 245). For the community, Pollock, *Van Gogh,* 52.

154. Gold is not among the colors used by van Gogh listed in Birren, *History of Color in Painting.*

155. Brusatin, *History of Colors,* 48–50.

156. On the halos surrounding van Gogh's sunflowers, see Bataille, "Sacrificial Mutilation," 63. See van Gogh's various oil paintings titled *Sower,* especially that of November 1888, where the sun presents a definite halo. On the colors of halos generally, see Straton, "Historical Study." Various analogies between sunflower and coin constitute the principal theme of the anonymous British engraving *A Collection of State Flowers* (1734, British Museum; no. 1 in *Folly and Vice*).

157. As for his *Potato Eaters* (1885), see Pollock, *Van Gogh,* 30.

158. Van Gogh, *Letters,* no. 604, September 1889; the painting of the wheatfield behind Saint-Paul-de Mausole, a converted convent, is at the State Museum Kröller-Müller, Otterlo. For other examples of such suffusion see *Wheatfield* (1883), *Three Women Digging* (1886), and *Sower* (1888).

159. On gold and the color of the sun: Axelos, in treating a particular fragment of Heraclitus—"All things are an equal exchange [*antamoibē*] for fire and fire for all things, as goods [*chrēmata*] are for gold [*chrysou*] and gold for goods" (Heraclitus, frag. 90, in *Heraclitus,* ed. Kirk, 345)—says it is significant that gold has the color of the sun (Axelos, *Héraclite,* 94). Oswald Spengler likewise suggests that the abstract operations of gold as money are paralleled by its supposedly abstract color (*Decline of the West,* 1:247–54; cf. his *Metaphysische Grundgedanke der Heraklitischen Philosophie*). On heliopoetics and the sun as the source of all wealth, see also Jacques Derrida, esp. "Economimésis." For the usual interpretations of van Gogh's sun (as a symbol of God as Christ) and that of the sunflower (as a symbol of the pious soul), see Kodera, *Vincent van Gogh,* esp. chap. 2.

Four Conclusion

1. Ashton, *New York School*, 56, reports that Moses Soyer overheard Schapiro saying these words.

2. The title of Malraux's book is generally rendered in English as *The Voices of Silence*. On van Haecht and Metsys's painting, see Speth-Holterhoff, *Les peintres flamands*, 105–6.

3. Metsys's work—or perhaps Marinus van Reymerswaele's imitation of it (fig. 94 below)—is also included in the art gallery depicted in *Festin chez le bourgmestre Rockox* by the Flemish painter Frans Fancken the Younger; Alte Pinakothek, Munich.

4. Schama, *Embarrassment of Riches*, esp. 370–72.

5. For other relevant paintings of married couples interested in money, see Bergström, "Disguised Symbolism."

6. Moxey, "Criticism of Avarice," esp. 21–22. Various other paintings allegorically representing usurers are attributed to Marinus van Reymerswaele. See Puyvelde, "*Percepteurs d'impôts*." Cf. the *Allegory of Avarice* at the Staatsgalerie, Cassel; Yamey, *Art and Accounting*, pl. 60.

7. See Panofsky et al., *Saturn and Melancholy*.

8. For Terbrugghen, see Pigler, *Barockthemen*, 277.

9. On Metsys's mirror, see also Sulzberger, "Considérations," 30. For viewers who postulate both that the mirror is concave and that the window reflected by the mirror is a major light source, there arises a contradiction: various shadows—including that cast by the mirror—indicate that the major light source is at left, but judging by its placement in the mirror, the window is at right.

10. The painting's two halos (in the illumination) here complement the remarkable hats worn by the money changer, the wife, the two people in the door frame, and the person represented in the oval frame. Besides the mirror there are other items with refractive curves: jewel rings, the wife's gold band (its design matches those of her gown's gilt brocade and her book's gilt edges), pearls, brass tacks, vases, hanging beads, stained window glass (in the "mirror"), and the metallic plate and burnished fruit that hover halolike overhead.

11. On anachronistic aspects of Metsys's painting, see de Roover, *Money, Banking, and Credit*, 262–63, and Schabacker, "*Saint Eloy*," 117, n. 45. On monetary and sexual generation, see Shell, *End of Kinship*, esp. 29–30, 124–27.

12. For examples of such works, see Martin, "Numismatique."

13. Saint Eligius was tenured at the mint in the reign of Clotaire II (Schabacker, "*Saint Eloy*," 108). On balances in artworks generally, see Pigler, *Barockthemen*, 518, and Menapace, "Il cambiavalute"; and see such artworks as Salomon Koninck's painting *The Gold Weigher* (Boymans-van-Beuingen Museum, Rotterdam). Schabacker, "*Saint Eloy*," also discusses a few fourteenth-century pilgrims' badges depicting Saint Eligius; cf. Peigné-Delacourt, *Miracles de Saint Eloi*.

14. Lev. 19:36; Prov. 16:11. Cf. Luke 12:15, 21–34, and Matt. 6:19–21. See Sulzberger, "Considérations," 27, and Vlam, "Calling of Saint Matthew," 566, n. 28. The painting now hangs in a relatively plain wooden frame.

15. See Wormald, "Crucifix."

16. Curtius, *European Literature*, 312, referring to *Peristephanon* (10.1121 ff.), by the Spanish poet Prudentius (ca. 400).

17. Job 6:2. On the topos of the balance in Jewish art—including such scenes as the gathering of the temple tax depicted in a Machsor of A.D. 1272 (taken from the synagogue at Worms)—see Wischnitzer, "Moneychanger with the Balance."

18. Weber points out that the old medieval idea of God's bookkeeping is carried on in John Bunyan's "comparing the relation of a sinner to his God [to that] of a customer to the shopkeeper. One who has once got into debt may well, by the product of all his virtuous acts, succeed in paying off the accumulated interest but never the principal" (*Protestant Ethic,* 124).

19. Baxter's *Saints' Everlasting Rest* (1650), chap. 12, explains God's invisibility with the remark that just as one can carry on a profitable trade with an invisible foreigner through correspondence, so is it possible by means of holy commerce with an invisible God to get possession of the one priceless pearl (Weber, *Protestant Ethic,* 238).

20. Nicholas of Cusa writes that "in a disputation, the layman proves superior to the scholar," because he has acquired his knowledge not from books of the schools but "from God's books," which he "has written with his own finger." Truth is "to be found everywhere," hence "here in this marketplace too" (*Der Laie über die Weisheit,* 43). Cf. Curtius, *European Literature,* 321, and Bergström, "Disguised Symbolism," 27.

21. Shakespeare, *2 Henry IV,* 3.2.229–30. "Death" was usually pronounced "debt."

22. Matt. 25:27.

23. The Mass is quoted from *Missel Quotidien,* 1130; my translation. This passage recalls John 1:29. On the relationship between Christian and Hegelian sublation, especially as it concerns kinship, see Shell, *Children of the Earth,* 139–40; on the commercial meaning of *tollo* and *Aufhebung,* see Shell, *Money, Language, and Thought,* chap. 5.

24. On the cancellation of the debts in such works, see Yamey, *Art and Accounting,* 71; cf. *The Cleansing of the Temple* by Giovanni Stradano (= Jan van der Straat), in Sancto Spirito, Florence. On the motif of the expulsion from the temple, see Malraux's discussion of the various versions of El Greco's *Christ Driving the Traders from the Temple* (Malraux, *Voices,* 421–25).

25. See above, chap. 2, n. 167.

26. Diringer, *Illuminated Book,* 334. On the Siena series see Carli, *Tablettes;* Shevill, *Siena;* Heywood, *Siena;* and Lisini, *Tavolette;* and for color copies of most of the *tavolette,* see Borgia, *Biccherne.*

27. Shevill, *Siena,* 146. On the fourteenth-century artist Lorenzetti's relevant work *City of Good Government* (1339), see White, "Lorenzetti."

28. On the transition from an artwork's covering a book to its hanging on a wall, see Heywood, *Siena*, 35. Diringer argues that certain thirteenth-century works are "among the earliest attempts at individual portraiture in the history of Italian art" (*Illuminated Book*, 335).

29. See above, chap. 2, "*Aurum* and Aura."

30. Lessing, *Zerstreute Anmerkungen über das Epigramm.*

31. Cf. Andreae, "Mögliche Zusammenhänge zwischen der Entwicklung des Geldwesens und der Erkenntnissen der Konzeptkunst," in Harten, *Museum des Geldes*, 1.76.

32. In Shakespeare's play, Hamlet presents Guildenstern with a pipe that, Hamlet says, is "as easy as lying" to play upon. Guildenstern responds that "these [ventages and stops] cannot I command to any utt'rance of harmony" (*Hamlet*, 3.2.347–48). On the twinlike Rosencrantz and Guildenstern as wergeld, or man-money, see Shell, *Children of the Earth*, 251.

33. The semiological similarity between number and coin may help to explain the etymology of *number*—from the Latin *nummus* and the Greek *nomisma*, both of which mean "coined money" or "coin." Wiedemann associates *numerus*, the direct etymon of *number*, with cognates meaning "monetary interest" (*Litausche Präteritum*, vol. 5) and "money" or *Geld* (*Beiträge*, 30:216 ff.); Ernout and Meillet connect *numerus* to *nummus*, which is a Sicilian dialect version of *nomisma* (*Dictionnaire*); and Festus writes, "Numerus ex Graeco nomismate existimant dictum" (*De verborum significatione*, 176, 35). Compare how the etymology of *numerus* puzzles Curtius (*Principles*, 1:389 ff.) and Benveniste ("Trois étymologies latines," 85). And on the transformation of the Greek *nemo* into the Latin *numerus*, see LaRoche, *Histoire de la racine nem-*, 260–64. Compare the apparent etymological connections of both *nummus* and *nomismos* with the Latin *numen* ("name").

34. Edgerton, *Renaissance Discovery of Linear Perspective*, 344.

35. Wisd. of Sol. 11:20. This sentence from the Apocrypha, which adapts to Judaism the pseudo-Platonic argument that the economy (*dispositio*) of the universe is governed by number, appears to be a naive adaptation of Plato, *Republic*, 602c–d, etc.

36. *Trattato d'abbaco.* The authors of the various *abbaco* texts borrowed freely from one another. However, most of their works are "ultimately based on the early thirteenth century mathematical writing of Leonardo Pisano, commonly known as Fibonacci. It was Fibonacci who introduced Arabic numerals and methods of computation" (Davis, *Piero della Francesca's Mathematical Treatises*, 12).

37. Cited in Yamey, *Art and Accounting*, 128.

38. Baxandall, *Painting and Experience*, 101–2. Baxandall shows how certain mathematical skills acquired at the *scuola d'abbaco* "are deeply involved in fifteenth century painting" (85).

39. *Divina proportione.* Leonardo da Vinci engraved the geometric figures for this book.

40. On Fibonacci's similar work, however, see Giesing, *Leben und Schriften Leonardos da Pisa.*

41. Goethe's Werner says: "Es [double-entry bookkeeping] ist eine der schönsten Erfindungen des menschlichen Geistes" (Goethe, *Wilhelm Meister,* 1.10). In *Faust* Goethe considers the kinship between wealth and poetic dispensation, as in *Torquato Tasso* he considers the implications of patronage in the arts and in *Wilhelm Meister's Apprenticeship* he considers the opposition between commerce and poetry. See Shell, *Money, Language, and Thought,* chap. 4.

42. Spengler, *Decline of the West,* 2:490. Cf. Hatfield, "Historical Defense of Bookkeeping."

43. The title "De computis et scripturis" names a section in Pacioli's *Summa.* On "fiction" in the sense used here, see Fuller, *Legal Fictions.*

44. Colinson, *Idea rationaria,* 1; cf. Yamey and Littleton, *Studies in the History of Accounting,* 8.

45. North, *Gentleman Accomptant,* 1–3.

46. Da Silva, "Réalités économiques et prises de consciences," 737. Cf. Jean-Christophe Agnew's question, "What is it that debars us from describing in a systematic fashion the fundamental structures of meaning . . . that have accompanied the different forms of commodity exchange over time?" (Agnew, *Worlds Apart,* 1).

47. "Il n'existe d'ouvert à la recherche mentale que deux voies, en tout, où bifurque notre besoin, à savoir, l'esthétique d'une part et aussi l'économie politique" (Mallarmé, *Oeuvres,* 399).

48. Grand-Carteret, *Vieux papiers,* 388.

49. Hyde, *Gift;* Robertson, *Economic Individualism,* 54.

50. Harten, *Museum des Geldes,* 2:145.

51. Most of the paper money designs submitted to *Avant Garde* were joke notes— like James Spanfeller's bank note showing flowers growing up through money, or Bob Blechman's bill with the words "For information on how you can place your ad here . . ."

52. The exhibition was held 7–31 May.

53. See chap. 3, first section, above.

54. Aristotle, *On Memory and Recollection,* 450–51; *On Interpretation,* 16a; *Aristotle's Theory of Poetry,* 124; and *Politics* 1257a. Aristotle uses words like *tupos* (English "type") to signify the perception (*aisthēsis*) by which memory is impressed. See Shell, *Economy of Literature,* 85–88.

55. Cf. Aristotle's argument that monetary interest is unnatural (*Politics* 1258b).

56. See "Icon and Inscription," above.

57. Benjamin, "Mechanical Reproducibility," 219–20. Benjamin allies a sense of the universal equality mainly with the modern age, but at no time was this sense greater than when coins (or mechanically reproduced works of art; "Mechanical Reproducibility," 220) or money itself (of which coins are the tokens) were being developed. See chap. 2, n. 156, above; and, on the modern minting machine, see chap. 3, n. 12.

58. Benjamin, "Mechanical Reproducibility," 224.

59. Compare Pierre Proudhon's view in the *Philosophie de la misère* (Philosophy of poverty) that the value of labor is not a mere "figurative expression" or "fiction" and his opponent Karl Marx's witticism in his *Misère de la philosophie* (Poverty of philosophy) that "labor-commodity is nothing but a grammatical ellipse." (For Proudhon: *Système,* 1:49–50; and for Marx: *Elend,* MEW 23:559; trans. Burns, 129.) Cf. Fraser's view in his *Economic Thought and Language* that economic production and distributions are not fundamentally metaphorical or semantic problems subject to a merely aesthetic fix; and Timothy Clark's suggestion that "economic life—the 'economy,' the economic realm, sphere, level, instance, or what-have-you—is in itself a realm of representations. How else are we to characterize money, for instance, or the commodity form, or the wage contract?" (*Painting of Modern Life,* 6).

60. For *Geltung* and *Geld,* see such books from the period as Lask's *Zum System der Logik* (esp. *Schriften* 3:57–170), Gatz's *Die Begriffe der Geltung,* and Ssalagoff's *Vom Begriff des Geltens* as well as Heidegger's *Vom Wesen der Wahrheit,* which began as series of talks in the 1920s (Shell, *Money, Language, and Thought,* chap. 6). On the German inflation of that period more generally, see Feldman, *Great Disorder.*

61. Benjamin observes about Georg Christoph Lichtenberg—the eighteenth-century German aphorist and physicist who studied electricity and satirized Lavater and Voss—that "if [he] had found paper money in circulation the plan of this work would not have escaped him" (Benjamin, "Tax Advice," 96).

62. Wagenführ, *Kunst als Kapitalanlage.* For this title and other "cultural histories" of money, see above, chap. 1, n. 18. It is worth noting Benjamin's statement that "[cultural history] may well increase the burden of the treasures that are piled up on humanity's back. But it does not give mankind the strength to shake them off, so as to get its hands on them" (Benjamin, "Eduard Fuchs, Collector and Historian").

63. See Beuys's essay, "Was ist Kapital?" (Harten, *Museum des Geldes,* 2:18). "Mais qu'est-ce que le capital? J'en déduis qu'il ne peut s'agir que des capacités humaines. Le concept élargi 'art' est le concept concret 'capital': art = capital" (Beuys, *L'Art et l'Etat,* 12 January 1978; *Les couleurs de l'argent,* 104).

WORKS CITED

Abelard, Peter. *Theologia*. Migne, PL 178:97–102.

Acta sanctorum. New ed. Ed. and pub. Society of the Bollandists. 67 vols. Brussels, 1863–.

Adorno, Theodor Wiesengrund, and Max Horkheimer. *Dialektik der Aufklarung: Philosophische Fragmente*. Frankfurt, 1988. Trans. as *Dialectic of Enlightenment*, John Cummings. New York, 1988.

Aeschylus, *Persae*. Ed. with intro. and notes A. Sidgwick. Oxford, 1964.

Agnew, Jean-Christophe. *Worlds Apart: The Market and the Theater in Anglo-American Thought, 1550–1750*. Cambridge, 1986.

Alexander, J. J. G., ed. *The Master of Mary of Burgundy: A Book of Hours for Engelbert of Nassau*. New York, n.d.

Alpers, Svetlana. *Rembrandt's Enterprise: The Studio and the Market*. London, 1988.

American Journal of Numismatics and Bulletin of American Numismatic and Archaeological Societies (Boston) 24 (July 1887): 1–9.

The American Presidency in Political Cartoons: 1776–1976. Catalog, Ed. Thomas C. Blaisdell, Jr., and Peter Selz. Berkeley, Calif., 1976.

Amok: Fourth Dispatch. "A sourcebook of the extremes of information in print." Bookseller's catalog. Los Angeles, 1990.

Andreae, Clemens-August. "Mögliche Zusammenhänge zwischen der Entwicklung des Geldwesens und der Erkenntnissen der Konzeptkunst." In Harten and Kurnitzky, *Museum des Geldes*, 1:76.

Antichkopf, E. "Le Saint Graal et les rites eucharistiques." *Romania* 55 (1929): 175–94.

Anti-illusion: Procedures / Materials. Catalog of an exhibition at the Whitney Museum of American Art. Essay for the "Post-minimal" exhibition at the Whitney Museum, by James Monte. New York, 1969.

Apter, Emily, and William Pietz, eds. *Fetishism as Cultural Discourse*. Ithaca, N.Y., 1993.

Aristeas. *Artisteas Judaeus*. Ed. P. Wendland. Leipzig, 1900.

Aristotle. *Aristotle's Theory of Poetry and Fine Arts.* Ed. and trans. S. H. Butcher. New York, 1951.

———. "On Interpretation." Trans. H. P. Cooke. In *Organon: English and Greek,* vol. 1. Cambridge, Mass., 1938–60.

———. *The Parva naturalia: De sensu et sensibili, De memoria et reminiscentia, De somno, De somniis, De divinatione per somnum,* ed. J. I. Beare. *De longitudine et brevitate vitae De iuventute et senectute, De vita et morte, De respiratione,* ed. G. R. T. Ross. Oxford, 1908.

———. *Politics.* Trans. Carnes Lord. Chicago, 1984.

Arnheim, Rudolf. *Art and Visual Perception.* Berkeley, Calif., 1954.

Art and Money. Special issue of *Art In America* 78 (July 1990).

"Art Finger: Turning Pictures into Gold." *Time Magazine,* 25 June 1973, 65–67.

"Art You Can Bank On: A Creative Interest in Cash." *See* "Paper Money Made into Art."

Ashton, Dore. *The New York School: A Cultural Reckoning.* Harmondsworth, England, 1979.

L'Assiette au Beurre 80 (11 October 1902).

Athanasius of Alexandria. *Oratio III contra Arianos.* Migne, PG 94:140–45.

El atlas Catalán de Cresques Abraham. First complete edition. Barcelona, 1975.

Aubrey, John. *Remaines of Gentilisme and Judaisme* (1686–87). 1881.

Aureus: Zeitschrift für Numismatik, Geldwesen, und Kultur (Vienna).

Auslegung und Beschreibung der Anathomy oder warhafften abcontersetung eines inwendigen Corpers des Manns und Weibs. Strasbourg, 1539.

Avant Garde (journal). Report on paper money art contest. May 1968.

Axelos, Konrad. *Héraclite et la philosophie.* Paris, 1968.

Baba Mezi'a. Trans. Salis Daisches and H. Freedman (1935). In *Babylonian Talmud.*

Babylonian Talmud. Ed. I. Epstein. London, 1935–48.

Baillet, Adrien. *Histoires des festes mobiles dans l'Eglise, suivant l'ordre des dimanches et des féries de la semaine.* Paris, 1703.

Baldessari, John. "Making Art, Making Money: Thirteen Artists Comment." *Art in America* 78 (July 1990): 133–41.

Baldwin, Joseph G. *The Flush Times of Alabama and Mississippi: A Series of Sketches.* New York, 1852.

Balzac, Honoré de. *Eugénie Grandet.* Paris, 1964.

———. *The Wild Ass's Skin.* Trans. Herbert J. Hunt. Harmondsworth, England, 1977.

Bann, Stephan. "Zeuxis and Parrhasius." In *The True Vine: On Visual Representation and the Western Tradition,* chap. 1. New York, 1989.

Barasch, Moshe. *Icon: Studies in the History of an Idea.* New York, 1992.

Barge, H. *Luther und der Frühkapitalismus.* Gütersloh, 1951.

Bataille, Georges. "Sacrificial Mutilation and the Severed Ear of Vincent van Gogh." In *Visions of Excess: Select Writings, 1927–1939,* ed. Allan Stoekl, trans. Allan Stoekl with Carl Lovitt and Donald M. Leslie, Jr. Minneapolis, 1989.

Battersby, Martin. *Trompe l'Oeil: The Eye Deceived.* London, 1974.

Baudrillard, Jean. *For a Critique of the Political Economy of the Sign.* Trans. Charles Levin. Saint Louis, Mo., 1981.

Baxandall, Michael. *Painting and Experience in Fifteenth Century Italy.* Oxford, 1972.

Baxter, Richard. *The Saints' Everlasting Rest.* 1650.

Beach, H. B. "The Monetary Theories of John Law." Ph.D. diss. University of Illinois, Urbana, 1933.

Benesch, Otto. *Rembrandt Harmenszoon van Rijn: Selected Drawings.* London, 1947.

Benjamin, Walter. *Charles Baudelaire: A Lyric Poet in the Era of High Capitalism.* London, 1973.

———. "Eduard Fuchs, Collector and Historian." In *One-Way Street and Other Writings,* trans. Edmund Jephcott and Kingsley Shorter, London, 1979.

———. "Kleine Geschichte der Photographie." In *Angelus Novus.* Frankfurt, 1966.

———. "Tax Advice." In *One-Way Street and Other Writings,* trans. Edmund Jephcott and Kingsley Shorter. London, 1979. First published as *Einbahnstrasse,* Berlin, 1928.

———. "The Work of Art in the Age of Mechanical Reproducibility" (first published in *Zeitschrift für Sozialforschung* [1936]). Trans. as "The Work of Art in the Age of Mechanical Reproduction" in *Illuminations,* ed. Harry Zohn., ed. and intro. Hannah Arendt. New York, 1968.

Benson, George Willard. *The Cross: Its History and Symbolism.* New York, 1976.

Bentley, James. *Restless Bones: The Story of Relics.* London, 1985.

Benveniste, Emile. "Trois étymologies latines." *Bulletin de la Société Linguistique de Paris* 32 (1931): 68–85.

Beresiner, Yasher. "Legal Tender." *Journal of the Playing Card Society* 7 (May 1979): 82–83.

Berger, John. *Ways of Seeing.* London, 1977.

Bergström, Ingvar. "Disguised Symbolism in 'Madonna' Pictures and Still Life: II." *Burlington Magazine* (London) 97: 303–8, 340–49.

Birgitta. *Reuelationes.* Nuremberg, 1500.

Birren, Faber. *History of Color in Painting.* New York, 1965.

Björkman, Görel Cavalli, ed. *Northern Mannerism.* Stockholm, 1985.

Blackman, Aylward M. Articles in *Journal of Egyptian Archaeology* 10 (1924): 47–59; 11 (1925); 12 (1926): 176–85; 21 (1935): 1–9; 27 (1941): 83–95.

Blake, William. *Lavater's Aphorisms on Man*. London, 1789.

————. *The Poetry and Prose of William Blake*. Ed. David V. Erdman. Commentary by Harold Bloom. New York, 1968.

Bloch, Marc. *Esquisse d'une histoire monétaire de l'Europe*. Paris, 1954.

Bloom, Murray Teigh. "The Money Maker." *American Heritage* 35 (August–September 1984): 98–101.

————. *Money of Their Own*. New York, 1957.

Blumenkranz, Bernhard. *Le Juif médiéval au miroir de l'art chrétien*. Paris, 1966.

Boeckler, Albert. *Das goldene Evangelienbuch Heinrichs III*. Berlin, 1933.

Boggs, J. S. G. *Smart Money (Hard Currency)*. Exhibition organized by the Tampa Museum of Art. Sponsored by SunBank of Tampa Bay, Tampa, Fla., 1990.

————. "Under Arrest." *Art and Antiques,* October 1987, 99–104, 126–27.

Bolger, Doreen, Marc Simpson, John Ilmerdings, and Thayer Tolles Mickel, eds. *William M. Harnett*. New York, 1992.

Bologna, Giulia. *Illuminated Manuscripts: The Book before Gutenberg*. Translation of *Manoscritti e miniature*. New York, 1988.

Bonin, Hubert. *L'argent en France depuis 1889*. Paris, 1989.

Borgia, L., et al. *Le biccherne*. Rome, 1984.

Bouchet, Guillaume. *Les sérées de Guillaume Bouchet*. Ed. C. E. Roybet. 6 vols. Paris, 1873–82.

Brand, John. *Observations on the Popular Antiquities of Great Britain: Chiefly Illustrating the Origin of Our Vulgar and Provincial Customs, Ceremonies and Superstitions*. 3 vols. London, 1872–75.

Braudel, Fernand. *Capitalism and Material Life, 1400–1800*. Trans. Miriam Kochan. New York, 1975.

————. *The Mediterranean World in the Age of Philip II*. 2 vols. New York, 1976.

Brett, Guy. *Transcontinental (an Investigation of Reality)—Nine Latin American Artists (Waltercio Caldas, Juan Davila, Eugenio Dittborn, Roberto Evangelista, Victor Grippo, Jac Leirner, Cildo Meireles, Tunga, Regina Vater)*. With texts by the artists, Lu Menezes, and Paulo Venancio Filho. Catalog for an exhibition held at Ikon Gallery in Manchester, 24 March–28 April 1990. London and New York, 1990.

Brisbane, Albert. *Philosophy of Money*. [United States, 1863?]

Broodthaers, Marcel. *Musée d'Art Moderne—Museum of Modern Art—Kunstmuseum. Section Financière, Département des Aigles—Finanzverwaltung, Abteilung Adler—Financial Section, Department of Eagles. Concernant le vente d'un kilog d'or Fin en l'ingot—Concerning the Sale of a Kilogram of Fine Gold in the Ingot—Betreffend den Verkauf von einem Kilgramm Feingold in Barren*. Publication of a project by Marcel Broodthaers intended for Fisher Gallery in 1971. Düsseldorf, 1987.

Brusatin, Manlio. *History of Colors*. Boston, 1991.

Bryk, Felix. *Circumcision in Man and Woman: Its History, Psychology, and Ethnology.* Trans. David Berger. New York, 1934. Reprint New York, 1974.

Bryson, Norman. "Chardin and the Text of Still Life." *Critical Inquiry* 15 (1989): 227–52.

———. *Looking at the Overlooked: Four Essays on Still Life Painting.* Cambridge, Mass., 1990.

Buchanan, George Wesley. "Symbolic Money-Changers in the Temple." *New Testament Studies* 37 (April 1991): 280–90.

Buffon [Georges Louis Leclerc, comte de]. *Voyage de Gemelli Careri.* Paris, 1719.

Bulletin, Société de l'Histoire du Protestantisme Français, vol. 4 (1888).

Büsch, Johann G. *Sämtliche Schriften über Banken und Münzwesen.* Hamburg, 1801.

Butler, Charles. *The Feminine Monarchie; or, A Treatise concerning Bees* (1609). London, 1634.

Butler, James Davie. "Judas and His Shekels." *Notes and Queries,* 7th ser., 5 (12 May 1888): 364–65.

Calvin, John. *A Treatise on Relics.* In Collin de Plancy, *Dictionnaire,* vol. 3.

Carli, Enzo, ed. *Les tablettes peintes de la biccherna et de la gabella de l'ancienne république de Sienne.* Milan, 1931.

Carlyle, Thomas. "The Paper Age." In *The French Revolution: A History; in Three Parts,* vol. 1, part 1, book 2. London, n.d.

Carmina burana. Ed. Alfons Hilka, Otto Schumann, and Bernard Bischoff. 3 vols. Heidelberg, 1961–78. Trans. as *The Love Songs of the Carmina Burana* by E. D. Blodgett and Roy Arthur Swanson, Garland Library of Medieval Literature (49, B), New York, 1987.

Carmon, Walt, ed. *Red Cartoons from the Daily Worker.* 2 vols. New York, 1926–28.

Carroll, Lewis. *Alice in Wonderland; Through the Looking Glass; The Hunting of the Snark; Backgrounds / Essays in Criticism.* Ed. Donald J. Gray. New York, 1971.

Carson, R. A. G. *Coins of the World.* New York, 1962.

"Cashiered." *Art in America* 76 (July 1988): 124–25.

Castagno, John. *American Artists: Signatures and Monograms, 1800–1989.* Metuchen, N.J., 1990.

Catalogue for the Sale of the Collection of William H. Shaw. New York, March 1890.

Catalogue of Prints and Drawings in the British Museum. Division 1, *Political and Personal Satires* (nos. 1236–2015). Vol. 2, June 1689 to 1733. London, 1873.

Catholic Encyclopedia. 16 vols. New York, 1967.

Cavell, Stanley. *The Claim of Reason.* Oxford, 1979.

Chambers, Bruce W. See *Old Money.*

Child, Heather, and Dorothy Colles. *Christian Symbols Ancient and Modern*. London, 1971.

Clain-Steffanelli, Elvira. *Select Numismatic Bibliography*. New York, 1965.

Clair, Jen. *Duchamp et la photographie: Essai d'analyse d'un primat technique sur le développement d'une oeuvre*. Paris, 1977.

Clark, Timothy J. *The Painting of Modern Life: Paris in the Age of Manet and His Followers*. New York, 1985.

Colinson, Robert. *Idea Rationaria, or, The Perfect Acomptant. Necessary for All Merchants and Trafficquers: Containing the True Forme of Book-keeping according to the Italian Methode*. Edinburgh, 1683.

Collaborative Projects, Inc. *The Check Show*. Exhibition, 7–31 May 1988, Citibank, New York.

Collin de Plancy, J. A. S. *Dictionnaire critique des relique set des images miraculeuses*. 3 vols. Paris, 1821–22.

Collins, Adela Yarbro. "The Function of 'Excommunication' in Paul." *Harvard Theological Review* 73 (1980): 251–63.

Comment penser l'argent: Troisième forum Le Monde Le Mans. Ed. Roger-Pol Droit. Paris, 1992.

Constantine VII Porphyrogenitus. *De ceremoniis aulae Byzantinae*. Bonn, 1829–40.

Cormack, Robin. "Painting after Iconoclasm." In *Papers Given at the Ninth Spring Symposium of Byzantine Studies* (University of Birmingham, March 1975), ed. Anthony Bryer and Judith Herrn, 147–64. Birmingham, 1977.

Corradini, Bruno. *Manifesti futuristi e scritti teorici*. Ed. Mario Verdone. Ravenna, 1984.

Les couleurs de l'argent: Exposition Musée de la Poste, 19 novembre 1991–1 février 1992. With texts by Jean-Michel Ribettes, Jacques Foucart, and Michel Nuridsany. Paris, 1992.

Covarrubias Orozco, Sébastien de. *Emblemas morales*. Madrid, 1610.

Coverdale, Miles. *The Newe Testament both Latine and Englyshe*. 1538.

Curtius, Ernst. "Über den religiösen Charakter des griechischen Münzen." *Monats berichte der Königlich Preussischen Akademie der Wissenschaften zu Berlin,* 1870.

Curtius, Ernst Robert. *European Literature and the Latin Middle Ages*. New York, 1953.

Curtius, Georg. *Principles of Greek Etymology*. Trans. A. S. Wilkins and E. B. England. 2 vols. London, 1875–76.

Danto, Arthur. *Encounters and Reflections*. New York, 1990.

da Silva, J. Gentil. "Réalités économiques et prises de consciences." *Annales: Economies, Sociétés, Civilisations* 14 (October–December 1959): 232–37.

Davenport, Homer. *Cartoons*. Introd. John J. Ingalls. New York, 1898.

———. *The Dollar or the Man? The Issue of Today*. Boston, 1900.

Davis, Margaret Daly. *Piero della Francesca's Mathematical Treatises*. Ravenna, 1977.

De Brosses, Charles. *Le culte des dieux fétiches*. 1760.

Defoe, Daniel. *Best of Defoe's Review*. Ed. William L. Payne. New York, 1951.

————. *The Chimera; or The French Way of Paying National Debts Laid Open*. London, 1720.

De Linas, C. "Le reliquaire de Pépin à Conques." *Gazette Archéologique*, 1887, 37–49, 291–97.

Del Mar, Alexander. *History of Monetary Systems*. Chicago, 1896. Reprint Orono, Maine, 1983.

De Meyer, Maurice. "Le diable d'argent: Evolution du thème du XVIe au XIXe siècle." *Arts et Traditions Populaires* 15 (July–December 1967): 283–89.

De Roover, Raymond. *Money, Banking, and Credit in Medieval Bruges*. Cambridge, Mass., 1948.

Derrida, Jacques. "La double séance." In *La dissémination*. Paris, 1972.

————. "Du *sans prix* ou le *juste prix* de la transaction." In *Comment penser l'argent: Troisième forum Le Monde Le Mans*, ed. Roger-Pol Droit, 386–401. Paris, 1992.

————. "Economimésis." *Diacritics* 11 (1981): 3–25.

————. *La verité en peinture*. Paris, 1978.

Desmonde, William H. *Magic, Myth, and Money*. New York, 1962.

Dickson, Gary. "The Burning of the Amalricians." *Journal of Ecclesiastical History* 40 (1989): 347–69.

Dictionary of Numismatic Names. With addenda by Albert R. Frey and glossary of numismatic terms by Mark M. Salton. London, 1947.

Dictionary of the Middle Ages. Ed. Matthew Bunson. New York, 1933.

Didron, M. *Christian Iconography; or, The History of Christian Art in the Middle Ages*. Trans. E. J. Millington. London, 1851.

Diels, H. *Fragmente der Vorsokratiker*. 5th ed. Berlin, 1934.

Dillistin, William H. *Bank Note Reporters and Counterfeit Detectors*. Numismatic Notes and Monographs 114, American Numismatic Society. New York, 1949.

Di Pascale, G. Paolo. *Bardonecchia e le sue valli: Storia, arte, folklore*. 4th ed. Turin, 1973.

Diringer, David. *The Hand-Produced Book*. New York, 1953.

————. *The Illuminated Book*. London, 1958.

Dobiache-Rojdestvensky, Olga. *Les poésies des goliards*. Paris, 1931.

Dobson, Henry Austin. *Austin Dobson: An Anthology*. Oxford, 1924.

Dorfman, Joseph. *The Economic Mind in American Civilization, 1606–1865*. New York, 1946.

Du: Kulturelle Monatsschrift (October 1959). Issue devoted largely to questions of economics and art.

Du Chaillu, Paul B. [Paul Belloni]. *The Viking Age: The Early History, Manners, and Customs of the Ancestors of the English Speaking Nations.* 2 vols. New York, 1889.

Duchamp, Marcel. Catalog for an exhibition of Duchamp's works held in the Galleria Schwarz (Milan), December 1972 to February 1973.

———. *The Complete Works of Marcel Duchamp.* Ed. Arturo Schwarz. New York, 1969.

———. *Entretiens avec Marcel Duchamps.* Ed. Pierre Bellfond. Paris, 1967. Trans. as *Dialogues* by Ron Padgett, introd. by Salvador Dali. New York, 1971.

Duchartre, P.-L. *L'imagerie parisienne russe.* Paris, 1961.

Dulaure, J. A. *Die Zeugung.* Trans. and expanded by S. Krauss and K. Reiskel. In *Beiwerke zum Studium der Anthropophyteia.* Leipzig, 1903.

du Méril, E. *Poésies populaires latines du Moyen-Age.* Paris, 1847.

Dykes, Oswald. *English Proverbs.* 1709.

Edgerton, Samuel Y. *The Renaissance Discovery of Linear Perspective.* New York, 1976.

Einzig, Paul. *Primitive Money.* London, 1949.

Eliade, Mircea, ed. *Encyclopedia of Religion.* 16 vols. New York, 1987.

Eliot, T. S. *The Waste Land.* London, 1922.

Enciclopedia Judaica Castellana. Ed. Eduardo Weinfeld. 10 vols. Mexico City, 1947–51.

Encyclopaedia Britannica. 11th ed. New York, 1911.

Encyclopaedia Judaica. 14 vols. Jerusalem, 1971–72.

Ernout, A., and A. Meillet. *Dictionnaire étymologique de la langue latine.* Paris, 1967.

Estoire du Saint Graal (Lancelot Grail Cycle). In *Le Saint Graal; ou, Josef d'Arimathie: Première branche des romans de la Table Ronde* (Robert de Boron). Ed. E. Hucher [Le Mans], 1874–78.

Explication des ouvrages de peinture, sculpture, architecture, gravure, et lithographie des artistes vivants, exposés au Musée Royal le 16 mars 1846. Paris, 1846.

Ezekiel: A New Translation with a Commentary Anthologized from Talmudic, Midrashic, and Rabbinic Sources. Ed. Rabbi Moshe Eisemann. New York, 1988.

Fabian, Ann. *Card Sharps, Dream Books, and Bucket Shops: Gambling in Nineteenth-Century America.* Ithaca, N.Y., 1990.

Farinati, Paolo. *Giornale (1573–1606).* Ed. Lionello Puppi. Florence, 1968.

Les fastes du Gothique: Le siècle de Charles V. Ed Bruno Donzet and Christian Siret. Exhibition catalog, Galeries Nationales du Grand Palais, 1 October 1981 to 1 February 1982. Paris, 1981.

Feidelson, Charles. *Symbolism and American Literature.* Chicago, 1953.

Feldman, Burton, and Robert Richardson. *Modern Mythology.* Bloomington, Ind., 1972.

Feldman, Gerald D. *The Great Disorder: Politics, Economics, and Society in the German Inflation, 1914–1924.* New York, 1993.

Ferguson, George Wells. *Signs and Symbols in Christian Art*. New York, 1972.

Festus, Sextus Pompeius. *De verborum significatione*. Ed. C. O. Mueller. New York, 1975.

Fisher, Philip. "Jasper Johns: Strategies for Making and Effacing Art." *Critical Inquiry* 16 (1990): 313–54.

Folly and Vice: The Art of Satire and Social Criticism. Catalog. Ed. Roger Malbert and Liz Allen. London, 1989.

Fontenoy, Elisabeth. *Les figures juives de Marx*. Paris, 1973.

Foucault, Michel. *Les mots et les choses*. Paris, 1966.

———. *This Is Not a Pipe*. Illus. and letters by René Magritte. Trans. and ed. James Harkness. Berkeley and Los Angeles, 1982.

Franciscus de Retza. *Defensorium immaculatae virginitatis*. Leipizg, 1925.

Frankenstein, Alfred. *After the Hunt: William Harnett and Other American Still Life Painters, 1870–1900*. Berkeley and Los Angeles, 1975.

———. *Peto: Catalogue of the Exhibition with a Critical Biography*. Brooklyn Museum (Brooklyn Institute of Arts and Sciences). New York, 1950.

———. *The Reality of Appearance: The Trompe l'Oeil Tradition in American Painting*. Written for an exhibition organized by University Art Museum. Berkeley, Calif., 1970.

Fraser, L. M. *Economic Thought and Language*. London, 1937.

Freedberg, David. *The Power of Images: Studies in the History and Theory of Response*. Chicago, 1989.

Freud, Sigmund. "Analysis of a Phobia in a Five Year Old Boy" (1909). In *Standard Edition*, vol. 10.

———. "Character and Anal Eroticism." In *Collected Papers*, ed. James Strachey, 2: 45–50. 5 vols. London, 1949–50.

———. *Moses and Monotheism* (1939). In *Standard Edition*, vol. 23.

———. *Standard Edition of the Complete Psychological Works of Sigmund Freud*. Ed. and trans. James Strachey, Anna Freud, Alan Tyson, and Alix Strachey. 24 vols. London, 1953–74.

Fried, Michael. *Absorption and Theatricality: Painting and Beholder in the Age of Diderot*. Berkeley and Los Angeles, 1980.

———. *Three American Painters: Kenneth Noland, Jules Olitski, Frank Stella*. Catalog notes for an exhibition at the Fogg Art Museum of Harvard University, held 21 April to 30 May 1965.

Friedländer, Max J. *On Art and Connoisseurship*. Trans. with introd. Tancred Borenius. Boston, 1960.

From the Secular to the Sacred: Everday Objects in Jewish Ritual Use. Exhibition catalog, Israel Museum. Curator in charge, Iris Fishof. Jersualem, 1985.

Fuchs, Eduard. *Die Juden in der Karikatur: Ein Beitrag zur Kulturgeschichte*. Munich, 1921.

———. *Die Karikatur der Europäischen Völker vom Jahre 1848 bis zu Gegenwart.* 2 vols. Munich, [ca. 1921].

Fuller, Lon L. *Legal Fictions.* Stanford, Calif., 1967.

Futurist Manifestos. Ed. Umbro Apollonio. New York, 1973.

Gadamer, Hans Georg. *Kleine Schriften.* 4 vols. Tübingen, 1967–77.

Gaidoz, H. "Le grand diable d'argent: Patron de la finance." *Mélusine: Recueil de Mythologie—Littérature populaire, traditions et usages.* Vol. 6 (1892–93) and vol. 7 (1894–95), passim.

Galton, Francis. *Finger Prints.* New York, 1892.

Garas, Claire. "Les oeuvres de J. H. Schönfeld et de J. Heiss en Hongrie." *Bulletin de Musée Hongrois des Beaux-Arts* (Budapest) 34–35 (1970): 111–23.

Gatz, Felix Maria. *Die Begriffe der Geltung bei Lotze.* Stuttgart, 1928.

Gauthier, Marie-Madeleine. *Les émaux du Moyen Age occidental.* Paris, 1973.

———. *Highways of the Faith: Relics and Reliquaries from Jerusalem to Compostela.* Trans. J. A. Underwood. Secaucus, N.J., 1986.

———. "L'or et l'église au Moyen Age." *Revue de l'Art* 26 (1974): 64–77.

———. "Le trésor de Conques." *Rouerge roman,* Saint-Léger Vauban, 1963 (La nuit des temps).

Geary, Patrick J. *Furta Sacra: Thefts of Relics in the Central Middle Ages.* Princeton, N.J., 1978.

Georgius Cedrenus. Bonn 1838, 1839.

Gibbons, Rodmond. *The Physics and Metaphysics of Money: With a Sketch of Events Relating to Money in the Early History of California.* New York, 1866.

Giesing, J. *Leben und Schriften Leonardos da Pisa: Ein Beitrag zur Geschichte des Arithmetik des 13. Jahrhunderts.* Dobeln, 1886.

Gilbert-Rolfe, Jeremy. *Immanence and Permanence.* New York, 1985.

Glaser, Lynn. *Counterfeiting in America: The History of an American Way to Wealth.* New York, 1967.

Glossa ordinaria. Migne, PL 113.

Godfrey, Frederick M. *History of Italian Painting, 1250–1500.* New York, 1965.

Goethe, Johann Wolfgang von. *Faust.* In *Goethes Werke,* ed. Erich Trunz. 14 vols. Hamburg, 1949–60.

———. *Faust.* Ed. Cyrus Hamlin, trans. Walter Arndt. New York, 1976.

———. *Wilhelm Meister.* Berlin, 1957–60.

Gogh, V. van. *The Complete Letters of Vincent van Gogh.* New York, 1958.

Gombrich, Ernst. *Art and Illusion.* Princeton, N.J., 1956.

Goodman, Nelson. *Language of Art.* Indianapolis, 1976.

Goux, Jean Joseph. *Les iconoclastes.* Paris, 1978.

Grabar, André. *L'empereur dans l'art byzantin.* Paris, 1936.

————. *L'iconoclasme byzantin: Dossier archéologique.* Paris, 1957.

Grabar, Oleg. *The Formation of Islamic Art.* New Haven, Conn., 1973.

Gramberg, Werner, and Gert Hatz, with Walter Lüden. *Das Buch vom Geld: Ein Kultur-geschichte Münzen und des Münzwesens.* Hamburg, 1957.

Grampp, William D. *Pricing the Priceless: Art, Artists, and Economics.* New York, 1989.

Grand-Carteret, John, ed. *Le livre et l'image: Revue documentaire illustrée mensuelle.* Vol. 3. Paris, 1894.

————. *Vieux papiers—vieilles images: Cartons d'un collectionneur.* Paris, 1896.

Gratama, G. D. "Caricaturen van den tulpenhandel." *De Kunst der Nederlanden* 1 (July 1930): 367–71.

Green, Frederick C. *Eighteenth Century France: Six Essays.* New York, 1964.

Greenberg, Clement. *Art and Culture.* Boston, 1961.

Greer, Donald M., Paul C. Mohl, and Kathy A. Sheley. "A Technique for Foreskin Reconstruction and Some Preliminary Results." *Journal of Sex Research,* n.s., 18, no. 4 (1982): 324–30.

Grimm, Jakob, and Wilhelm Grimm. *Deutsches Wörterbuch.* 33 vols. Leipzig, 1854–1984. Reprint Munich, 1991.

————. *Teutonic Mythology.* Trans. James Steven Stallybrass. 4 vols. London, 1882–88.

Het groote tafereel der dwaasheid. Amsterdam, 1720. Consulted in Buffalo and Erie Public Library, Buffalo, N.Y.

Groseclose, Elgin. *Money and Man.* New York, 1961.

Grosjean, G. *Mappamundi der Katalanische Weltatlas vom Jahre 1375.* Zurich, 1977.

Guibert (abbot of Nogent). *De pignoribus sanctorum.* Migne, PL 156:609–79.

Guth, Klaus. *Guibert von Nogent und die hochmittelalterliche Kritik an der Reliquienverehrung.* Augsburg, 1970.

Haacke, Hans. *Framing and Being Framed: Seven Works, 1970–75.* New York, 1975.

————. *Unfinished Business.* Cambridge, Mass., 1987.

Hapgood, Susan. "Remaking Art History." *Art in America* 78 (July 1990): 115–22, 181.

Harten, Jürgen. "An Open Letter to the Bishop of Carlisle; or, What Should the Artist Do in Relation to Industry and Commerce?" *Studio International* 184 (April 1972): 146–49.

Harten, Jürgen, and Horst Kurnitzky. *Musée des sacrifices, musée de l'argent: De la nature étrange de l'argent dans l'art, la société, et la vie.* Catalog of exhibition, Centre Georges Pompidou, 4 July to 24 September 1979. Paris, 1979.

————. *Museum des Geldes: Über die seltsame Natur des Geldes in Kunst, Wissenschaft, und*

Leben. 2 vols. Stadtische Kunsthalle Düsseldorf und Kunstverein für Rheinlande und Westfalen. Düsseldorf, 1978.

Hartland, Edwin Sidney. *The Legend of Perseus: A Study in Story, Custom, and Belief.* Vol. 1, *The Supernatural Birth.* 3 vols. London, 1894.

Harvey, William H. *Coin's Financial School.* Ed. Richard Hofstadter. Cambridge, Mass., 1963.

Hasson, C. J. "The South Sea Bubble and Mr. Snell." In *Contemporary Studies in the Evolution of Accounting Thought,* ed. Michael Chatfield, 86–94. Belmont, Calif., 1968. First published in *Journal of Accountancy* 54 (August 1932): 128–37.

Hastings, James, ed. *Encyclopedia of Religion and Ethics.* Edinburgh, 1918.

Hatfield, Henry Rand. "An Historical Defense of Bookkeeping." *Journal of Accountancy* 37 (April 1924): 241–53.

Heidegger, Martin. "'Abraham a Sancta Clara': Zur Enthüllung seines Denkmals in Kreenheinstetten am 15. August 1910." *Allgemeine Rundschau: Wochenschrift für Politik und Kultur* 35 (27 August 1910).

———. *Sein und Zeit.* Halle, 1929. Trans. as *Being and Time* by John Macquarrie and E. Robinson. New York, 1962.

———. *Vom Wesen der Wahrheit.* Frankfurt, 1967. Trans. as "On the Essence of Truth" in Heidegger, *Existence and Being,* ed. R. F. C. Hull and Alan Crick, introd. Werner Brook. Chicago, 1949.

Heinzelman, Kurt. *The Economics of the Imagination.* Amherst, Mass., 1980.

Henkel, Albert, and Albrecht Schöne, eds. *Emblemata: Handbuch zur Sinnbildkunst des XVI, und XVII Jahrhunderts.* Stuttgart, 1976.

Heraclitus of Ephesus. *The Cosmic Fragments.* Ed. with introd. and comm. G. S. Kirk. Cambridge, 1954.

Herder, Johann Gottfried. *Anmerrkungen über das griechische Epigramm.* In *Herders sämmtliche Werke,* ed. B. Suphan, 15:337–92. Berlin, 1888.

Herford, C. H. *Studies in the Literary Relations of England and Germany.* Cambridge, 1886.

Herrick, Robert. *The Poetical Works of Robert Herrick.* Pref. Humbert Wolfe. Decorations Albert Rutherston. 4 vols. London, 1928.

Hess, Moses. *Philosophische und sozialistische Schriften, 1837–1850: Eine Auswahl.* Ed. Wolfgang Monke. Liechtenstein, 1980.

Hess, Thomas B. *The Art Comics and Satires of Ad Reinhardt.* Düsseldorf, 1975.

Hessler, Gene. *The Comprehensive Catalogue of U.S. Paper Money.* Chicago, 1974.

Heuscher, Julius E. *A Psychiatric Study of Myths and Fairy Tales: Their Origin, Meaning, and Usefulness.* 2d ed. enl. and rev. Springfield, Ill., 1974.

Heywood, William. *A Pictorial History of Siena.* Siena, 1902.

Higger, M., ed. *Massekhet Soferim.* (In Hebrew.) New York, 1937.

Hill, G. F. *The Medallic Portraits of Christ; The False Shekels; The Thirty Pieces of Silver.* Oxford, 1920.

Hill, O. T. *English Monasticism: Its Rise and Influence.* London, 1867.

Holmes, Urban T. "A New Interpretation of Chrétien's *Conte del Graal.*" *Studies in Philology* 44 (1947): 453–76.

Holmes, Urban T., and M. Amelia Klenke. *Chrétien de Troyes and the Grail.* Chapel Hill, N.C., 1959.

Hoogenboom, Ari, and Olive Hoogenboom, eds. *The Gilded Age.* Englewood Cliffs, N.J., 1967.

Hudson, H. R. *The Epigram in the English Renaissance.* Princeton, N.J., 1947.

Hughes, Robert. "On Art and Money." *New York Review of Books* 31 (6 December 1984): 20–28.

———. *The Shock of the New.* New York, 1981.

Hughes, Thomas Patrick. *A Dictionary of Islam.* London, 1896.

Hyde, Lewis. *The Gift: Imagination and the Erotic Life of Property.* New York, 1983.

The Image of America in Caricature and Cartoon. Catalog, Amon Carter Museum. Fort Worth, Tex., 1975.

Italiaander, Rolfe, Klaus Gundermann, and Joachim Buchner. *Geld in der Kunst: Geld und Geldeswert in Skulptur, Graphik und Malerei.* Hannover, 1976.

Jameson, Fredric. *Marxism and Form: Twentieth Century Dialectical Theories of Literature.* Princeton, N.J., 1974.

Jaquiet, Christian. "Über die Preisbildung von Kunstgütern." *Du: Kulturelle Monatsschrift* 19 (October 1959): 38–42.

Joannes of Hildesheim. *Liber de gestis et translatione trium regum* (The story of the three kings). Cologne, 1486.

John of Damascus. *De imaginibus orationes.* Migne, PG 94:1–3, 1231–1420.

———. *Orationes tres adversus eos qui sacras imagines abjiciunt.* Migne, PG 94:1227–1598.

John of Jerusalem. "De sacris imaginibus adversus Constantinum." Migne, PG 95:310–46.

Johnson, Edwin. *The Mouth of Gold.* New York, 1873.

Johnson, Malcolm. *The Great Loco Foco Juggernaut.* Drawn by D. C. Johnston. Barre, Mass., 1971.

Joswig, Heinz. *Das Geld.* Berlin, 1968.

Judd, Donald. *Complete Writings, 1959–1975: Gallery Reviews, Book Reviews, Articles, Letters to the Editor, Reports, Statements, Complaints.* New York, 1975.

Jung, Emma, and Marie Louise von Franz. *The Grail Legend.* Trans. Andrea Dykes. New York, 1970.

Kahane, Henry, and Renée Kahane. *The Krater and the Grail.* Urbana, Ill., 1965.

Keller, Arnold. *Deutsche Kleingeldscheine, 1916–22.* 4 vols. Berlin, 1955–56.

———. *Das Notgeld besonderer Art Scheine und Münzen.* Munich, 1977.

Keller, Arnold, Albert Pick, and Carl Siemsen. *Das Deutsche Notgeld.* 4 vols. Munich, [ca. 1975–].

Kerley, Richard E. "Putting Snap into Still Life." *Cincinnati Commercial Tribune,* 8 August 1921, 6.

Kerschlagel, Richard. *John Law: Die Erfindung der Modernen Banknote.* Vienna, 1965.

Kienholz. Exhibition catalog, with essay by Edward Kienholz. Helsinki, 1974.

Kirk, G. S., and J. E. Raven. *The Presocratic Philosophers.* Cambridge, 1971.

Kirschbaum, Engelbert, ed. *Lexikon der christlichen Ikonographie.* Rome, 1968–76.

Klein, Yves. *Il mistero ostentato.* Turin, 1970.

Klossowski, Pierre, and Pierre Zucca. *La monnaie vivante.* Paris, 1970.

Kodera, Tsukasa. *Vincent van Gogh: Christianity versus Nature.* Philadelphia, 1990.

Kökeritz, H. *Shakespeare's Pronunciation.* New Haven, Conn., 1953.

Kostof, Spiro K. *The Orthodox Baptistery of Ravenna.* New Haven, Conn., 1965.

Krauss, H. "Der Suaheli Arzt." *Münchener Medizinische Wochenschrift* 55, no. 10 (1980): 517.

Krucke, Adolf. *Der Nimbus und verwandte Attribute in der frühchristlichen Kunst.* Strasbourg, 1905.

Kurnitsky, Horst. *La estructura libidinal del dinero: Contribución al teoría de la femineidad.* Trans. from the German by Félix Blanco. Mexico City, 1978.

Kurtz, K. C. Handwritten letters to Jules David Prown (30 November 1969 and 16 January 1970). Manuscripts. Department of American Art, Yale University Art Gallery.

La Borie, Henri. *Otis Kaye: The "Trompe l'Oeil" Vision of Reality.* Oak Lawn, Ill., 1987.

Ladner, G. B. "The Concept of the Image in Greek Fathers and the Byzantine Iconoclastic Controversy." *Dumbarton Oaks Papers* 7 (1953): 3–33.

Lampe, G. W. H. *A Patristic Greek Lexicon.* Oxford, 1961.

Laqueur, Thomas. *Making Sex: Body and Gender from the Greeks to Freud.* Cambridge, Mass., 1990.

LaRoche, E. *Histoire de la racine nem- en grec ancien.* Paris, 1949.

Lask, Emil. *Gesammelte Schriften.* Ed. Eugen Herrigel. Tubingen, 1923.

Latham, R. E. *Revised Medieval Latin Word-List.* British Academy. London, 1965.

Laum, Bernard. *Heiliges Geld.* Tübingen, 1924.

Laurent, Emile, and Paul Nagour. *Magica Sexualis: Mystic Love Books of Black Arts and Secret Sciences.* Trans. Raymond Sabatier. New York, 1934.

Lavin, Marilyn Aronberg. "The Altar of Corpus Domini in Urbino: Paolo Uccello, Joos van Ghent, Piero della Francesca." *Art Bulletin* 69 (1967): 1–24.

Layard, John. "The Incest Taboo and the Virgin Archetype." *Eranos Jahrbuch* 12 (1945): 254–307.

Leiden Magical Papyrus. Ed. A. Dieterich. Leipzig, 1891.

Lenormant, François. *La monnaie dans l'antiquité.* 3 vols. Paris, 1878–79.

Lessing, G. E. *Zerstreute Anmerkungen über das Epigramm* [On the epigram]. Vol. 14 of *Lessings Werke,* Vollständige Ausgabe, ed. J. Petersen, W. von Olhausen, et al. 25 vols. Berlin, 1925.

Lévi-Strauss, Claude. *Leçon inaugurale, faite le mardi 5 janvier, 1960.* Paris, 1966.

Levy, Raphael. "The Quest for Biographical Evidence in *Perceval.*" *Medievalia et Humanistica,* fasc. 6 (1950): 76–83.

Lewes, G. H. *Comte's Philosophy of the Sciences.* London, 1853.

Lexikon der Kunst: Architektur, bildende Kunst, angewandte Kunst, Industrieformgestaltung, Kunsttheorie. Leipzig, 1987–.

Leyden, Rudolf von. *Indische Spielkarten: Inventarkatalog der indischen Sammlung des Deutsches Spielkarten-Museums.* Leinfelden-Echterdingen, 1977.

———. "Oriental Playing Cards: An Attempt at Exploration of Relationships." Trans. Fred G. Taylor. *Journal of the Playing Card Society* 4, suppl. 2 (1976): 1–37.

Lichtenstein, Roy. *Lichtenstein.* Ed. John Coplans. New York, 1972.

Lindschotten, J. H. von. *Das Ander Theil der orientalischen Indien.* Frankfurt am Main, 1598.

Lipman, Jean. "Money for Money's Sake as Art." *Art in America* 58 (January–February 1970): 76–83.

Lippard, Lucy R. *Six Years: The Dematerialization of the Art Object, 1966–72.* New York, 1973.

Lippard, Lucy R., and John Chandler. "The Dematerialization of Art." *Art International* 12 (February 1968): 31–36.

Lippincott, Louise. *Selling Art in Georgian London: The Rise of Arthur Pond.* New Haven, Conn., 1983.

Lisini, Alessandro. *Le tavolette dipinte di biccherna e di gabella del R. Archivio di Stato in Siena.* Florence, 1904.

Little, Lester K. *Religious Poverty and the Profit Economy in Medieval Europe.* Ithaca, N.Y., 1978.

Littré, Emile. *Dictionnaire de la langue française contenant . . . la nomenclature . . . la grammaire . . . la signification des mots . . . la partie historique . . . l'étymologie.* 4 vols. Paris, 1882.

Livy, Titus. *Histoire romaine.* Ed. Jean Bayet. Trans. Gaston Baillet. 4 vols. Paris, 1954–61.

Loomis, R. S. *A Mirror of Chaucer's World.* Princeton, N.J., 1956.

Lopez, R. S. "The Dollar of the Middle Ages." *Journal of Economic History* 11 (1951): 209–34.

L'Orange, H. P. *Studies on the Iconography of Cosmic Kingship in the Ancient World.* Oslo, 1953.

Lowry, Martin J. C. *The World of Aldus Manutius: Business and Scholarship in Renaissance Venice.* Oxford, 1979.

Luchaire, Achille. *Innocent III: Le Concile de Latran et la reforme de l'église.* Paris, 1908.

Lucie-Smith, Edward. *Late Modern: A Visual Art since 1945.* New York, 1975.

Luther, Martin. *Tischreden.* 6 vols. Weimar, 1912–21.

————. *Von Kaufshandlung und Wucher* (1524). In Luther, *Werke,* Kritische Gesamtausgabe, ed. J. K. F. Knaake, G. Kawerau, E. Thiele, et al. Weimar, 1883–.

Lycophron. *Lycophronis Alexandra.* Ed. Eduard Scheer. Berlin, 1881–1908.

Lyotard, Jean François. *Heidegger et les juifs.* Paris, 1988.

————. *Duchamp's TRANS/formers: A Book.* Venice, Calif., 1990.

MacCulloch, J. A., and Vincent A. Smith. "Relics." In Hastings, *Encyclopedia of Religion and Ethics,* vol. 10.

Macfie, A. L. *An Essay on Economy and Value: Being an Enquiry into the Real Nature of Economy.* London, 1936.

Mackendrick, Russ. "When Stamps Were Used for Small Change." *New York Times,* 7 August 1977.

Mâle, Emile. *L'art religieux du VIIe siècle.* 2d ed. Paris, 1951.

Mallarmé, Stéphane. *Oeuvres complètes.* Ed. Henri Mondor. Paris, 1945.

Malraux, André. *La monnaie de l'absolu.* 3 vols. Geneva, 1947–50. Trans. as *The Voices of Silence* by Stuart Gilbert. New York, 1953.

Mansel, Henry L. *The Gnostic Heresies of the First and Second Centuries.* London, 1871.

————. *Prologomena logica.* 2d ed. London, 1860.

Mantel, Hugo. *Studies in the History of the Sanhedrin.* Cambridge, Mass., 1961.

Marin, Jonier. "Distribution des billets de mille lires sur la place du Duomo, Milan." Pamphlet, 12 December 1972.

————. *Money Art Service.* Galerie Lara Vincy. Paris, 1973.

Markx-Veldman, Ilja. "Een serie allegorische prenten van Coornhert met een ontwerptekening van Maarten can Heemskerck." *Bulletin van het Rijksmuseum* 19 (May 1971): 70–76.

Marlowe, Joyce. *The Life and Times of George I.* Introd. Antonia Fraser. London, 1973.

Martin, Colin. "La numismatique dans l'art." *Schweizerische Numismatische Rundschau* 37 (1955): 37–45.

Martin, Edward James. *A History of the Iconoclastic Controversy.* New York, 1930.

Marx, Karl. *Capital.* Trans. S. Moore and E. Aveling. New York, 1967.

————. *The Economic and Philosophic Manuscripts of 1844.* Trans. Martin Milligan. New York, 1964.

———. "The Jewish Question." In *Writings of Young Marx on Philosophy and Society,* ed. Lloyd Easton and Kurt Guddat. Garden City, N.Y., 1967.

Marx, Karl, and Friedrich Engels. *Poverty of Philosophy [Elend d. Phil.].* Trans. Emile Burns, in Marx and Engels, *Collected Works,* vol. 6. New York, 1975–.

———. *Werke.* Institut für Marxismus-Leninismus beim ZK der SED. Berlin, 1956–68.

Massin. *Letter and Image.* Trans. Caroline Hill and Vivienne Menkes. New York, 1970.

Mastai, N. L. d'Otrange. *Illusion in Art: Trompe l'Oeil—A History of Pictorial Illusionism.* New York, 1975.

Mattick, Paul. "Die Zerstörung des Geldes." In *Beiträge zur Kritik des Geldes,* ed Paul Mattick, Alfred Sohn-Rethel, and Hellmut G. Haasis. Frankfurt am Main, 1976.

Maundeville, Sir John. *The Buke of John Maundeuill* (ca. 1400). London, 1889.

Mauss, Marcel. *The Gift: The Form and Reason for Exchange in Archaic Societies.* New York, 1967. First published 1925.

Mayer, Leo Ary. *Mamluk Playing Cards.* Ed. R. Ettinghausen and O. Kurz. London, 1971.

McCorquodale, Charles. "Carlo Dolci's *David with the Head of Goliath.*" *Connoisseur* 787 (1977): 54–59.

McCusker, John J. "Colonial Paper Money." In *Studies on Money in Early America,* ed. Eric P. Newman and Richard G. Doty. New York, 1976.

McLachlan, R. W. *The Canadian Card Money: A Bibliography.* Montreal, 1911.

Mclaughlin, Kevin. *Writing in Parts.* Stanford, Calif., 1994. Forthcoming.

Medieval Latin Word-List. Ed. J Houston. London, 1934.

Meiss, Millard. *French Painting in the Time of Jean De Berry: The Limbourgs and Their Contemporaries.* New York, 1974.

Melville, Herman. *The Confidence-Man: His Masquerade.* Ed. H. Parker. New York, 1971.

Mély, Fernand de. "Les deniers de Judas dans la tradition du Moyen Age." *Revue Numismatique,* 1899, 500–509.

———. "Les reliques du lait de la vierge et la Galactite." *Revue Archéologique,* 3d ser., 15 (1890): 103–16.

———. "*Les très riches heures* du duc de Berry et les influences italiennes, Domenico del Coro et Filippus di Francesco." In *Académie des Inscriptions et Belles Lettres, Paris, Commission de la Fondation Piot: Monuments et Mémoires* 18 (1910): 183–224.

Menapace, Luigi. "Il cambiavalute nelle incisioni e nella ritrattistica dall'antichità al rinascimento." *Economia e Storia* 17 (1970): 264–70.

Mendelssohn, Moses. *Jerusalem, oder Über religiöse Macht und Judentum.* Berlin, 1783. Reprint Brussels, 1968.

————. *"Jerusalem" and Other Jewish Writings.* Trans. Alfred Jospe. New York, 1969.

Messer, Thomas M. "Coins by Sculptors." *Art in America* 2 (1963): 32–38.

Michaels, Walter Benn. *The Gold Standard and the Logic of Naturalism.* Berkeley and Los Angeles, 1987.

Migne, J. P., ed. *Patrologiae cursus completus, series Graeca* (PG). 161 vols. Paris, 1857–66.

————. *Patrologiae cursus completus, series Latina* (PL). 221 vols. Paris, 1844–64.

Miller, Bryan. "The Art of the Deal." *New York Times,* 26 March 1994, sec. V, p. 4.

The Minor Tractates of the Talmud. Ed. A. Cohen. London, 1966.

Minton, John. *John Law: The Father of Paper Money.* New York, 1975.

Missel quotidien et vespéral. Ed. Gaspar Lefebvre and the Benedictine monks of the Abbey of Saint-André. Scriptural trans. E. Osty. Bruges, 1958.

Mitchell, W. J. Thomas. *Iconology: Image, Text, Ideology.* Chicago, 1986.

Moakley, Gertrude. *The Tarot Cards Painted by Bonifacio Bembo.* New York, 1966.

Möbius, Helga. *Passion und Auferstehung in Kultur und Kunst des Mittelalters.* Berlin, 1979.

Moelwyn, W. *Shakespeare and the Artist.* London, 1959.

Mohl, Paul C., Russell L. Adams, Donald M. Greer, and Kathy A. Sheley. "Prepuce Restoration Seekers: Psychiatric Aspects." *Archives of Sexual Behavior* 10 (August 1981): 383–93.

Money Matters: A Critical Look at Bank Architecture. A museum exhibition organized by the Museum of Fine Arts (Houston) and Parnassus Foundation, 1992.

Montag, Alice, and Ingrid Stadler. "Artworks and Pricetags." In *Contemporary Art and Its Philosophical Problems,* ed. Ingrid Stadler, 15–34. Buffalo, N.Y., 1987.

Montesquieu, Charles Secondat de (baron de). *Lettres Persanes.* In *Oeuvres complètes,* ed. Roger Caillois, 129–374. Paris, 1949.

"More Money Than Art." *Vogue Magazine* 154 (1969): 160–61.

Morison, Samuel Eliot. *The Oxford History of the American People.* New York, 1965.

Morris, Robert. "Notes on Sculpture; Part 4: Beyond Objects." *Art Forum,* April 1969, 50–54.

Morse, H. B. "Currency in China." *Journal of the North Branch of the Royal Asiatic Society,* 1907, 12.

Mosher, Stuart. "Coin Mottoes and Their Translation." *Numismatist* 61 (April 1948): 230–36; 61 (May 1948): 328–34; 61 (July 1948): 471–76; 61 (September 1948): 591–600; 61 (December 1948): 815–21.

Motherwell, Robert. "The Modern Painter's World." *Dyn* 6 (1949). Reprinted in Rose, *Readings in American Art,* 31–35.

Moulton, James Hope. *Early Zoroastrianism.* London, 1913.

Moxey, Keith P. F. "The Criticism of Avarice in Sixteenth Century Netherlandish Painting." In *Northern Mannerism,* ed. Görel Cavalli Björkman. Stockholm, 1985.

Muensterberger, Werner. *Collecting: An Unruly Passion*. Psychological Perspectives. Princeton: Princeton University Press, 1994.

Müller, Alphons Victor. *Die "hochheilige Vorhaut Christi" in Kult und in der Theologie der Papstkirche*. Berlin, 1907.

Murrel, William. *History of American Graphic Humor*. New York, 1933.

Muscalus, John A. *The Extensive Use of Christ on Paper Money Circulated in the United States*. Bridgeport, Pa., 1968.

———. *Famous Paintings of God and the Infant Jesus on Paper Money Issued in New Jersey*. Bridgeport, Pa., 1969.

———. *Famous Paintings Reproduced on Paper Money of State Banks, 1800–1866*. Bridgeport, Pa., 1939.

Nast, Thomas. *Cartoons and Illustrations by Thomas Nast*. Text by Thomas Nast St. Hill. New York, 1974.

Neal, Daniel. *The History of the Puritans or Protestant Nonconformists* (1732–38). London, 1754.

Nelson, Benjamin. *The Idea of Usury: From Tribal Brotherhood to Universal Otherhood*. 2d. ed. Chicago, 1969.

Neusner, Jacob. "Geldwechsler im Tempel: Von der Mischnan her erklärt." Trans. I. Betz. *Theologische Zeitschrift* 45, no. 1 (1989): 73–80.

New Catholic Encyclopedia. Prepared by the Catholic University of America. 18 vols. New York, 1967–79.

Newman, Eric P. *The Early Paper Money of America*. Racine, Wis., 1967.

Newman, John Henry (cardinal). *The Arians of the Fourth Century*. London, 1919.

Nicolai, Johann. *Disquisitio de nimbus antiquorum*. Jena, 1699.

Nicolas of Cusa. *Der Laie über die Weisheit*. Trans. E. Bohnenstadt. Leipzig, 1936.

———. *De ludo globi*. In *Quellen und Studien zur Geschichte der Philosophie,* ed. Paul Wippert, vol. 6. Berlin, 1967.

Nicquet, Honorat. *Titulus sanctae crucis*. New ed. Antwerp, 1870.

Niemer, G. *Das Geld: Ein Beitrag zur Volkskunde*. Breslau, 1930.

Nietzsche, Friedrich. *The Birth of Tragedy*. Trans. Francis Golffing. New York, 1956.

———. *Die Geburt der Tragödie*. In *Werke in drei Bänden,* vol. 1. Munich, 1954.

Nitze, W. "Spitzer's Grail Etymology." *American Journal of Philology* 66 (1945): 279–81.

Noël du Fail. *Contes et discours d'Eutrapel*. Paris, 1585.

North, Roger. *The Gentleman Accomptant; or, An Essay to Unfold the Mystery of Accompts*. London, 1715.

Nygren, Edward J. "The Almighty Dollar: Money as a Theme in American Painting." *Winterthur Portfolio* 23 (Summer–Autumn 1988): 129–50.

Old Money: American Trompe l'Oeil Images of Currency. Catalog for an exhibition of paintings at the Berry-Hill Galleries in New York City, 11−17 November 1988. Essay by Bruce W. Chambers. New York, 1988.

Orvell, Miles. *The Real Thing: Imitation and Authenticity.* Chapel Hill, N.C., 1989.

Ovid. *Metamorphoses.* Latin with English trans. by Frank Justus Miller. 3d ed. rev. G. P. Goold. 2 vols. Cambridge, Mass., 1977−84.

Ovide moralisé: Poème du commencement du quatorzième siècle. Ed. C. de Boer. Vol. 2. Wiesbaden, 1921.

The Oxford English Dictionary. Edited James A. H. Murray et al. 13 vols. Oxford, 1933.

Pacioli, Luca. *Divina proportione.* 1509.

———. *Summa de arithmetica, geometria, proportioni et proprotionalita.* 1494.

Panofsky, Erwin. *Early Netherlandish Painting.* Cambridge, Mass., 1953.

———. "Der gefesselte Eros." *Oud Holland* 50 (1933): 193−217.

———. *Problems in Titian, Mostly Iconographic.* Wrightsman Lectures. New York, 1969.

Panofsky, Erwin, with Raymond Klibanksy and Fritz Sax. *Saturn and Melancholy: Studies in the History of Natural Philosophy, Religion, and Art.* London, 1964.

"Paper Money Made into Art You Can Bank On—Prophets with Capital Ideas." *Life Magazine* 67 (19 September 1969): 51−61.

Pastreich, Emanuel. "Sanchūjin Tanomura Chikuden" (Literatus Tanomura Chikuden and the use of poetry and painting in the late Edo period). Dir. Sukehiro Hirakawa. M.A. thesis, University of Tokyo, 1991.

Pater, Walter H. *Works.* 8 vols. London, 1900−1901.

Pauly, August Friedrich von. *Paulys Realencyclopädie der classischen Altertumswissenschaft.* Ed. Georg Wissowa. 49 vols. in 58. Stuttgart, 1894−1980.

Peck, Harry Thurston, ed. *Harper's Dictionary of Classical Literature and Antiquities.* New York, 1962.

Peigné-Delacourt, Achille, ed. *Les miracles de Saint Eloi: Poème du XIIIe siècle.* Paris, 1839.

Pelikan, Jaroslav. *Imago Dei: The Byzantine Apologia for Icons.* A. W. Mellon Lectures in the Fine Arts (1987). Bollingen Series (35, 36). Princeton, N.J., 1990.

Pepper, Stephen Coburn. *World Hypotheses: A Study in Evidence.* Berkeley, Calif., 1942.

Perkins, Dexter. *The New Age of Franklin Roosevelt: 1932−45.* Chicago, 1957.

Phillips, Moberly. "Bank Note Collecting." *Connoisseur: An Illustrated Magazine for Collectors* 6 (May−August 1903): 44−47.

Picavet, F. J. *Les idéologues.* Paris, 1891.

Pietz, William. "The Problem of the Fetish." Part 1. *Res* 9 (1985): 5−7.

Pigler, A. *Barockthemen: Eine Auswahl von Verzeichnissen zur Ikonographie des 17. und 18. Jahrhunderts.* Vol. 2. Budapest, 1956.

Pinkerton, Alan. *Thirty Years a Detective.* New York, 1884. Reprint 1900.

Plato. *Republic*. Trans. Allan Bloom. New York, 1968.

Pogel, Nancy, and Paul Somers, Jr. "Editorial Cartoons." In *Handbook of the American Popular Culture*. Westport, Conn., 1980.

Pollock, Griselda. *Van Gogh: Artist of His Time*. Oxford, 1978.

Polo, Marco. *The Book of Ser Marco Polo*. Ed. and trans. Henry Yule. London, 1929.

Porte, Wilhelm. *Judas Ischarioth in der bildenden Kunst*. Berlin 1883.

Pound, Ezra. *ABC of Economics*. London, 1933.

"Prophets with Capital Ideas." See "Paper Money Made into Art You Can Bank On."

Proudhon, Pierre Joseph. *Système des contradictions économiques; ou, Philosophie de la misère*. Paris, 1846.

Proust, Marcel. *Contre Sainte-Beuve, précédé de pastiches et mélanges et suivi d'essais et articles*. Ed. Pierre Clarac and Yves Sandre. Paris, 1971.

Prunner, Gernot. *Ostasiatische Spielkarten*. Bielefeld, 1969.

Pusey, Edward B. *The Real Presence of the Body and Blood of Our Lord Jesus Christ; the Doctrine of the English Church* (1857). London, 1869.

Puyvelde, Leo van. *Les peintres flamands du XVIIe siècle*. Brussels, 1957.

———. "*Un portrait de Marchand* par Quentin Massys et *Les précepteurs d'impôts* par Marin van Reymerswaele." *Revue Belge d'Archéologie et d'Histoire d'Art* 26 (1957): 3–23.

Randall, Lillian M. *Images in the Margins of Gothic Manuscripts*. Berkeley and Los Angeles, 1966.

Rankin, H. D. "Catullus and Incest." *Eranos* 74 (1976): 113–21.

Ratcliff, Carter. "The Marriage of Art and Money." *Art in America* 76 (July 1988): 76–84, 145.

Readings in American Art since 1900: A Documentary Source. Ed. Barbara Rose. New York, 1968.

The Realm of the Coin: Money in Contemporary Art. Exhibition held 27 October to December 13 1991, curator Barbara Coller. Hofstra Museum, Hofstra University, Hempstead, N.Y.

Reik, Theodor. *Fragments of a Great Confession*. New York, 1949.

Remondino, Peter Charles. *History of Circumcision from the Earliest Times to the Present: Moral and Physical Reasons for Its Performance*. Philadelphia, 1891.

"Revaluation of the Dollar: Artists Design a New One-Dollar Bill." *Avant Garde* (ed. Ralph Ginzburg, New York) 3 (May 1968): 4–9.

Richard (bishop of London and treasurer of England). *Dialogus de scaccario* (1179). Printed by Thomas Madox in *History and Antiquities of the Exchequer*. London, 1711.

Richardson, D. W. *Electric Money: Evolution of an Electronic Funds-Transfer System*. Cambridge, Mass., 1970.

Richesses du patrimoine écrit (Ville du Mans). Pref. Robert Jarry, introd. Brigitte Richter and François Lenell. Ville du Mans, 1991. Sacramentaire. Saint-Amand. Second half of ninth century. MS 77, Ville du Mans.

Ripa, Cesare. *Iconologia.* Paris, 1644.

Robertson, Hector Menteith. *Aspects of the Rise of Economic Individualism: A Criticism of Max Weber and His School.* Cambridge, 1933.

Robinson, H. R. *A Correct Map of Alta California and the Gold Region: From Actual Survey Embracing All the New Towns and the Dry and Wet Diggins.* New York, 1848.

Rogers, William A. *Hits at Politics: A Series of Cartoons.* New York, 1899.

Roosevelt, Clinton. "On the Paradox of Political Economy in the Coexistence of Excessive Population." In *Proceedings of the American Association for the Advancement of Science,* 13th Meeting, August 1859, 344–52. Cambridge, 1860.

Rosand, David. Review of Puppi and Zampetti. *Art Bulletin* 53, no. 3 (1971): 407–9.

Rose, Barbara, ed. *Readings in American Art since 1900: A Documentary Source.* New York, 1968.

Rossi-Landi, F. *Semiotica e ideologia.* Milan, 1979.

Rotermund, H.-M. "The Motif of Radiance in Rembrandt's Biblical Drawings." *Journal of the Warburg and Courtauld Institutes* 25 (July–December 1952): 101–21.

Rothko, Mark. *Personal Statement.* David Porter Gallery. Washington, D.C., 1945.

Rouyer, J. "Le diable d'argent." *Revue Belge de Numismatique* 39 (1883): 389–96.

———. "Méreaux de la Sainte Chapelle." *Revue Numismatique Française,* n.s., 17 (1862): 481–97.

———. "Notes pour servir à l'étude des méreaux." *Revue Numismatique Française* 14 (1849): 446–64.

Royal Bank of Canada. Personal correspondence with S. Carroll, April 1979.

———. *The Story of Canada's Currency.* 2d ed. Ottawa, 1966.

Rücker, Elisabeth. "Eine Allegorie des Handels: Bemerkungen zu einem Thema der Augsburger Malerei im 18. Jahrhundert und zu einem Bozzetto im Germanischen Nationalmuseum." In *Anzeiger des Germanischen Nationalmuseums,* 160–65. Nuremburg, 1963.

Ruhmer, E. *Cranach.* London, 1965.

Ruskin, John. " 'A Joy Forever' (and Its Price in the Market): Being the Substance (with Additions) of Two Lectures on the Political Economy of Art, Delivered at Manchester, July 10th and 13th, 1857." In *The Works of John Ruskin,* vol. 16, ed. E. T. Cook and Alexander Wedderburn. 39 vols. London, 1903–12.

———. *The Works of John Ruskin.* Ed. E. T. Cook and A. Wedderburn. 39 vols. London, 1903–12.

Russel, Margo. *Coins.* Philadelphia, 1989.

St. Armand, Barton Levi. "Poe's 'Sober Mystification': The Uses of Alchemy in *The Gold-Bug.*" *Poe Studies* 4 (1971): 1–7.

Saintyves, Yves. *Les reliques et les images légendaires.* Paris, 1912.

Samhaber, Ernst. *Das Geld: Eine Kulturgeschichte.* Munich, 1964.

Samuelson, P. A., and H. E. Krooss, eds. *Documentary History of Banking and Currency in the United States.* 4 vols. New York, 1969.

Sandler, Erving. *The Triumph of American Painting: A History of Abstract Expressionism.* New York, 1970.

Santiago, Luciano. *The Children of Oedipus: Brother-Sister Incest in Psychiatry, Literature, History, and Mythology.* New York, 1973.

Sapori, Armando. *Merchants and Companies in Ancient Florence.* Comments on the illustrations by Ugo Procacci. Translated by Gladys Elliott. Florence, 1955.

Schabacker, Peter H. "Petrus Christus' *Saint Eloy:* Problems of Provenance, Sources, and Meaning." *Art Quarterly* 34, no. 1 (1972): 103–13.

Schama, Simon. *The Embarrassment of Riches.* London, 1987.

Schapiro, Meyer. "From Mozarabic to Romanesque in Silos." *Art Bulletin: An Illustrated Quarterly* 21 (December 1939): 325 ff.

―――. *Late Antique, Early Christian, and Medieval Art.* New York, 1979.

Schevill, Ferdinand. *Siena: The History of a Medieval Commune.* New York, 1909.

Schiller, Gertrud. *Ikonographie der christlichen Kunst.* Gütersloh, 1966.

Schischmánoff, Lydia. *Légendes religieuses bulgares.* Paris, 1896.

Schmitz, Neil. "Tall Tale, Tall Talk: Pursuing the Lie in Jacksonian Literature." *American Literature* 48 (1977): 473–77.

Schütz, Wilhelm von. *Göthes "Faust" und der Protestantismus: Manuskript für Katholiken und Freunde.* Bamberg, 1844.

Schwarz, Arturo. *Il reale assoluto.* Illus. Marcel Duchamp and Man Ray. Milan, 1964.

Schwarz, P. *De fabula Danaeia.* 1881.

Scriptores historiae Augustae. Ed. and trans. D. Magie. Cambridge, Mass., 1953.

Seiden, Mortin Irving. *The Paradox of Hate: A Study in Ritual Murder.* London, 1967.

Seldes, Lee. *The Legacy of Mark Rothko: An Exposé of the Greatest Art Scandal of Our Century.* Harmondsworth, England, 1969.

Servius. *Aeneidos librorum VI–XII.* In Servius, *Vergilii carmina commentarii,* ed. Georgius Thilo and Hermannus Hagen. 3 vols. Leipzig, 1881–1902.

Shakespeare, William. *Hamlet.* Ed. Willard Farnham. Baltimore, 1966.

―――. *The Merchant of Venice.* Ed. Brents Stirling. Baltimore, 1973.

―――. *The Second Part of King Henry the Fourth.* Ed. A. R. Humphreys. London, 1967.

―――. *The Tempest.* Ed. Robert Langbaum. New York, 1964.

Shell, Hanna. "The Book of Ezekiel." Public lecture on the occasion of her Bat Mitz-vah. Delivered at the Jewish Community of Amherst, Mass., on 6 October 1990.

Shell, Marc. "Argent et art." *Revue d'Economie Financière* 22 (Fall 1992): 207–22.

―――. "L'art en tant qu'argent en tant qu'art." In *Comment penser l'argent: Troisième forum Le Monde Le Mans,* ed. Roger-Pol Droit, 103–28. Paris, 1992.

―――. *Children of the Earth: Literature, Politics, and Nationhood.* New York, 1993.

―――. "Children of the Nation: Roman Catholicism, Imperial Rome, and the Uni-versal Family in Jean Racine." *Western Humanities Review* 44 (Fall 1990): 260–94.

―――. *The Economy of Literature.* Baltimore, 1978. Reprint Baltimore, 1993.

―――. *Elizabeth's Glass. With "The Glass of the Sinful Soul" (1544) by Elizabeth I and "Epistle Dedicatory" and "Conclusion" (1548) by John Bale.* Lincoln, Neb., 1993.

―――. *The End of Kinship: "Measure for Measure," Incest, and the Ideal of Universal Sib-linghood.* Stanford, Calif., 1988.

―――. "The Forked Tongue: Bilingual Advertising in Québec." *Semiotica* 4, no. 4 (1978): 259–69.

―――. "The Issue of Representation in Commerce and Culture." *Regional Review of the Federal Reserve Bank of Boston* 2 (Fall 1992): 20–24.

―――. "Les lis des champs: *Assurance,* insurance, et *ensurance.*" *Revue d'Economie Fin-ancière,* 1995. Forthcoming.

―――. *Money, Language, and Thought.* Berkeley and Los Angeles, 1982. Reprint Bal-timore, 1993.

―――. "The Want of Incest in the Christian Family." *Journal of the American Academy of Religion* 62, no. 2 (1994). Forthcoming.

Shevill, Ferdinand. *Siena: The History of a Medieval Commune.* 1909. Reprint New York, 1964.

Shibley, George H. *The Money Question.* Chicago, 1896.

Sidler, Nikolaus. *Zur Universalität des Inzesttabu: Eine kritische Untersuchung der These und der Einwände.* Stuttgart, 1971.

Simmel, Georg. *The Philosophy of Money.* Trans. Tom Bottomore and David Frisby with Kaethe Mengelberg. London, 1988.

Simpson, David. *Fetishism and Imagination: Dickens, Melville, Conrad.* Baltimore, 1982.

Smith, Adam. *An Inquiry into the Nature and Causes of the Wealth of Nations* (1776). Ox-ford, 1869.

Smith David. "A Symposium on Art and Religion." *Art Digest* 28 (15 December 1953): 8–11, 32–33.

Smith, William. *Dictionary of Greek and Roman Biography and Mythology.* 3 vols. Boston, 1867.

Smolar, L., and M. Aberbach. "The Golden Calf Episode in Postbiblical Literature." *Hebrew Union College Annual* 39 (1968): 91–116.

Snowden, James Ross. *The Coins of the Bible and Its Money Terms*. Philadelphia, 1864.

Solomon (bishop of Basra). *Book of the Bee*. Ed. and trans. Ernest A. Wallis Budge. Oxford, 1886.

Sombart, Werner. *Der moderne Kapitalismus*. 6th ed. Munich, 1924.

Sophocles, E. A. *Greek Lexicon of the Roman and Byzantine Periods*. New York, 1887.

Sotheby's. *American Nineteenth and Twentieth Century Paintings, Drawings, and Sculptures*. New York, 1985.

———. *Important American Paintings, Drawings, and Sculptures*. New York, 1986.

Soullié, Prosper. *Critique comparative des fables de La Fontaine*. Reims, 1881.

Soviet Encyclopedia (The Great). New York, 1973.

Spengler, Oswald. *Decline of the West*. New York, 1926.

———. *Der metaphysische Grundgedanke der Heraklitischen Philosophie*. Halle, 1904.

Speth-Holterhoff, S. *Les peintres flamands de cabinets d'amateurs au XVIIe siècle*. Brussels, 1957.

Spizter, Leo. "The Name of the Holy Grail." *American Journal of Philology* 65 (1944): 354–63.

Ssalagoff, Leo. *Vom Begriff des Geltens in der modernen Logik*. Leipzig, 1910.

Steinhausen, Georg. *Der Kaufmann in der deutschen Vergangenheit*. Leipzig, 1899.

Stewart, Susan. "On the Work of Ann Hamilton." In *Ann Hamilton*, pp. 16–26. Exhibition catalog, San Diego Museum of Contemporary Art. Introd. Lynda Forsha, essay Susan Stewart. La Jolla, Calif., 1991.

Stoll, Otto. *Das Geschlechtsleben in der Völkerpsychologie*. Leipzig, 1908.

Stone, Julien. "Danaë: *Aurum divinum*. Das göttliche Gold." *Aureus* 16 (1971): 14–25.

Straton, E. M. "An Historical Study of the Development of Halo Symbolism from an Art Appreciation Perspective." Ed.D. diss., University of Tulsa, 1974.

Sulzberger, Suzanne. "Considérations sur le chef-d'oeuvre de Quentin Metsys: Le prêteur et sa femme." *Bulletin des Musées Royaux de Belgique* 14 (1965): 27–34.

Taralon, J. *Trésors*. Paris, 1966.

Tenney, T., and Mary McWhorter. *Communion Tokens: Their Origin History and Use—With a Treatise on the Relation of the Sacrament to the Vitality and Revivals of the Church*. Grand Rapids, Mich., 1936.

Tertullian. *De idolatria*. Migne, PL 1:661–96.

Tervarant, Guy de. *Attributes et symboles dans l'art profane, 1450–1600—Dictionnaire d'un langage perdu*. Geneva, 1958.

———. *Les énigmes de l'art du Moyen Age*. Paris, 1938.

———. "Les tapisseries du Roceray et leurs sources d'inspiration." *Gazette des Beaux-Arts* 10 (1933): 79–99.

Theordore Studites. *On the Holy Icons (Antirretikoi kata ton eikonomachon)*. Trans. Cathe-

rine P. Roth. Crestwood, N.Y., 1981. Also Migne, PG 99.

Thiers, J. B. *Dissertation sur la sainte larme de Vendôme.* Paris, 1669.

Thiveaud, Jean-Marie. "L'ambassadeur-poète, Paul Claudel devant la crise de 1929." *Revue d'Economie Financière.* 5/6 September 1988, 283–92.

———, ed. *"La crise": Correspondence diplomatique. Amérique 1927–1932,* by Paul Claudel. Present. Erik Izraëlewicz. Collection Economie de la Littérature. Paris, 1993.

Thomas Aquinas. *Tractatus de regimine principium.* In *Opera omnia,* ed. St. E. Frette and P. Mare. 34 vols. Paris, 1871–80.

Tomkiewicz, Wladyslaw. "'Alegoria Handlu Gdanskiego' Izaaka van dem Blocke." *Biuletyn Historii Sztuki* 16 (1954): 404–19.

Torrey, Charles C. *The Commercial Terms in the Koran.* Leiden, 1892.

Trachtenberg, Moises. "Circumcision, Crucifixion, and Anti-Semitism: The Antithetical Character of Ideologies and Their Symbols Which Contain Crossed Lines." Trans. P. Slotkin. *International Review of Psycho-Analysis* 16, no. 4 (1989): 459–71.

Transformation: Art, Communications, Environment. Ed. Harry Holtzman. 3 vols. New York, 1950–52.

Trésors des églises de France. Musée des Arts Décoratifs. Paris, 1965. 2d ed., Paris, n.d.

Turbayne, Colin Murray. *The Myth of Metaphor.* Foreword Morse Peckham and Foster Tait. Appendix Rolf Eberle. Columbia, S.C., 1970.

Twain, Mark, and Charles Dudley Warner. *The Gilded Age: A Tale of To-day.* Hartford, Conn., 1873 [dated 1874].

Ueda, Akinari [Tosaku Ueda]. "Wealth and Poverty" (*Himpuku-ron*). In Ueda, *Tales of Moonlight and Rain* (*Ugetsu monogatari,* 1776), trans. with introd. Leon Zolbrod, 194–203. Tokyo, ca. 1974.

Veit, Ludwig. *Das Liebe Geld: Zwei Jahrtausende Geld- und Münzgeschichte.* Munich, 1969.

Vermeule, Cornelius. *Numismatic Art in America.* Cambridge, Mass., 1971.

Vlam, Grace A. H. "The Calling of Saint Matthew in Sixteenth Century Flemish Painting." *Art Bulletin* 59 (December 1977): 561–70.

Voltaire. *Oeuvres historiques.* Preface René Pomeau. Paris, 1957.

Waal, H. van de. *Iconclass: An Iconographic Classification System.* Completed and ed. L. D. Couprie with E. Tholen and G. Vellekoop. Amsterdam, 1977.

Wagenführ, Horst. *Der goldene Kompass: Vom Weiden und Wandel des Geldes.* Stuttgart, 1953.

———. *Handelsfürsten der Renaissance.* Stuttgart, 1957.

———. *Kunst als Kapitalanlage.* Stuttgart, 1965.

Waring, Mark. *Foreskin Restoration (Uncircumcision).* Listed and described in *Amok: Fourth Dispatch.*

Warner, Thomas. "Communion Tokens." *American Journal of Numismatics and Bulletin of American Numismatic and Archaeological Societies* (Boston). 22 (July 1887): 1–9; 22 (October 1887): 34–39; 22 (January 1888): 62–66; 22 (April 1888): 84–89.

Wawrzyn, Lienhard. *Walter Benjamins Kunsttheorie: Kritik einer Rezeption*. Darmstadt, 1973.

Weber, Max. *Economy and Society: An Outline of Interpretative Sociology*. Ed. Guenther Roth and Claus Wittich. Trans. Ephraim Fischoff. 2 vols. Berkeley and Los Angeles, 1978.

———. *The Protestant Ethic and the Spirit of Capitalism*. Trans. Talcott Parsons, foreword R. H. Tawney. New York, 1950.

Weissbuch, Ted N. "A Note on the Confidence-Man's Counterfeit Detector." *Emerson Quarterly* 19, no. 2 (1960): 16–18.

Weitzmann, Kurt. *The Icon: Holy Images—Sixth to Fourteenth Century*. New York, 1978.

Welch, S. M. *Home History: Recollections of Buffalo during the Decade from 1830–1840*. Buffalo, N.Y., 1891.

Wells, David A. *Robinson Crusoe's Money; or, The Remarkable Financial Fortunes and Misfortunes of a Remote Island Community*. Illus. Thomas Nast. New York, 1876. Reprint New York, 1931.

Werveke, Hans von. "Aantekening bij de zogenaamde Belasting pachters en *Wisselaars* van Marinus van Reymerswael." *Gentsche Bijdragen tot de Kunstgeschiedenis* 12 (1949–50): 48–50.

———. *Brveke and Anvers*. Brussels, 1944.

Weschler, Lawrence. "Onward and Upward with the Arts: Value." *New Yorker*, 18 January 1988, 33–56; 25 January 1988, 88–98.

———. *Shapinsky's Karma, Bogg's Bills, and Other True-Life Stories*. San Francisco, 1988.

White, John. "Ambrogio Lorenzetti." In *The Birth and Rebirth of Pictorial Space*. London, 1967.

White, Richard Grant. "Caricature and Caricaturists." *Harper's Monthly Magazine* 24 (April 1862): 586–607.

Wiedemann, Oskar. *Beiträge zur Kunde der indogermanischen Sprachen*. Ed. Adalbert Bezzenberger. 30 vols. Göttingen, 1877–1906.

———. *Das Litausche Präteritum*. Vol. 5. Strasbourg, 1889–91.

Wiellandt, Friedrich. *Schaffhauser Münz- und Geldgeschichte*. Schaffhausen, 1959.

Wildenstein, G., and J. Adhémar. "Les images de Denis de Mathonière d'après son inventaire (1598)." *Art et Traditions Populaires* 8 (1960): 150–57.

Williams, William Carlos. *Paterson*. New York, 1951.

Wischnitzer, Rachel. "The Moneychanger with the Balance: A Topic of Jewish Iconography." In *Eretz-Israel: Archaeological, Historical, and Geographic Studies*, 6:23–25. Jerusalem, 1960.

Wolfe, Tom. "The Worship of Art." *Harper's* 269 (October 1984): 61.

Woodside, William W. *Communion Tokens—A Bibliography.* Pamphlet, signed at the Carnegie Museum in Pittsburgh in December 1958.

Woodward, Jocelyn M. *Perseus: A Study in Greek Art and Legend.* Cambridge, 1937.

Wormald, Francis. "The Crucifix and the Balance." *Journal of the Warburg and Courtauld Institutes* 1 (1937–38): 276–80.

Wright, Thomas. *Historical and Descriptive Account of the Caricatures of James Gillray, Comprising a Political and Humorous History of the Latter Part of the Reign of George the III.* London, 1851.

Wroth, W. *Catalogue of the Imperial Byzantine Coins in the British Museum.* 2 vols. London, 1908.

Wycliffe, John. *The Holy Bible, Made from the Latin Vulgate by John Wycliffe and His Followers.* Ed. J. Forshall and F. Madden. London, 1850.

Wynn Jones, Michael. *The Cartoon History of the American Revolution.* New York, 1975.

Yamey, Basil S. *Art and Accounting.* New Haven, Conn., 1989.

Yamey, Basil S., and A. C. Littleton, eds. *Studies in the History of Accounting.* Homewood, Ill., 1956.

Yang, Lien-sheng. "Das Geld und seine Bezeichnungen in der chinesischen Geschichte." *Saeculum* 8 (1957): 196–209.

———. *Money and Credit in China: A Short History.* Cambridge, Mass., 1952.

Young, Pamela. "Masterpieces and Millions: Prices for Artwork Go Sky High." *Macleans,* 16 April 1990, 41–44.

Zampetti, Pietro, ed. *Lorenzo Lotto nel suo e nel nostro tempo.* Urbino, 1980.

Die Zeit der Staufer: Geschichte, Kunst, Kultur. Ed. Reiner Haussherr. Katalog der Ausstellung. Wurttembergisches Landesmuseum. 5 vols. Stuttgart, 1977–79.

Zelizer, Vivianna A. Rotman. "Earmarked Money." Paper delivered at the National Humanities Center Conference on The Gift, November 1990.

———. "Social Meaning of Money: 'Special Monies.'" *American Journal of Sociology* 95 (1989): 342–77.

Zwingli, Huldrich. *Sämtliche Werke.* Unter Mitwirkung des Zwingli-Vereins (Zürich) Ed. E. Egli, G. Finsler, W. Köhler, et al. 11 vols. Berlin, 1905–35.

ARTISTS DISCUSSED

Amman, Jost. Switzerland, 1539–91
Andre, Carl. United States, 1935–
Andrea di Bartolo. Florence, 1389–1428
Arman (Armand Fernandez). France, 1928–

Barbieri, Giovanni Francesco (called Il Guercino). Italy, 1591–1666
Barcet, Emmanuel. France, nineteenth to twentieth century
Barrit, Leon. United States, 1852–1938
Bassano, Leandro. Italy, 1557–1622
Benes, Barton Lidice. United States, 1942–
Beuys, Joseph. Germany, 1921–86
Blake, William. England, 1757–1827
Blechman, Robert O. United States, 1930–
Boggs, J. S. G. United States, 1955–
Botticelli, Sandro (Allesandro Filipepi). Florence, 1445–1510
Broodthaers, Marcel. Belgium, 1924–76
Brueghel, Jan. Flanders, 1568–1624

Caldas, Waltercio. Brazil, 1946–
Caravaggio, Michelangelo da (Michelangelo Merisi). Caravaggio, 1573–1610
Cenedella, Robert. United States, 1941–
Chalfant, J. D. [Jefferson David]. United States, 1856–1931
Christus, Petrus. Netherlands, ca. 1420–72/73

Cotton, Paul. United States, 1939–

Danton, Ferdinand, Jr. United States, 1877–after 1912
Daumier, Honoré. France, 1808–79
Davenport, Homer Calvin. United States, 1867–1912
Dionisio Fiammingo (Denys Calvaert). Flanders (Italy after 1562), 1540–1619
Dolci, Carlo. Florence, 1616–86
Dowd, Robert [Robert O'Dowd]. United States, 1937–
Dubreuil, Victor. United States, active ca. 1886–1900
Duchamp, Marcel. France, 1887–1968
Dürer, Albrecht. Germany, 1471–1528

Eckart, Christian. France, twentieth century
Eisenstein, Sergey Mikhaylovich. USSR, 1898–1948
Engels, Pieter. Netherlands, 1938–
Escher, M. C. [Maurits Cornelis]. Netherlands, 1898–1972

Fancken, Frans (called the Younger). Flanders, 1581–1642
Farinati, Paolo. Verona, ca. 1524–1606
Ferrer, Rafael. Puerto Rico, 1933–

Godall, H. L. United States, nineteenth to twentieth century

Gogh, Vincent van. Netherlands, 1853–90

Gossaert, Jan. Flanders, ca. 1478– ca. 1533

El Greco (Doménikos Theotokópoulos). Spain (b. Crete), 1541–1614

Greubenak, Dorothy. United States, twentieth century

Guillaume van Haecht. Belgium, 1593–1637

Haacke, Hans. United States (b. Germany), 1936

Haberle, John. United States, 1856–1933

Hamilton, Ann, United States, 1956–

Harnett, William Michael. United States (b. Ireland), 1848–92

Heiss, Johann. Germany, 1640–1704

Hilsing, Werner. Germany, 1938–

Holbein, Hans (called the Younger). Germany, 1497?–1543

Huebler, Douglas. United States, 1924–

Jacobsz, Dirck. Netherlands, 1497–1567

Jakober, Ben. Austria, 1930–

Jeannet. France, 1931–77

Johns, Jasper. United States, 1930–

Johnston, David Claypoole. United States, 1799–1865

Jud, Anne. Germany, 1953–

Judd, Donald. United States, 1928–

Kaye, Otis. United States, 1885–1974

Keppler, Joseph. United States (b. Austria), 1838–94

Kienholz, Edward. United States, 1927–

Klein, Yves. France, 1928–62

Klimt, Gustav. Austria, 1862–1918

Koninck, Salomon. Netherlands, 1609–56

Labisse, Félix. France, 1905–

Lairesse, Gerard de. Flanders, 1641–1711

Leandro da Ponte Bassano. Bassano, 1557–1622

Leirner, Jac. Brazil, 1961–

Leonardo da Vinci. Florence, 1452–1519

Leonardo of Pisa (Leonardo Fibonacci). Italy, ca. 1170–after 1240

Levine, Les. United States (b. Ireland), 1935–

Lichtenstein, Roy. United States, 1923–

Litterini, Bartolomeo. Italy, eighteenth century

Lochner, Stefan. Germany, ca. 1400–1451

Lorenzetti, Ambrogio. Siena, ca. 1290–1348

Lotto, Lorenzo. Venice, 1480–1556

Lubelski, Abraham. United States, twentieth century

Lucas van Leyden. Netherlands, 1494–1533

Lye, Len. United States, 1901–80

Mac Phail, Campbell. Scotland (b. Hawaii), 1938–

Magritte, René. Belgium, 1898–1967

Maître de la Manne. Netherlands, fifteenth century

Manet, Edouard. France, 1832–83

Marin, Jonier. France, twentieth century

Marinus van Reymerswaele. Netherlands, active ca. 1509–ca. 1567

Martini, Simone. Siena, ca. 1284–1344

Martorell, Bernardo. Catalonia, active 1427–52

Masaccio (Tommaso Guidi). Florence, 1401–28

Master of Berry. France, fifteenth century

Matteo de Pasti. Italy, fifteenth century

Meireles, Cildo. Brazil, 1948–

Metsys, Quentin (Quentin Massys). Flanders, ca. 1466–1530

Meurer, Charles A. United States (b. Germany), 1865–1955

Morely, Malcom. United States (b. Great Britain), 1931–

Morris, Robert. United States, 1931–

Motherwell, Robert. United States, 1915–

Murphy, John. Great Britain, 1945–

Nast, Thomas. United States (b. Germany), 1840–1902

Oppenheim, Dennis. United States, 1938–

Peale, Raphaelle. United States, 1774–1825

Peeters, Clara. Flanders, 1594–1657?

Peto, John Frederick. United States, 1854–1907

Picasso, Pablo. Spain, 1881–1973

Piero della Francesca. Italy, ca. 1420–92

Pietro della Vecchia (Pietro Muttoni). Venice, 1605–78

Pollock, Jackson. United States, 1912–56

Pond, Arthur. Great Britain, 1701–58

Poussin, Nicolas. France, 1594–1655

Proksch, Peter. Austria, 1935–

Rauschenberg, Robert. United States, 1925–

Reinhardt, Ad [Adolf Frederick]. United States, 1913–67

Rembrandt (Rembrandt Harmensz van Rijn). Netherlands, 1606–69

Reni, Guido. Italy, 1575–1642

Retti, J. P. Italy, twentieth century

Reuterswärd, Carl Frederik. Sweden, 1934–

Reynolds, Sir Joshua. England, 1723–92

Rigaud, Hyacinthe. France, 1659–1743

Rivers, Larry. United States, 1923–

Robinson, Henry R. United States, active 1830–50

Rogers, William A. United States, 1854–1931

Rothko, Mark. United States (b. Russia), 1903–70

Sano di Pietro (Asano di Pietro di Mencio). Italy, 1406–81

Sargent, John Singer. United States, 1856–1925

Sarony, Napoleon. United States (b. Canada), 1821–96

Schumann, F. G. Germany, eighteenth to nineteenth century

Slevogt, Max. Germany, 1868–1932

Smith, David. United States, 1906–65

Snyers, Alain. France, twentieth century

Soyer, Moses. United States (b. Russia), 1899–1974

Spanfeller, James. United States, 1930–

Spoerri, Daniel. Romania (Galicia), 1930–

Stankowski, Anton. Germany, 1906–

Stradano, Giovanni (Jan van der Straat). Florence (b. Brussels), 1523–1605

Taddeo di Bartolo. Siena, ca. 1362–1422

Teniers, David (called the Younger). Flanders, 1610–90

Terbrugghen, Hendrik. Netherlands, 1588–1629

Titian (Tiziano Vecelli). Venice, ca. 1488–1576

Uccello, Paolo. Florence, 1397–1475

Veronese, Paolo (Paolo Caliari). Verona and Venice, 1528–88

Warhol, Andy. United States, 1931–87

Wewerka, Stephan. Germany, 1928–

Wright, Joseph (called Wright of Derby). England, 1734–97

Zeuxis. Greece, fifth century B.C.